PHOTOGRAPH BY DON BOX

KATHLEEN POWERS ERICKSON,
who has been trained in art history and holds a
Ph.D. in the history of Christianity from the
University of Chicago, is a freelance writer and
photographer. She has spoken and written
widely on Vincent van Gogh and his work.

He had kept quite a number of prints
which he had collected in those days,
little lithographs after paintings, etc.
He brought them to show me repeatedly,
but they were always completely spoiled:
the white borders were literally covered with
quotations from Thomas à Kempis and the Bible.

— Mendes da Costes,
tutor to Vincent van Gogh

AT ETERNITY'S GATE

The Spiritual Vision
of
Vincent van Gogh

Kathleen Powers Erickson

WILLIAM B. EERDMANS PUBLISHING COMPANY
GRAND RAPIDS, MICHIGAN / CAMBRIDGE, U.K.

© 1998 Wm. B. Eerdmans Publishing Co.

255 Jefferson Ave. S.E., Grand Rapids, Michigan 49503 /
P.O. Box 163, Cambridge CB3 9PU U.K.

Printed in the United States of America

03 02 01 00 99 98 7 6 5 4 3 2 1

Library of Congress Cataloging-in-Publication Data

Erickson, Kathleen Powers.
At eternity's gate: a religious biography of Vincent Van Gogh /
Kathleen Powers Erickson.
p. cm.
Includes bibliographical references and index.
ISBN 0-8028-3856-1
1. Gogh, Vincent van, 1853-1890 — Religion.
2. Painters — Netherlands — Biography.
3. Spirituality in art.
I. Title.
ND653.G7E68 1998
759.9492 — dc21
[B] 98-13660
 CIP

To Vincent,
in honor of your memory

Contents

List of Illustrations and Plates

BLACK AND WHITE ILLUSTRATIONS

COLOR PLATES

Foreword

At Eternity's Gate COULD HAVE BEEN MERELY AN IMPORTANT BOOK, throwing light, as it perceptively does, on the ways painting, faith (or nonfaith), and personal existence meet in Vincent van Gogh. Students of painting, faith, and biography could enjoy the book and profit from reading it.

More than that, *At Eternity's Gate* could also be a *very* important book in its own genre. I say this because in order effectively to throw such light on van Gogh, the author finds it urgent to engage in cultural criticism, not so much about the milieu in which the artist worked as about the environment in which experts appraise art, faith, and life in our own time. As such, *At Eternity's Gate* delivers even more to the perceptive reader.

Having seen earlier versions of some of this book, I had been prepared to revisit this their fruition and be satisfied with its contribution to the study of van Gogh. The impressionists get a good press in our time. We are increasingly curious about them as individuals. Van Gogh is in the select two or three among them that every informed and perceptive person ought to know something about. Getting him into fresh focus has to be a valuable exercise on its own terms. Kathleen Powers Erickson will not disappoint such persons, though I picture some conventional art critics sharpening their own critical knives to take her to task or loading oil and pigment on their palette knives to send a splat or three in her direction.

She is willing to venture into several dimensions of critique in a time when hyperspecialists narrow the focus.

While all that art criticism is going on in these pages, however, the author readies what will be surprises for many readers as she ponders some questions about art, religion, and culture today.

To the point: as she guides us through van Gogh's life and then appraises significant works, she comes up with information so neglected or so frequently misread, and with interpretations that, in the light of that information and perspective, are so cogent, that one is led to ask questions like, Why *is* this "spiritual vision" so frequently disdained, overlooked, or misconstrued? How can so many people, whether art historians, gallery-goers, or physicians writing in *The Journal of the American Medical Association,* have failed to grasp this vision with more firmness and clarity?

I have given a very wrong impression about Erickson if I am setting readers up for a peevish, polemical work. She gives credit to others where credit is due. She does not seem to have to engage in correcting others in order to carve a space for her own new work. She knows that no single author can be equally competent in all aspects of interpretation and criticism, and she shows respect for any number of critics. Erickson does not have to deflate others in order to inflate her own ego and enlarge her own space. She has something very "other" in mind than any of that.

At Eternity's Gate is not an ill-tempered argument about a culture many of whose educated, gifted, and experienced people are tone-deaf to the sounds of the sacred or color-blind to the subtleties that accompany it. The author is not a whiner who complains that a cabal of rationalist children of the Enlightenment willfully screen out signals of the sacred and the spiritual. What comes through to this reader is not a whimpering about secularism or a whomping of humanists but instead a positive contribution to religious humanism of an emergent sort. Erickson can expect criticism for her courageous and learned engagement with so many others who have underplayed or malconstrued van Gogh's "spiritual vision," but one hopes that such criticism will be directed to the specifics of her elaborations, not to her overall intentions.

By no means is the author discovering that there is some sort of spiritual or religious vision in van Gogh. Some such vision is immediately apparent to anyone who walks through the galleries or turns the pages of reproductions. She mentions Paul Tillich, the notable mid-century theologian. I have strolled past paintings and stopped at *Starry Night* with that profound

thinker and heard him expatiate, as he regularly did, on how such a work was more religious than many a portrayal of Jesus in the mediocre art of our time. But Erickson helps us to see features that even a Tillich did not grasp.

If I read her correctly, the author sees that the academic ethos, the art establishment, the conventional critics living in a conventional house of post-Enlightenment meanings miss much. Among those meanings have been identifications of inherited, institutional, dogmatic religion with all things spiritual. If van Gogh distances himself from his own earlier association with such religion, they reason, he must have ended in simple unfaith or nonfaith.

Not at all, says Erickson, citing chapter and verse from the many letters of van Gogh. He could not have made it more clear: to the end, he was wrestling with the profound themes of faith, even to the point of revisiting classic paintings with biblical themes and giving new expression to them. Yes, he was tormented in those late years when he was portraying those biblical events and persons. But, Erickson shows, he was tormented in ways that helped him to see, and not to lapse into nostalgia or second-rate reproduction. Goethe liked to speak of the artist's ability to see, *schauen, really* to see. And the author is able to engage the labyrinth of van Gogh's interestingly troubled mind in his late years to see and to read how he stayed engrossed with the deep things that conventional religion in his day was missing.

Ancillary to her major intention is another: she helps us take the artist on his own terms. In our time, when "identity politics" often reigns and when observers and critics have to make everyone fit a specific category, she shows how the geniuses — and maybe, by inference, other people — are often misfits, transcenders of categories and stereotypes. Many critics have located van Gogh geographically and decided that he had to be a Calvinist and then a lapsed Calvinist; what other choices do we have? But there is the evidence, waiting to be set forth, that the evangelical Christianity of van Gogh's youth, extending through his missionary years, never did fit in the Calvinist mold; so he never had to be an ex-Calvinist. He was thoroughly himself, to be taken on his own terms, terms set forth hundreds of times in those quoted and so quotable letters that Erickson has read and is forwarding to us.

Erich Heller and other writers of our time have shown how in modernity the symbols of the transcendent have often become opaque and are subsequently seen as *mere* symbols. Tillich liked to say that a project

of our time is to make efforts to remove the adjective, to permit symbols and representations to be transparent, or at least translucent in respect to the realm of "being" behind them. Erickson's van Gogh can be seen as in the vanguard of such restorers, tortured by illness though he may have been as he went about his acts and art.

The author did her doctoral work at a school whose scholars often place a premium on "close reading" of classical texts. They tend to engross themselves close up, as if tracking each molecule of ink on each molecule of paper, in efforts to disinter and disclose previously hidden meanings. Erickson gives such close reading to the lines of van Gogh's letters and then engages in "close looking" at several of his works of art. She merits close attention. Even where readers might disagree with this or that reading of a letter or a work of art, it is a good bet that they will be teased into doing some fresh looking of their own. If that means that they will along the way call into question some of the perspectives, biases, and preconceptions they bring to the study of art and literature and thus of the larger culture of van Gogh's own time or ours, they will have helped to certify that this has turned out to be, as promised, an important — a *very* important — work.

MARTIN E. MARTY

Acknowledgments

WHILE THE ACT OF WRITING A BOOK OCCURS IN RELATIVE ISOLA-
tion, the actual production of a book is something else — a public
collaboration much like a Broadway play. While readers, editors, and
publicists take the place of set designers, lighting experts, makeup artists,
and producers, the end result is a body of work that goes far beyond the
original "script" tapped out alone on a computer keyboard. I was
passionately compelled in my writing of *At Eternity's Gate* by the strong
belief that no one had yet really told van Gogh's story. It is the great joy
of my life to see it set before me in the form of a completed book.

I want to thank my own "designers," "artists," and "producers" who
are responsible for bringing this story out of isolation and into the public
realm. First, my advisors at the University of Chicago, where I began my
research on van Gogh more than a decade ago: Jerald Brauer and Bernard
McGinn, in the Divinity School, whose seasoned knowledge of all aspects
of Western Christian thought guided me along the way, and Reinhold
Heller in the Art Department, with whom I was amazed to share a belief
in the importance of pursuing the spiritual aspects of an artist's life as a
way of understanding the context in which art is created. I must also
acknowledge the contribution of my former husband, Dr. Robert K. Erick-
son, professor of neurosurgery, who lent his expertise and helped me wade
through the medical literature that formed the substance of my chapter
on van Gogh's debilitating illness.

Next, I want to thank several readers, whose work is almost entirely

behind the scenes — people who give of their time and expertise, without compensation, for the pure love of learning and the desire to hold all of us to the highest possible standards in our work: Chris Parr, who did not overlook a single detail; John Walford, whose compliment that "this is the most reliable resource to date for those who seek to understand van Gogh's life, thought, and motivation" I will take to my grave; and Doug Abrams Arava, whose tireless commitment to telling van Gogh's story was second only to mine.

Finally, I must acknowledge the valuable assistance of the staff at Eerdmans Publishing Company, who are most responsible for the visual and literary quality of the final production. In particular I would like to thank Jennifer Hoffman, Amanda van Heukelem, and Anne Salsich. In their competent hands, I felt completely at ease entrusting the story that has meant so much to me.

<div align="right">

KATHLEEN POWERS ERICKSON

</div>

Introduction

THE FIRST TIME I READ VAN GOGH'S PROLIFIC CORRESPONDENCE, I was astonished to see how deeply his religious faith permeated his entire life. His letters are filled with biblical quotations, prayers, stories of his missionary work, arguments with the family and struggles over traditional religious views and modern thought, as well as revelations of the religious ideas that informed his art. Yet when I began my research, I noticed very little mention of van Gogh's religious concerns in the monographs of his life. Those biographers who did comment on van Gogh's spiritual journey seemed to believe that he ceased to be religious when he left the Church in 1880 to pursue a career as an artist. Few acknowledged the importance of his early Christian beliefs in shaping his artistic vision. For example, in the recent 1990 retrospective of van Gogh's work, honoring the centenary of his death, both of his most conventionally religious paintings, *The Pietà* and *The Raising of Lazarus,* remained in the basement vault of the Rijksmuseum van Gogh; the organizers of the exhibit did not see them as necessary to include, even though he discussed these paintings more in his letters than many others exhibited in the retrospective. Another painting of a traditional Christian subject, *The Good Samaritan,* remained on view in rural Otterlo, not readily available to most who would be visiting the exhibit held in Amsterdam.

In conjunction with the 1990 retrospective, an important work on van Gogh's religious life, Tsukasa Kōdera's *Christianity versus Nature,* was published. Yet Kōdera makes no attempt to relate van Gogh's early reli-

gious training to his life as an artist, persisting as others have in dividing van Gogh's life into two halves, one in which he was fanatically religious and the other in which he abandoned Christianity altogether for Natural Religion. My concern is to show the continuity of van Gogh's pilgrimage of faith, from his early religious training, through his evangelical period, to his struggle with religion and modernity, and finally to the synthesis of religion and modernity he achieved in both his life and art.

Some recent biographies have discussed the importance of van Gogh's religious journey, but many are full of misconceptions about his theological background. For example, in his book *Van Gogh and God* (1989), Cliff Edwards writes: ". . . the feelings of Vincent and Theo [van Gogh's brother] are the logical and planned outcome of John Calvin's interpretation of Scripture and approach to the human condition. . . . If Vincent's sense of guilt and anxiety appear to have been abnormal, his chief fault was that he took to heart his Calvinist heritage."[1] Edwards shares the popular misconception that Vincent van Gogh was Calvinist simply because he was Dutch Reformed. His family actually subscribed to a distinctive theology which diverged sharply from Calvinism. Van Gogh's father and famous uncle Stricker exposed him, at an early age, to the numerous theological controversies that dominated the age of religious inquiry.

In addition to the lack of reliable information about van Gogh's theological background, no one has yet discussed van Gogh's evangelical conversion or the importance of his belief in personal salvation as the foundation of his missionary work in Belgium. While many have documented van Gogh's rejection of institutional Christianity, none have pointed out the congruity of van Gogh's life as an artist with his religious past. Although van Gogh's enigmatic life continues to fascinate biographers, fallacies abound, especially regarding his mental illness. Here, I present the first systematic account of the history of diagnoses of van Gogh's illness, with a definitive diagnosis as well as a discussion of the link between his illness and his religious life. I also include the first in-depth discussion of the artistic and religious significance of his lesser-known religious "trilogy" of paintings, *The Pietà, The Raising of Lazarus,* and *The Good Samaritan.* When we begin to realize that religion was the central driving force of van Gogh's life, we can also appreciate the hidden spirituality of better-known works, such as *The Sower, Crows over the Wheatfield,* and *Starry Night.*

1. Cliff Edwards, *Van Gogh and God* (Chicago: Loyola University Press, 1989), 20.

Vincent van Gogh was born in 1853 in the midst of a tumultuous century in which religious thinking, like thinking in so many spheres, was in a constant state of flux. The cataclysmic events of the French Revolution had shattered the political order and had rocked the foundations of religious order within the Catholic Church. The rational certitudes of the previous century, the Age of Enlightenment, were crumbling before the tempest of a growing spirit of critical inquiry and investigation — to which both the Bible and Christian tradition were perpetually subject. Ralph Waldo Emerson observed, "Young men were born with knives in their brains." He would later bespeak the skeptical spirit of his era in observing, "The faith that stands on authority is not faith." This was the century that spawned the thought of Schleiermacher, for whom faith was a matter of deep personal feeling, and Kierkegaard, for whom faith involved a risky leap into the darkness. By the end of the nineteenth century, both the infallible authority of Catholic tradition and the absolute certainty of the Bible had been undermined, prompting an inward-looking search for an experience of faith. The religious person of the nineteenth century became the spiritual wanderer, a pilgrim, as van Gogh himself observed, "a stranger on earth." And in this, van Gogh was a man of his times, caught up in the struggle between the shattered unity of the medieval vision and the disjointed facets of modernity, part medieval mystic and part modern seeker.

Van Gogh's genius lies not so much in the originality of his vision, but in his unique synthesis of the traditional and the modern, both in art and religion. Essential to the nineteenth-century Romantic aesthetic was the belief that art and religion are inextricably linked. As Schelling wrote, "Art is silent poetry" and is meant to express spiritual thoughts from out of the soul, "not only by speech, but like Nature, by shape, by form, by corporeal works." It "stands as a uniting link between the soul and Nature and can be apprehended only in the living center of both."[2] Van Gogh echoed Schelling's sentiment when he wrote, "Art, although produced by man's hands is not created by hands alone, but by something which wells up from a deeper source out of our soul. . . ."[3] Schleiermacher, to whom

2. Quoted in Lorenz Eitner, *Neo-Classicism and Romanticism* (Englewood Cliffs: Prentice-Hall, 1970), 43.

3. Heinz R. Graetz, *The Symbolic Language of Vincent van Gogh* (New York: McGraw-Hill, 1963), 209.

van Gogh's father was indebted for his religious theology, wrote that religion is a fundamental expression of human need; all other endeavors, whether science, art or literature, flow from its wellspring. Van Gogh lived out this theology, though his pilgrimage was an erratic and complex one.

Initially, van Gogh embraced the theology of his father, whom he admired and adored. Known as the Groningen School, named for the Groningen region in the northern Netherlands where it originated, it is often called "the mediating school" because its proponents shared tenets of faith embraced by both the most orthodox and the most liberal thinkers of the time. On the one hand it insisted on the verbal inspiration of Scripture and its ultimate authority; and on the other hand, it denied the deity of Jesus. Vincent intended to follow in his father's footsteps and become a pastor of the Dutch Reformed faith, but he lacked formal training and chose instead to become a missionary to the Belgian coal miners in the Borinage district.

During the Borinage period, van Gogh's religious convictions diverged sharply from his father's. He left behind the Groningen theology for evangelical faith, which emphasized scriptural authority, personal salvation, "born again" experience, and the importance of preaching the Gospel. Van Gogh does not explain in his letters what caused this shift, but his language suggests a conversion experience, which seems to have occurred around September, 1875. His letters from this period are filled with scriptural references, particularly those referring to salvation, such as the famous query from the New Testament story of the Philippian jailer, "What must I do to be saved?" He apparently attended revivalist meetings, such as those of the Chicago-based preacher, Dwight L. Moody, read the work of the great evangelist, Charles Spurgeon, and worked toward the one goal of preaching and living out the Gospel. Each day he read his two beloved devotional works, Thomas à Kempis' *The Imitation of Christ* and John Bunyan's *The Pilgrim's Progress*. He ministered to the poor, giving away everything he had and living in abject poverty as if he had taken the vow of St. Francis. This asceticism and dedication to the literal practice of the Sermon on the Mount won him the respect and admiration of the coal miners but seemed extreme and repulsive to the established church. When the Dutch Consistory dismissed van Gogh from his work, he abandoned institutionalized religion. His sister-in-law, Johannna van Gogh-Bonger, later recalled, "His illusions of bringing through the Gospel comfort and cheer into the miserable lives of the miners had gradually

been lost in the bitter strife between doubt and religion, which he had to fight at that time; and which made him lose his former faith in God."[4]

The "bitter strife" between doubt and religion, in many ways the struggle of so many who lived as van Gogh did during this century of flux, led to Vincent's increasing alienation from his father. He became more interested in modern literature and read avidly, particularly the French Realist novels of Victor Hugo and Emile Zola, which his father, a dedicated Dutch nationalist, roundly condemned. Vincent edged toward a synthesis of tradition and modernity, which his father could not embrace. In 1883, his sister-in-law observed that he had "completely broken with all religion."[5]

In addition to his increasing conflict with his father, another important event in van Gogh's life contributed to his ultimate disillusionment with traditional Christianity, his unrequited love for his cousin Kee. She was the daughter of his famous uncle, Johannes Stricker, noted both for his preaching and his numerous critical publications on biblical history, including the first modern "Life of Jesus" published in the Netherlands. Van Gogh was intimately acquainted with his uncle. He studied with Stricker for over a year while Stricker tried unsuccessfully to tutor him in theology and biblical criticism so that he could gain entrance to a university degree program in theology. Although Stricker expressed great warmth for his nephew during their mentor-student relationship, he completely rejected him when Vincent proclaimed his deep love for Stricker's only surviving daughter, Kee.

The icy hypocrisy of his uncle Stricker and the rigid close-mindedness of his father led Vincent to condemn the institutional faith he had once hoped to proclaim as his life's work: "I frankly said that I thought their whole system of religion horrible, and just because I had gone too deeply into those questions during a miserable time in my life, I did not think of them anymore, and must keep clear of them as something fatal."[6] In rejecting what he called his family's "whole system of religion," van Gogh did not, of course, entirely banish his own religious sensibility or yearning.

4. Johanna van Gogh-Bonger, "Memoirs of Vincent van Gogh," 1913, *The Complete Letters of Vincent van Gogh*, 3 vols., hereafter abbreviated as *Letters*, intro. V. W. van Gogh, preface and memoir, Johanna van Gogh-Bonger (Greenwich, Conn.: New York Graphic Society, 1958), 1:xxix. Dates for van Gogh's letters are taken from Jan Hulsker's *Van Gogh door van Gogh* (Amsterdam: Muelenhoff, 1973), 217-23.

5. Ibid., 1:xxxv.

6. L166, 29 December 1881, *Letters* 1:294.

As he said himself (with respect to his famous *Starry Night* canvas), "That does not keep me from having a terrible need of — shall I say the word — religion. Then I go out at night to paint the stars."[7]

Van Gogh may have left the traditional Christian faith of his family behind, but he continued his religious pilgrimage. In subscribing to Victor Hugo's maxim, "Religions pass, but God remains," van Gogh indicated that his own faith went outside the boundaries of the institutional forms available to him and engaged a profound and private search for God.[8] This search animated his artistic life as he struggled to find his own style, a balance between the Dutch Realism in which he had been schooled and the "new art" taken up by Paul Gauguin and the Symbolists. Romanticism, indirectly influenced by the thought of Friedrich Schleiermacher, characterized van Gogh's piety at this time. He fully embraced Schleiermacher's notion that religion is an "affection, a revelation of the Infinite in the Finite, God being seen in it and it in God." According to Schleiermacher, "The contemplation of the pious is the immediate consciousness of the universal existence of all finite things, in and through the Infinite, and of all temporal things in and through the Eternal. Religion is to seek this and find it in all that lives and moves, in all growth and change, in all doing and suffering."[9] From his luminous starry skies that reach out for the Infinite to the smallest sunflower, the traditional symbol of devotion to God, van Gogh's art reflects his inner search for meaningful faith.

Tragically, when van Gogh was beginning to emerge as a pioneer of a new modern synthesis in art, he became violently ill. Though his illness has been labeled by many as "insanity," it was in fact a type of psychomotor epilepsy called temporal lobe disfunction, which accounted for his self-mutilation in December, 1888. This was the original diagnosis of the doctors who examined and treated van Gogh after he severed part of his ear. Only when van Gogh became the subject of popular myth did such inappropriate diagnoses as schizophrenia, based on a complete ignorance of the nature of psychomotor epileptiform illness, appear in his biographies. I shall discuss the complexities of his illness, as well as its relation to his religious beliefs, and give a history of his varied diagnoses.

7. L543, 29 September 1888, *Letters* 3:56.
8. L253, 12-18 December 1882, *Letters* 1:513.
9. Friedrich Schleiermacher, *On Religion: Speeches to Its Cultured Despisers,* Harper Torchbook edition (New York: Harper and Row, 1958), 36.

In the course of attempting to manage this crisis, particularly during his confinement in the hospital at St. Rémy, van Gogh turned to religion for comfort and solace. During this difficult period, he painted his most overtly religious subjects, *The Pietà, The Good Samaritan,* and *The Raising of Lazarus.* All reprises after other artists, *The Pietà* and *The Good Samaritan* after the French Romantic painter, Eugène Delacroix, and *The Raising of Lazarus* after Rembrandt, the three works are religious images of suffering and healing, death and resurrection. Van Gogh viewed his respite at St. Rémy as a time of revitalization and, he hoped, recuperation from his illness. He identified with the suffering of the dying Christ, the victimized Samaritan, and the decaying Lazarus, conveying this identification artistically by replacing the face of Christ in *The Pietà* and the face of Lazarus in *The Raising of Lazarus* with his own face. His religious belief that temporal existence is a period of trial and pain, with the ultimate hope of deliverance and rebirth, governed his choice of subjects.

I have taken the title of this biography from one of van Gogh's own works, one that summarizes his belief in the existence of a transcendent God as well as his hope for an eternal home. While studying painting at the Hague in 1882, van Gogh produced a lithograph of an old man sitting by the fire, his face buried in his hands, titled, *At Eternity's Gate.* Toward the end of his life, during his recuperation in the asylum at St. Rémy, he made an oil painting copied from the earlier lithograph. The fundamental importance and the character of religious thinking that shaped both his life and work are evident in his own discussion of *At Eternity's Gate:*

> It seems to me it's a painter's duty to try to put an idea into his work. In this print I have tried to express . . . what seems to me one of the strongest proofs of the existence of the "quelque chose là-haut" [something on high] in which Millet believed, namely the existence of God and eternity — certainly in the infinitely touching expression of a little old man, which he himself is unconscious of, when he is sitting quietly in the corner by the fire. At the same time, there is something noble, something great, which cannot be destined for the worms. . . . This is far from all theology, simply the fact that the poorest little woodcutter or peasant on the hearth or miner can have moments of emotion and inspiration that give him a feeling of an eternal home, and of being close to it.[10]

10. L248, 26 and 27 December 1882, *Letters* 1:495.

In the pages that follow, I will trace van Gogh's complex pilgrimage of faith, from the quiet of a rural Dutch parsonage to the dark caverns of the Belgian coal mines, through his colorful years as an artist in Paris and later, the French countryside, and finally to the edge of eternity, when he took his own life in 1890. We'll begin with the story of the son of a dedicated Dutch pastor, whose only goal was to emulate his father in carrying the light of the Gospel into the harsh lives of the peasants in the parish of his provincial homeland in southern Holland.

1. *The Faith of Our Fathers*

FROM THE EARLIEST RECORDS OF THE VAN GOGH FAMILY IN THE
Netherlands, the professions connected with art and religion were
intertwined. In the seventeenth century, both Cornelius van Gogh and his
son, Matthias, were clergymen. The first known artist in the family, another
Vincent van Gogh (1729-1802), was a successful sculptor. Having never
married, he left his fortune to his nephews, one of whom, Johannes, was
a Bible teacher and clerk at the Cloister church in the Hague. His son,
also a Vincent van Gogh (1789-1874), grandfather of the painter, received
his degree in theology at the University of Leiden in 1811. He eventually
settled at Breda, in the region of North Brabant, located along the southern
border of the Netherlands, where he lived until his death in 1874.

Three of his six sons were art dealers: Hendrik, Cornelius, who
headed the firm of C. M. van Gogh, and Vincent (affectionately known
to the painter as "Uncle Cents"), whose firm became an associate of the
large international art dealership of Goupil & Cie in 1858. Another son
was Theodorus van Gogh (1822-1885), Vincent van Gogh's father.
Theodorus obtained his theology degree from Utrecht in August, 1849,
but did not secure his appointment at Groot-Zundert, a small village
along the Belgian border, until January 11, 1850. The reason for the
delay is puzzling, but probably owes to the State Board's concern over
his somewhat unorthodox stance on certain theological issues; his sister,
Maria Johanna, recounts in her journal that Theodorus was "out of favor
with those of Groningen, which explains why to begin with, he waited

in vain for an appointment."[1] Apparently his examiners questioned Theodorus' allegiance because of his education at Utrecht.[2] Groningen University was moderate but Utrecht was the citadel of Calvinist orthodoxy, and during his years at Utrecht, there had been numerous student rebellions against the Groningen school.[3]

Zundert, as well as the whole region of Noord-Brabant, was and is today overwhelmingly Catholic. The differences between the Northern provinces of the Netherlands, which are more industrialized, Protestant, and Germanic, and the Southern provinces, which are agrarian, Catholic, and Gallic, reflect their different history. In 486, the southern regions of what is now the Netherlands were invaded by the Frankish tribes of Clovis, while Germanic tribes, especially the Thuringians, as well as the Saxons, maintained control of the northern regions.

Between 1477 and 1543, the seventeen provinces of the Netherlands had fallen to the control of the Hapsburgs, beginning with the Emperor Maximillian. Maximillian's son, "Philip the Fair," married a Spanish princess, a daughter of Ferdinand and Isabella. Their son became the famous Hapsburg Emperor, Charles V, who united the Netherlands with his other Spanish dominions. With the coming of the Reformation, the northern provinces of the Netherlands had become predominantly Protestant, with Calvinists and Lutherans experiencing some measure of toleration, while the Anabaptists, or those who followed the "radical" wing of the Reformation, were persecuted severely. Under the reign of Charles V, and particularly his son, Philip II, a devout Catholic, the Hapsburgs attempted to force the Low Countries back to Catholicism, but the inten-

1. Marc Edo Tralbaut, *Vincent van Gogh* (Lausanne: Edita, 1969), 12.

2. Tralbaut quotes Maria Johanna's journal as saying: "Dorus stond niet bij de Groningers in de gunst. Vandaar zijn aanvankelijk vergeefs uitzien naar een beroep." Regarding Dorus' education at Utrecht, Tralbaut writes, "In Utrecht, dus juist daar, waar Ds. Theodorus van Gogh gestudeerd had, waren de theologische professoren Bauman en Vinke gematigd orthoksen, maar, in tegenstelling met de Groningers, hielden zij vast aan de kenmerkende leerstukken van Kristendom en Konfessie, maar alles zeer gematigd. De studenten evenwel wilden wel eens wat meer. Door Da Costa [leader of the Calvinist reveil] lieten zij voordrachten houden, die zeer gewaardeerd werden, maar waardoor 'een hoog oplaaiende haat tegen de Groningers onstond" (Mark Edo Tralbaut, "Over de Godsdienstige Richtingen in Vincent's Tijd," *Van Goghiana* 7 [1970]: 103-8). It is difficult to determine if Theodorus was actually more conservative than his Groningen counterparts on the State Board, but his teachers at Utrecht were not orthodox Calvinist and were doctrinally closer to Groningen than to the students who followed the reveil and rebelled against Groningen.

3. See Frank Van den Berg, *Abraham Kuyper* (Grand Rapids: Eerdmans, 1960), 46.

sification of the Inquisition, the influx of Jesuit missionaries, and the establishment of "The Council of Blood" to try heretics all failed.

Under the leadership of William of Orange, the Dutch launched a long struggle to obtain independence from Spanish dominance, beginning in 1568. By 1579, the northern provinces had been successful and formed the Union of Utrecht, dividing them from the southern provinces, which remained the "Spanish Netherlands." The northern provinces retained their Protestant faith, while the Spanish were successful in maintaining the Catholic majority in the south. It was not until 1621 that the Spanish were forced to relinquish control of the southern provinces. The Netherlands were finally united, in 1648, with the peace of the Hague, but their religious divisions remained.[4]

Until the nineteenth century, the southern provinces included the provinces of Belgium as well. With the help of French armies, who repelled the Dutch, Belgium declared its independence in 1831. Although battles over boundaries continued, the territories were finally settled by 1839, with only a portion of Limburg remaining under Dutch control. This was only 14 years before Vincent van Gogh's birth, in 1853. Theodorus' role, then, was to be not only a minister to the Protestant congregations but a missionary to the Catholic peasants.

That Theodorus was Groningen, not Calvinist, is also noteworthy, given his location. Although Noord-Brabant was predominantly Catholic, Calvinism had its largest successes during the Reformation in this region, where the Walloons or those of French descent lived. The few Protestants that lived in the parishes that Theodorus took were most likely orthodox Calvinists. Theodorus headed parishes in a region of the country which was not only unsympathetic to his doctrinal beliefs but was essentially of a different faith. Perhaps Vincent van Gogh's tendency to pursue a course of his own conviction, against the mainstream, had its antecedents in this characteristic independence of his family.

By all accounts, though, the villagers of the region, Catholics and Protestants alike, both loved and respected Theodorus.[5] The mayor of

4. See Petrus Johannes Blok, *History of the People of the Netherlands*, 5 vols. (New York: G. P. Putnam's Sons, 1889).

5. "Doch bij Katholiek eveneer als bij niet-Katholiek heeft Ds. van Gogh zich hier een achting, eerbied en toegenegenheid verworven, zoals men die slechts zeer zelden ontmoet" (Benno J. Stokvis, *Nasporingen Omtrent Vincent van Gogh in Brabant* [Amsterdam: S. L. van Looy, 1926], 9).

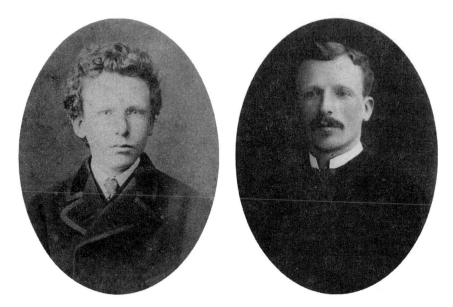

1. *Left,* Vincent van Gogh at age 13, 1866;
2. *right,* Theo van Gogh, Vincent's brother

Zundert apparently referred to him as "a Protestant mini-Pope."[6] It seems that much of Theodorus' ministry was in providing services to the poor, including the donation of goods to Catholic peasants.[7] A parishioner from Helvoirt described Theodorus as a "man of faith who was deeply beloved."[8] An account of Theodorus in Etten refers to him as a "strong powerful figure," who was more kind than the Kerkeraad (Consistory of the Reformed Church) approved, to Catholics as well as Protestants. His missionary efforts involved traveling long distances to farms throughout his parish to invite those to church who did not regularly attend. Vincent described his father as one ". . . who so often goes long distances, even in the night with a lantern, to visit a sick or dying man, to speak with him about One whose Word is a light, even in the night of suffering and agony."[9]

6. Ibid., 10.
7. Ibid.
8. Ibid., 14.
9. L110, 18 September 1877, *Letters* 1:140.

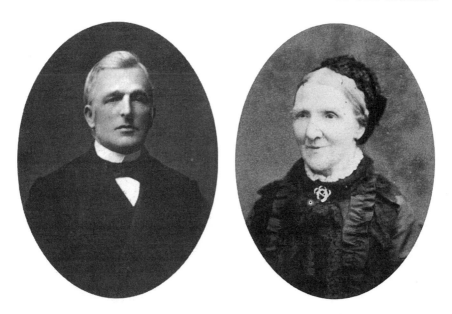

3. *Left,* Theodorus van Gogh, Vincent's father;
4. *right,* Anna Cornelius van Gogh-Carbentus, Vincent's mother

Vincent had the deepest admiration for his father and hoped eventually to become the kind of minister of the Gospel his father was. He wrote to Theo, his brother, "It is God who makes real men and who can enrich our lives with moments and periods of higher feeling. Has the sea made itself, has an oak tree? But men like our father are more beautiful than the sea."[10] When Vincent felt discouraged in the pursuit of his goal to become a minister of the Gospel, he remembered his father: "As to the religious work, I still do not give it up. Father has so many interests and he is so versatile. I hope that in whatever circumstances I may be, something similar will develop in me." He accepted the trials and setbacks along the way because he believed that the Christ he knew through his parents was also guiding his path. "God sees the trouble and sorrow," he wrote, "and He can help in spite of all. Faith in God is firm in me — it is not imagination nor idle faith. It is so, it is true, there is a God who is alive, He is with our parents, and His eye is also upon us; and I am sure

10. L72, 2 August 1876, *Letters* 1:64.

13

that he plans our life and that we do not quite belong to ourselves, as it were. This God is no other than Christ."[11]

Not only did Vincent respect and admire his father, but he had a deep and intimate affection for him, as his account to Theo of a visit with his father in Amsterdam reveals:

> As you know, Father has been here, and I am so glad he came. Together we went to see Mendes, Uncle Stricker and Uncle Cor, and the two Meyes families — the most pleasant recollection of father's visit is a morning we spent together in my little room, correcting some work and talking over several things. You can imagine how the days flew by.
>
> After I had seen father off at the station and had watched the train go out of sight, even the smoke of it, I came home to my room and saw father's chair standing near the little table on which the books and copy books of the days before were still lying; and though I know we shall see each other again soon, I cried like a child.[12]

Vincent was later to immortalize the symbol of the empty chair, particularly Gauguin's chair with his pipe resting on it, which so deeply conveyed his sense of loneliness and loss.

From the accounts of others who knew them both, Vincent van Gogh followed the example of his father. One recollection of Vincent when he lived with his parents in Etten described his extraordinary generosity to the poor, recalling an incident in which Vincent gave away his "almost-new" velvet suit to a beggar.[13] Van Gogh retained this characteristic concern for the poor, which he had been taught from his youth, throughout his life. Because van Gogh had such respect for both his father, Theodorus, and his uncle, Stricker, it was their theology that had the greatest impact on his early faith. While both had a deep, personal faith in the Gospel and a desire to emulate the life of Christ, they were fully aware of the turmoil facing the church during this great century of inquiry and upheaval. Neither led the life of the simple country pastor; both participated directly in the dialogue over the character of Christian faith.

The Dutch church was no less affected than other Protestant churches,

11. L98, 30 May 1877, *Letters* 1:119.
12. L118, 10 February 1878, *Letters* 1:160.
13. Stokvis, *Omtrent Vincent van Gogh in Brabant,* 18.

both in America and Europe, by the turmoil of the nineteenth century. The van Gogh family, though isolated in a small peasant village in the south, entered directly into the conflict. It was Groningen theology and modernism that most affected Vincent in his early development. While modernism was continental in scope, the Groningen theology to which van Gogh's father, Theodorus, subscribed was a product of the Dutch universities. Consistent with the Dutch Nationalism of the time, its proponents claimed only Dutch thinkers, such as Erasmus and Arminius, as its antecedents, although in reality, the Groningen school owes its deepest debt to the German pietist thought of Friedrich Schleiermacher. Nonetheless, it arose out of the single most important theological synod in Dutch history, the Synod of Dordrecht (1618-19), which convened as a result of the controversy instigated by Jacob Arminius, professor of theology at the University of Leiden from 1603 until 1609.[14] While van Gogh's biographers have universally claimed Calvinism as his religious heritage, his family actually took the opposite side of the religious debate, embracing instead the teachings of Arminius.

In particular, Arminius objected to the Calvinist doctrines of predestination and limited atonement which argued that only those few whom God chose before the dawn of time would ultimately find salvation. The Arminian doctrines were formally set down in the Remonstrance of 1610, which advocated that man's will was free and he could therefore choose to accept or reject the grace of God, and that salvation was available to all human beings, not just a few chosen elect.[15] The van Gogh family, begin-

14. Carl Bangs, *Arminius, A Study in the Dutch Reformation* (Grand Rapids: Zondervan, 1985), 240-51.

15. On 14 January 1610, some forty Arminians met in the city of Gouda to draw up the "Remonstrance," a petition to be circulated among the political authorities setting forth the views of those sympathetic to Arminius. The Remonstrants argued that Calvinism was inconsistent with both the Holy Scriptures and the Apostolic Creed. The Five Arminian Articles (Articuli Aminiani side Remonstrantia) can be summarized as follows: (1) It was God's preordained plan to save the fallen human race through the saving act of Christ's death on the cross, and that salvation comes, not through election, but through simple faith in Christ, to those who "shall believe in this His Son Jesus Christ and persevere in this faith and obedience to the end." (2) Jesus died on the cross for the forgiveness of all who would believe in Him, not a select few. ". . . Jesus Christ, the saviour of the world, died for all men and for every man, so that He merited reconciliation and forgiveness of sins for all through the death of the cross." (3) Man can do nothing to earn his salvation and must be regenerated by the Holy Spirit to be able to receive the grace of God. (4) Man is free to accept or reject God's saving grace. "But with respect to the mode of this grace,

ning with Cornelius van Gogh, who was a Remonstrant preacher at Boskoop, avowed the Arminian doctrines on free will and atonement from the seventeenth century forward.[16]

The five points of doctrine disputed at the Synod were finally settled for Calvinist orthodoxy in the Five Canons. Subscription to the Canons as well as to the Belgic Confession and the Heidelberg Catechism became mandatory for all persons who held teaching and preaching positions in the Hervormd Kerk.[17] The Five Canons upheld the basic points of Calvinist doctrine: (1) original sin — all people have inherited a sinful nature from the first sinner, Adam. God chose a few "elect" to deliver from sin. All others are lost and without recourse to change their unhappy fate. (2) Christ died on the cross to achieve forgiveness and redemption only for the "elect," not for the sins of the world. (3) Human beings have no free will to accept or reject the grace of God's forgiveness.[18] In affirming the Calvinist doctrines of original sin and the total depravity of man, justification by the grace of God's act of salvation through Christ's death on the cross, a redemption limited to the predestined elect, the Synod of Dort categorically rejected the Arminian doctrines of the Remonstrants. As a result, some two hundred Remonstrant ministers were officially removed from their posts. Also, because the States General, the civil authority, accepted the doctrinal stance of the Synod of Dort, many Re-

it is not irresistible, since it is written concerning many that they resisted the Holy Spirit, in Acts 7 and elsewhere in many places." (5) The Christian, with the help of the Holy Spirit, is able to strive against evil, but the Remonstrants suggest that it is possible that he may lapse and fall from grace (Peter Y. De Jong, *Crisis in the Reformed Churches, Essays in Commemoration of the Synod of Dort, 1618-1619* [Grand Rapids: Reformed Fellowship, 1968], 207-9).

16. "Zoo werd een traditie die in de XVII eeuw met Cornelius van Gogh, Remonstrantsch predikant te Boskoop, begonnen was, verscheidene geslachten lang bestendigd." (Walter Van Beselaere, *De Hollandsche Periode in het Werk van Vincent van Gogh* [Antwerp: De Sikkel, 1937], 4).

17. The Belgic Confession of 1561 was adopted in the Netherlands in 1566 as the official doctrinal confession of the Reformed Church. The Heidelberg Catechism, compiled in 1562, at the request of the Elector Frederik III, became the official doctrine of the Palatinate in 1563. Both affirmed the standard Calvinist doctrines of the total depravity of man, justification by faith alone, the sovereignty of the Scriptures, limited atonement, irresistible grace, and predestination (Elizabeth A. Livingstone, ed., *The Concise Oxford Dictionary of the Christian Church* [Oxford: Oxford University Press, 1977], 56).

18. *The Articles of the Synod of Dort,* trans. Thomas Scott (Utica, N.Y.: Williams, 1831), 93-120.

monstrants were not only deposed but also deported. Eventually the attitudes of the civil authority relaxed, however, and by 1634 the Remonstrants were able to establish a seminary in Amsterdam, though they never again constituted a large segment of the Dutch church.[19]

Although the van Gogh family chose to stay within the Hervormd Kerk, they steadfastly maintained the Arminian doctrines of their Remonstrant predecessor, Cornelius van Gogh.[20] Vincent van Gogh's grandfather received his theological degree at the University of Leiden, which held the least doctrinally confessional views of the three state universities, conferring even to this day a Remonstrant degree. Van Gogh's father, Theodorus, was the first to break with the family tradition in obtaining his degree from Utrecht, but even there he declared his alliance with the Groningen theology, which was also Arminian.[21]

Both Vincent's father and his Uncle Stricker, at least at the beginning of his career, followed the Groningen teaching. This was, therefore, the teaching on which Vincent van Gogh was raised. The Groningen theology arose among the disciples of the Dutch philosopher, P. W. van Heusde, who was a professor of literature and history at Utrecht, from 1804 through 1839. Like the German philosopher, Friedrich Hegel, van Heusde was concerned with the evolution of ideas, claiming Christianity to be "the peak of the humanistic training of the human race."[22] He espoused the dynamic view of history held by the German thinkers, Herder and Lessing, with particular emphasis on the progress of the human race through education. Two of van Heusde's disciples, Petrus

19. D. H. Kromminga, *The Christian Reformed Tradition, from the Reformation to the Present* (Grand Rapids: Eerdmans, 1943), 35.

20. We know from Vincent van Gogh's birth certificate that his father, Theodorus, was Hervormd. He would not have been a clergyman of the Hervormd Kerk had he been Remonstrant, although he could still hold many of the Remonstrant views. "Verscheen voor ons Ambtenaar van den Burgerlijken Stand der Gemeente Zundert en Wernhout, De Wel Eerwaarde Heer Theodorus van Gogh oud een dertig jaren Hervormd Predikant wonende te Zundert dewelke aan ons heeft aangegeven, dat op den Dertigsten Maart dezes jaars om elf ure des voormiddags, binnen deze gemeente, wijk letter A nummer Negenentwintig van hem Comparant en van Zijne Echtgenoote Vrouwe Anna Cornelia Carbentus Particuliere mede wonende te Zundert is geboren een kind van de mannelijke kunne en aan hetwelk hij verklaard heeft te geven de voornamen van Vincent Willem" (Van Beselaere, *De Hollandsche Periode in het Werk van Vincent van Gogh*, 5).

21. Johannes Stellingwerf, *Werkelijkheid en Grondmotief bij Vincent Willem van Gogh*, 2 vols. (Amsterdam: Swets & Zeitlinger, 1959), 1:18.

22. Kromminga, *The Christian Reformed Tradition*, 113.

Hofstede de Groot and J. F. van Oordt, who was Stricker's mentor, joined the theological faculty of Groningen in 1829,[23] followed by L. G. Pareau in 1831.[24]

Together, the three originated the Groningen Richting, a name by which they were known, though they called themselves the "Evangelical Party."[25] They publicized their new movement in a journal, *Waarheid in Liefde* (Truth in Love), founded in 1837.[26] Appealing to the wide-spread rise of nationalism in the nineteenth century, the Groningen School rejected the Calvinism of Dort as a foreign invasion. They argued that the Dutch tradition was fundamentally humanistic, Arminian, mystical, and pietistic. They claimed as important Dutch antecedents Thomas à Kempis, Wessel Gansfort, Erasmus, Arminius and the Remonstrants, as well as the seventeenth-century Dutch Pietist, Jodocus van Lodensteijn. They also blamed Calvinist intolerance for the many splits that occurred in the Hervormd Kerk, such as the Counter-Remonstrant vs. Remonstrant split of 1611.[27]

While Calvinist doctrines of election, predestination, and limited atonement excluded many, the Groningen doctrines of universal atonement and perfection were all-inclusive. The Groningen School elevated pious feeling and practical ethics above dogma. De Groot, whose slogan was "Religio habitat in sensu" (religion resides in feeling), argued that the only certain religious commitment was that based on the heart and the inner experience. This "theology of affect" of course echoes the pietism of Schleiermacher and it was this strain of Groningen thought that van Gogh

23. *Levensberichten der Afgestorvene Medeleden van de Maatschappij der Nederlandsche Letterkunde* (Leiden: E. J. Brill, 1887), 27-55.

24. Kromminga, *The Christian Reformed Tradition*, 113.

25. De Groot and Pareau were van Heusde's nephews, van Oordt was one of van Heusde's students. Van Heusde taught a kind of Christian Platonism, arguing that Jesus was the ideal human being, the perfect example for all humans to emulate (A. J. Rasker, *Der Nederlandse Hervormde Kerk vanaf 1795: Haar Geschiedenis en Theologie in de Negentiende en Twintigste Eeuw* [Kampen: J. H. Kok, 1974], 48).

26. Ibid., 46.

27. "Hun historisch bewustzijn uitte zich in de overtuiging een oud-vaderlandse traditie van theologisch denken voort te zetten. Het was de national-gereformeerde Richting, voor hen vertegenwoordigd door namen als Thomas à Kempis, Wessel Gansfort, Agricola, Erasmus; ook door Remonstranten als Episcopius, Hugo de Groot en van Limborch, doopsgezinden, Coccejanen, Janssenisten en Mystieken als van Lodensteyn" (A. J. Rasker, *Der Nederlandse Hervormde Kerk vanaf 1795: Haar Geschiedenis en Theologie in de Negentiende en Twintigste Eeuw* [Kampen: J. H. Kok, 1974], 47).

would retain even after abandoning the institutionalized form of religion his family practiced. Although proponents of the Groningen School claimed no debt to Schleiermacher or any non-Dutch theologians, they did admire the Moravian tradition, from which Schleiermacher came, for its emphasis on inward piety. De Groot explained that religion, "life in God," could not be obtained through following correct doctrine but only by personally experiencing God's love. This was the fundamental principle Vincent van Gogh retained throughout his life.

The Groningen School based its understanding of the religious experience on the encounter between God and man in the person of Jesus Christ, whom Schleiermacher also taught was the one sufficient mediator between the finite and the Infinite.[28] De Groot stated the dominant notion of the Groningen School as "the revelation and education by God in Jesus Christ, given to us in order to make us more and more similar in form to God. In Him, God reveals to us that which we should contemplate and observe; and by Him, educates us to that which we must become."[29] Jesus did not come to save by His death on the cross, but rather, to lead us all into union with God by teaching us to follow His example. Human beings are relieved of the burden of sin by following the example of Christ and trying to imitate his life. The event of the cross is the ultimate sacrifice and revelation of who Jesus was.[30] Through imitation of the life of Jesus Christ, humans could develop their full potential and become more like God. In this, Groningen also echoes the basis of Schleiermacher's ethical teaching in which he claimed that man's chief vocation was to create in himself the consciousness and character of Jesus.

Rather than the Calvinist notion of the total depravity of man, Groningen emphasized the continuity between God and humankind and the possibilities of perfection and reconciliation through Christ. The Groningen theology was fundamentally both mystical and humanistic, claiming that, in Jesus:

> We see what God is, what man is and what man's relationship to God is. God is the Holy Father of mankind. In Jesus, in His relationship to

28. Ibid., 53.
29. Hofstede de Groot, *De Groninger Godgeleerden in Hunne Eigenaardigheid* (Groningen: Scholtens, 1955), 42.
30. Ibid., 44.

God, we can see how all relationships with God can and should be, how we can obtain a reprieve from our guilt and desire for sin, and be reconciled with God, and we can cease to be the enemy of God. We can become rather the friend of God — yes, we can and must become one with God, by faith and love, and eventually attain eternal life, which is already here on earth.[31]

Although the Groningers criticized the views of the Reformers, Luther and Calvin, for concentrating on original sin and the view of Christ as the redeemer of sinners from the wages of sin, they did acknowledge the existence of sin itself. However, while Calvin and Luther argued that man was sinful by nature, the teachers of the Groningen School, de Groot, van Oordt, and Pareau, argued that man was sinful by his condition of being apart from Jesus Christ. The Groningers distinguished between man's nature, which is godlike, and his condition, which is sinful. Because the Groningen School rejected the notion that man is sinful by nature, they also rejected the Calvinist notion of election and the view of Christ as the propitiation for sin.

The Groningers believed ethics, which were based fundamentally on following the example of Jesus, to be their most distinguishing contribution to Christianity. They argued that Christian ethics, after Apostolic times, had deteriorated into a "doctrine of duties." The Reformation brought some improvement, in the "attempt to reclaim the Christian life by bringing it back to the source, Jesus Christ."[32] In practicing this type of ethic, de Groot claimed to be carrying on the tradition of the Dutch mystics, the Brethren of the Common Life, because the foundation of the Groningen ethical system is not duty or obedience to the law, but the love which unites God and man in Christ.[33]

The ethic is realized in the kingdom of God, which Christ established on earth, at least in imperfect form, in His Church. Through Jesus, we can come to God and release the burden of the guilt of sin, and by the renewing of God's spirit, eventually bring about the spiritual kingdom. The Church is not static, but a dynamic, growing organism, moving toward the perfect actualization of the kingdom of God. In essence, the

31. De Groot, *Groninger Godgeleerden in Hunne Eigenaardigheid,* 44.
32. Ibid., 84.
33. Ibid., 105.

kingdom of God is not imminent but has already occurred, though in an imperfect form: "The goal of this revelation and education of God in and through his son is practical, to bring us to God through Christ, to guide us to community with the Father, to make us more and more like God. . . . In order to recreate man and thus, to bring about a new spiritual world — the Son of God came on earth, taught, suffered, died, was resurrected, and still rules in His Church."[34]

Although Groningen was orthodox in advocating the imitation of Christ as the foundation of Christian ethics and the basis for establishing the kingdom of God, de Groot strayed from orthodox Reformed theology in his christology. He acknowledged Jesus as both the Son of God and the Son of Man, whereby he argued that while Jesus is the perfect image and reflection of God's being, he is subordinate to God. He is completely human, but without sin, perfect and holy: "Yet, to us, He is not God and Man, but God in human form: He does not have more than one nature because man is of God's nature."[35] There is no categorical distinction between the divine and human nature. God is spiritual, and man, who is created in God's image, is also spiritual. The Son of Man assumed two forms of appearance, the earthly and the heavenly, but one nature — godly, or spiritual.[36] This was the most mystical tenet of the Groningen theology, more like the teachings of the medieval mystics than the dogma of the Calvinists.

Perhaps the most conservative aspect of the Groningen theology, however, is its high view of Scripture, reflecting an understanding of Christianity as fundamentally grounded in history.[37] Its proponents skirted the concerns of modern criticism by arguing that although the apostles, in writing Scripture, could have erred, they in fact did not. Groningers distinguished between the Old Testament, "the Word of God directed to Abraham, Moses, and Gideon," and the New Testament, "the Word of God given to us, the Evangelicals," claiming the Old Testament as the

34. Ibid., 46.

35. Ibid., 45.

36. Rasker, *Hervormde Kerk vanaf 1795: Haar Geschiedenis en Theologie in de Negentiende en Twintigste Eeuw,* 115. Docetism, taking its name from the Greek "to seem," occurred in some groups within the early Church who denied the humanity of Jesus, suggesting that his suffering on the cross was imaginary (J. N. D. Kelly, *Early Christian Doctrines* [New York: Harper & Row, 1960], 141).

37. Ibid., 53.

"preparation and foreshadowing of the New Testament," which was "the Christian core of the Bible."[38]

The Groningers allowed for the possibility of biblical criticism and investigation because they believed such inquiry would only affirm their understanding of God's revelation of himself in Jesus Christ. "We feel free in our treatment of the Bible, and have no fear because we find support in Jesus Christ, as is still evidenced in His Church. More important than the testimony of Him is He, Himself."[39] They placed preeminent emphasis on the person of Jesus. They argued that the apostles were not perfect, faultless humans, but that they were, rather, in possession of the Perfect Truth in their proclamation of the Gospel.[40] The Groningen School accepted as genuine the accounts of the miracles performed by Jesus and also affirmed a literal interpretation of the Genesis account of creation. They considered the Gospel's account of the life of Jesus to be without error and the only true source of knowledge of the Christian faith. After van Gogh left the provincial confines of his Dutch home for Paris and began avidly reading modern literature, he eventually rejected this conservative strain of Groningen thought, contributing to his irreparable rift with his father.

The Groningen School began as a strong movement of renewal within the Church, but Calvinists challenged its unorthodox christology, universalism, and notion of the godliness of human nature. On the other side, modernists challenged the reticence of the Groningen theology to undertake a complete investigation of the Bible and, consequently, to reject the possibility of supernatural intervention in the natural order, such as miracles.

By the mid-nineteenth century, modernism began to replace Groningen as the new "reformation" of Dutch theology. The precipitating event that ushered in Dutch modernism occurred at Utrecht while Theodorus was still a student there. Cornelius Willem Opzoomer, upon his initiation as professor of philosophy in 1846, delivered the famous address "De Wijsbegeerte den Mensch met Zichzelven Verzoenende" (Philosophy Reconciling Man with Himself).[41] In his address, Opzoomer asserted the fundamental distinctives of his "modern theology": the denial of the su-

38. Ibid., 61.
39. Ibid., 60.
40. Ibid., 62.
41. Eldred C. Vanderlaan, *Protestant Modernism in Holland* (London: Oxford University Press, 1924), 19.

pernatural, the call for full critical investigation of the Bible, and the assertion of the complete humanity of Jesus. It was an attempt at the harmonization of Christianity with the modern view of the world, which accepts fully the precepts of modern science. Opzoomer's modernism, however, still affirmed a personal, holy God who is profoundly related to man. He claimed Christianity as his own religion but not the one final truth. Opzoomer's mysticism, which is akin to that of Groningen theology, revealed itself in his notion that the fundamental principle of Christianity "is the oneness of the Divine and the human."[42]

Vincent van Gogh's uncle, Johannes Paulus Stricker, was aligned first with the Groningen School and then with the type of modernism popularized by Opzoomer. Stricker is a major figure in understanding Vincent's religious background mainly because he is the only close relative who left an extensive account of his religious views. While virtually all of van Gogh's biographers emphasize van Gogh's unsuccessful pursuit of Stricker's daughter, Kee, they have all but ignored the positive impact that Stricker had on the young Vincent's life.

Vincent lived with his uncle, Jan van Gogh, a rear admiral in the Navy, in Amsterdam, from May of 1877 until July of 1878, during which time he spent a great deal of time with Stricker. Of the 24 letters from Vincent to Theo during this period, 16 mention specific visits with Stricker: "I often visit Uncle Stricker in his study. He possesses a great many fine books: he loves his work and his profession deeply."[43] These visits were not primarily social as Stricker's main role was to tutor Vincent in biblical studies in preparation for his university entrance examinations. He wrote, "I have lessons from Uncle Stricker twice a week now. I profit a great deal from it, as Uncle is very clever, and I am glad he has found time for it."[44] Stricker not only tutored Vincent personally, but supervised the lessons in Latin and Greek, which Vincent took from Mendes da Costa. The reminiscences of da Costa regarding his work with Vincent (recorded in 1910) reveal a warm and respectful relationship between Stricker and his nephew:

> It was probably in the year 1877 or thereabouts that the Reverend Mr.
> J. P. Stricker, a preacher universally respected in Amsterdam, asked me

42. Ibid., 21.
43. L104, 3 August 1877, *Letters* 1:131.
44. Ibid.

whether I was willing to give lessons in Latin and Greek to his cousin [actually, nephew] Vincent. . . . The Reverend Mr. Stricker spoke with much love of Vincent himself as well as of his parents.[45]

Another important way in which Stricker influenced Vincent's religious development was through his preaching, since Vincent attended services in which Stricker preached nearly every Sunday for more than a year. Vincent seems to have regarded Stricker's sermons highly, as he explained to Theo, "I heard Uncle Stricker speak on Acts 2:1-4, a very fine, sincere, warm sermon. This morning I am going to hear Uncle again."[46] Vincent often attended one or two other churches early Sunday morning, but afterward, he always went to hear Stricker preach.[47]

Vincent's deep concern and affection for his uncle is evident in his account of a sermon delivered when Stricker was in failing health at the age of 61:

> One night I heard one of his last sermons, and it was clear from what he said that he shuddered and shrank from each new day and night, especially from the one which followed the exertion of preaching. Even then, one could not hear him without feeling with him and shuddering involuntarily, for the road leading to the eternal home is dark, and happy is he who is strengthened by the hope of a better life when the darkness and night approaches.[48]

As both a teacher and minister, Stricker was Vincent's spiritual mentor during his time in Amsterdam.

In addition to recounting numerous visits with his Uncle Stricker, Vincent also mentions visiting the house of Stricker's daughter, Kee.[49] When Vincent came to live in Amsterdam, he found Kee in tragic

45. The Dutch word "neef" may be translated either nephew or cousin. It is the English translation, not the recollection of Mendes da Costa, that is in error (Reminiscences of Mendes da Costa, 1910, *Letters* 1:169).

46. L96, 21 May 1877, *Letters* 1:116. (Acts 2:1-4 is an account of the day of Pentecost.)

47. L103, 27 July 1877, *Letters* 1:130.

48. L122, May 1878, *Letters* 1:168.

49. L105, 5 August 1877, *Letters* 1:133; L110, 18 September 1877, *Letters* 1:140; and L116, 9 November 1877, *Letters* 1:155.

circumstances. On February 4, 1877, shortly before Vincent's arrival, Kee's one-year-old baby son died, leaving her with one surviving child, the seven-year-old Johannes Paulus, named after her father. Her husband, Dr. Christoffel Martinus Vos, had taken ill with a "lung disease," which had forced him to abandon his preaching post.[50] Vincent saw in Kee and Vos the ideal of hearth and home. "I spent Monday evening with Vos and Kee; they love each other truly, and one can easily perceive that where love dwells, God commands his blessing. It is a nice home, though it is a great pity that he could not remain a preacher. When one sees them sitting side by side in the evening, in the kindly lamplight of the little living room, quite close to the bedroom of their little boy, who wakes up now and then and asks his mother for something, it is an idyll."[51] On October 27, 1878, Vos died. Vincent's admiration for Kee eventually turned to a deep romantic love. Kee became for Vincent van Gogh the object of an obsessive unrequited love from which he never fully recovered. Regarding his feelings for Kee, Vincent explained to Theo both the depth and intensity of his love, relaying this famous incident in which he held his hand in a flame and declared his eternal affection for no other than Kee:

> To express my feelings for Kee, I said, "She, and no other." And her "no, never, never" was not strong enough to make me give her up. I still had hope, and my love remained alive, notwithstanding this refusal, which I thought was like a piece of ice that would melt. But I could find no rest. The strain became unbearable because she was always silent and I never received a word in answer.
>
> Then I went to Amsterdam. There they [Rev. and Mrs. Stricker] told me, "When you are in the house, Kee leaves it. She answers, 'Certainly not him' to your 'she, and no other'; your persistence is disgusting."
>
> I put my hand in the flame of the lamp and said, "Let me see her for as long as I can keep my hand in the flame" — no wonder that Teersteg perhaps noticed my hand afterward. But I think they blew out the lamp and said, "You will not see her." Well, it was too much for me, especially when they spoke of my wanting to coerce her, and I felt that the crushing

50. See Anne Stiles Wylie, "Vincent and Kee and the Municipal Archives in Amsterdam," *Vincent* 2, no. 4 (1973): 2-7.

51. L110, 18 September 1877, *Letters* 1:141.

things they said to me were unanswerable, and that my "she, and no other" had been killed.[52]

Vincent recounted to Theo that Stricker opened the discussion as a "minister and a father," alluding to the important role Stricker once played in his life.[53] Also, Vincent clearly identified Stricker's faith with that of his own family, since when he decided to leave the Church, he wrote, "We are full-grown men now, and stand like soldiers in the rank and file of our generation. We do not belong to the same generation as Father and Mother and Uncle Stricker. We must be more faithful to the modern than to the old. . . ."[54] Vincent had already begun to experience conflict between the traditional religious views of his family and the new modern views he encountered in his own reading. Sadly, as a result of his pursuit of Kee, bitter feelings developed on both sides between the Strickers and Vincent. Nonetheless, the nurturing and spiritual guidance which Stricker had provided during the year that Vincent spent in Amsterdam studying for the ministry had an important role in shaping his religious affections.

Who, then, was Uncle Stricker and what do we know of him apart from Vincent's letters?[55] His contemporaries described Stricker as a man of "deep inner piety."[56] Stricker, like van Gogh's father, received a degree in theology in preparation for ordination into the Dutch Reformed Church. While van Gogh's father attended the more orthodox University of Utrecht, Stricker attended the University of Leiden, where Arminian views prevailed. This is where he began his work with van Oordt, one of the founders of the Groningen theology. Just as had been the case for Theodorus van Gogh, Stricker's appointment to a ministerial post was delayed, from May to October, 1841. There was no ambivalence about the reason for this. In Stricker's case, it was definitely due to his doctrinal

52. Kee's answer to Vincent, "niet, nooit, nimmer," is the most emphatic refusal possible. It was Vincent's persistence beyond this that alienated Stricker and the rest of Kee's family (L193, 14 May 1882, *Letters* 1:351).

53. L164, 21 December 1881, *Letters* 1:283.

54. L160, 19 November 1881, *Letters* 1:271.

55. An obituary of Stricker, written by a close friend, H. P. Berlage, appeared in *Levensberichten der Afgestorvene Medeleden van de Maatschappij der Nederlandsche Letterkunde* in 1887. Berlage tells us that Stricker had given him a "levensschets" (life history) shortly before his death in 1886, so we can assume that the details are accurate.

56. Ibid.

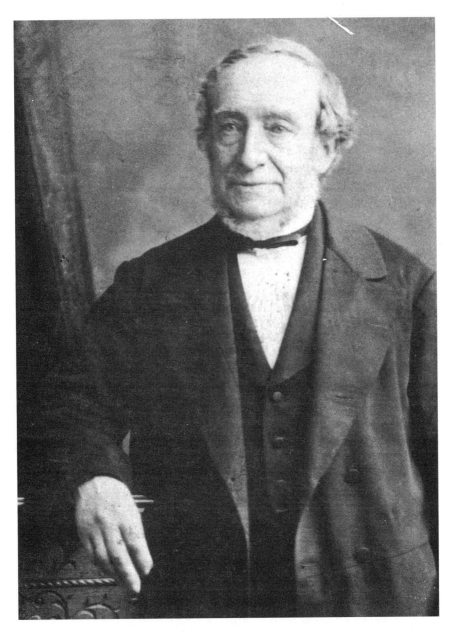

5. Johannes Paulus Stricker, Vincent's uncle

stance. During his ordination examination, in May, Stricker defended the views of his mentor, van Oordt. The Provinciaal Kerkbestuur (Consistory) found particularly offensive Stricker's defense of the Groningen christology, which considered Jesus to be subordinate to God. The theological faculty at Leiden immediately came to Stricker's defense, arguing that individuals should be free to develop doctrine and pursue academic inquiry without the interference of the Consistory. An apparent compromise was the result. Upon signing a statement regarding his theological views that was acceptable to the Consistory, Stricker was finally installed in August, and received an appointment to a church in Driehuizen in October.

The following January, he married Willemina Catharina Gerardina Carbentus, the sister of Vincent van Gogh's mother. Because he believed that a minister of the Gospel should be well-educated, Stricker went back to Leiden to pursue a doctoral degree in theology, which he received in January, 1845.[57] In November of 1855, he took the prestigious post as minister of the Amstel Church in Amsterdam. Soon after, tragedy struck his family, resulting in the deaths of two daughters and one son, with only Kee and two of her brothers surviving.[58] Stricker seemed to accept this adversity as God's will, asserting, "God knows what he does and he who feeds the birds does not forget his children."[59] Vincent van Gogh's acceptance of sorrow and pain as a necessary part of the Christian journey, which we shall take up in the next chapter, reflects the piety of his Uncle Stricker.

Stricker published numerous theological writings, the most important being his modern "life of Jesus." His first endeavor, however, was the *Bijbelwoordenboek voor het Christelijke Gezin* (Biblical Dictionary for the Christian Family), published in 1855. Although an erudite man, Stricker's writings were popular in character and he considered himself a "Volksleraar" (people's teacher). One of his popular publications that indicates concern with personal piety and evangelism is *Het Geloof in Jezus Christus de Eenige Weg tot Zaligheid* (Belief in Jesus Christ, the only Way to Salvation), published in 1861. Stricker asks, "what must one do to be saved?" noting that the word "zaligheid" (salvation) "points to a blessed

57. Stricker's dissertation was titled "De Mutatione Homini, Secundum Jesu et Apostolorum Doctrinam Subeunda."

58. *Levensbericht*, 40.

59. Ibid., 42.

or joyful deliverance, a peace of mind which results in salvation from the darkest distress."[60] He writes, "Sin is the sole cause of all essential unhappiness. If man was a purely sensual being, he would be happy if his sensual needs alone were satisfied, but he would be on the same level as an animal. But man is created in the image of God, he is a reasonable and ethical being."[61] This reiterates the Groningen theology, as well as Schleiermacher's piety, with its view of man as participating completely in the same divine nature as God. Sin is a hindrance to communion with God and faith in Jesus Christ is the only way to remove this obstacle, but this faith must be one of a deep personal experience with Christ. As Stricker explained, in accordance with Schleiermacher, faith is a matter of feeling, not intellect. "Many Christians are wandering, like aimless pilgrims on the wrong path. They accept everything that is said in the Bible, and faith becomes a matter of the intellect and memory. This kind of belief is belief on Jesus, but not belief in Jesus. . . . Belief in Jesus Christ is absolute submission to the Son of God."[62]

Vincent was to be deeply affected by this notion of the wandering pilgrim, a prevalent theme in his art where there are many roads — meandering through wheat fields or illuminated by pulsating celestial beacons of crescent moons and whirling stars. Stricker taught that personal piety leads the pilgrim to utter fulfillment because man is thus reconciled to God, which is the ultimate destiny of his divine nature: "He who is in Jesus Christ, who is taught and ruled by Him, reconciles with God and is sanctified to God, lives in communion with God and feels himself in this association with the Holy, utterly fulfilled. He enjoys the same bliss as Christ in communion with the Father. What brings one to communion with God? — knowledge of God, faith in God, love of God."[63] Peace is a product of this intimate faith, and Stricker warns, "There is no use looking for these things in external religiousness. Truly it is faith in Jesus Christ that brings fulfillment."[64] This christocentric "piety of experience" is the axiomatic principle of the Groningen theology which Vincent learned at home.

60. Johannes Paulus Stricker, "Het Geloof in Jezus Christus de Eenige Weg tot Zaligheid," *Christelijk Album* (1858), 195.
61. Ibid.
62. Ibid., 196.
63. Ibid., 199.
64. Ibid., 203.

But Vincent was to be permanently alienated from Stricker, who expended great effort to keep his nephew from having any contact with his daughter, the object of Vincent's deepest life-long affection. After an unsuccessful attempt to visit Kee at the Strickers' house, Vincent went home and wrote to Theo, "I cannot live without love, without a woman. I would not value life at all if there were not something infinite, something deep, something real. . . . Every woman at every age can, if she loves and is a good woman, give a man, not the infinity of a moment, but a moment of infinity."[65] Although it was his profound hope to do so, Vincent was denied the possibility of marrying Stricker's daughter, Kee, and indeed never married or had any children. Still, the theology Stricker preached, wrote about, and lived, particularly its modern spirit of critical inquiry and its mystical tenor, were to stay with Vincent throughout his life, affecting both his religious life and his art.

The popularity of the Groningen School had diminished by the second half of the nineteenth century and modernism had begun to take its place as the new Dutch theology. By 1868, Stricker acknowledged a shift in his piety from the Groningen School to modernism, but a type of modernism untainted with skepticism. Stricker's eulogy described him as a "liberal servant of the Gospel, with undeniable conservative tendencies."[66] Although Stricker broke with Groningen (and therefore the theology of Vincent van Gogh's household) in advocating complete critical investigation of the Bible and in denying the possibility of miraculous intervention in the natural order, he did so not to undermine the Christian faith, but to buttress it with the proof of history. He believed that his task as a modernist was to bring a factual historical ground to Christian piety; thus began his "quest for the historical Jesus."

In 1868, Stricker published his most significant and most popular work, *Jezus van Nazareth volgens de Historie Geschetst* (Jesus of Nazareth, Drawn according to History). His was a critical inquiry into the Gospel accounts of Jesus to ascertain what in these accounts might be taken as genuine. The first task was one of disentangling myth from history, but Stricker was far more interested in reconstructing a historically reliable Jesus as the cornerstone of Christian faith. Stricker showed his concern that faith should triumph over critical inquiry in declaring, "If faith is proved to be an illusion, I pray you,

65. L164, 21 December 1881, *Letters* 1:285-86.
66. *Levensbericht,* 42.

let us keep the illusion."[67] His work presumed the possibility of establishing objective historical fact. He wrote, "The highest that can be expected of a historian is that he strives toward objectivity."[68] Stricker based his historical inquiry on the principle, "all things in conflict with the Christian concept of God, with the approved law of nature, and with the normal course of human experience must be relegated to the realm of legend."[69] He determined Mark to be the earliest and most reliable of the Gospel accounts of the life of Jesus and accepted the sermon on the mount, in the Gospel of Matthew, as the actual words of Jesus.[70]

The sermon on the mount, Stricker argued, was the foundation of Christian ethics, teaching that the Christian is to be gentle and meek, that he must serve his fellowman, and that he must value the spiritual kingdom of God above the material world. In his "De Christen volgens de Bergrede van Jezus" (The Christian according to the Sermon on the Mount), Stricker wrote, "The Christian is meek and a lover of peace."[71] Stricker placed the highest value in the Christian life on service, in stating that "Love of one's fellow-man is equal to love of God."[72] Finally, for Stricker, to be a Christian required abandoning allegiance to the material world and complete commitment to the kingdom of God. "The Christian regards the Kingdom of God and Justice above transient and earthly things, even above the needs of the body. Earthly matters are transient and the Christian does not care about them, only the heavenly things, which are intransient."[73] Vincent van Gogh's piety was fundamentally grounded in the same religious principles as those of his Uncle Stricker.

Stricker's understanding of the person of Jesus and the Christian obligation to imitate him, as well as his understanding of the nature of the kingdom of God, had a lasting impact on Vincent van Gogh's faith. First, Stricker disclaimed the deity of Jesus, but acknowledged his special gifts and abilities. "The synoptics gave us indeed nothing else than the

67. Johannes Paulus Stricker, *Jezus van Nazareth volgens de Historie Geschetst* (Amsterdam: Gebroeders Kraay, 1868), 140.

68. Ibid., 48.

69. Ibid.

70. Ibid., 48-49.

71. Johannes Paulus Stricker, "De Christen volgens de Bergrede van Jezus," *Christelijk Maadschrift* (Amsterdam, 1861), 563.

72. Ibid., 562.

73. Ibid., 560.

life of a man, although it is also a man imbued by God with extraordinary gifts and supernatural powers, yet only slightly different from the old prophets," a sentiment van Gogh later echoed when he described Jesus not as the Son of God but as the supreme artist, molding people rather than clay.[74] Regarding the person of Jesus, Stricker observed that Jesus lived in poverty and was a friend of the poor, often warning against the lure of material riches. Stricker believed those who lived in poverty were more receptive to the kingdom of God. "The poor are less susceptible to the seduction of worldly things and feel themselves to be more dependent on God."[75] Stricker noted that Jesus brought his message to all people, citing the example of the good Samaritan as the prototype of Christian compassion. (The good Samaritan later became the subject of one of Vincent van Gogh's paintings.) He urged Christians to imitate the example of Jesus: "Jesus preached the Gospel of the Kingdom. We must listen, follow, and practice His teaching, which is the highest gift of God's love."[76] Stricker believed that the main mission of Jesus on earth was to bring Christian people to a close union with God, the Father. He wrote, "God is the Father of man. With this one word is made a religion for all people — an unmovable, indestructible foundation laid. This was the Gospel of the Kingdom of God that Jesus proclaimed."[77]

The second book of Stricker's *Jezus van Nazareth* explains Stricker's modernized notion of the kingdom of God:

Everywhere where the kingdom of God is, God is living amidst the believers, and imbues them with His spirit in order to sanctify them in his community, to console them, and to bestow upon them joy. His kingdom, founded among the people, is the kingdom of truth, justice, and life: the kingdom in which everyone by mutual love is closely bound to each other. . . . Jesus saw in the kingdom of God a community of the truly pious, who guided by faith and love, surrendered themselves to God, and who show this especially in the love they have for one another. . . . It has not arrived yet and can only be seen in the distance.[78]

74. Stricker, *Jezus van Nazareth*, 50.
75. Ibid., 166.
76. Ibid., 176.
77. Ibid., 177 and 179.
78. Ibid., 136-37 and 143.

The metaphors of the kingdom of God in Stricker's *Jezus van Nazareth* become important symbols in the artistic oeuvre of Vincent van Gogh. For example, wheat, which must crumble into the earth in order to bring forth new life, appears frequently in van Gogh's work as a symbol of resurrection and rebirth. Stricker quoted John 12:24 and 25 in likening the kingdom of God to a grain of wheat: "Truly, truly I say unto you, unless a grain of wheat falls into the earth and dies, it remains alone; but if it dies, it bears much fruit. He who loves his life loses it, and he who hates his life in this world will keep it for eternal life."[79] Christ is the Sower who scatters the seed to prepare the way for the kingdom. As Stricker observed, "Those who enter the Kingdom are as God's seeds, sown on the field of the world."[80] Van Gogh, who painted over thirty images of the Sower, was obviously deeply affected by the biblical symbolism of sowing and reaping: "One does not expect to get from life what one has already learned it cannot give; rather, one begins to see more clearly that life is only a kind of sowing time, and the harvest is not here."[81] In a letter to his artist friend, Bernard, he linked his artistic preoccupation with such imagery with the faith of his family and homeland: "I won't hide from you that I do not dislike the country, as I have been brought up there — I am still charmed by the magic of hosts of memories of the past, of a longing for the Infinite, of which the sower and the sheaf are the symbols — just as much as before."[82]

The association of the Christian journey with a difficult and narrow path, so prevalent in biblical literature, is also prominent in Stricker's *Jezus van Nazareth:* "The way is narrow and the gate to the path is also narrow. That is why just a few have found the path of life. Christians must examine themselves to see if they have the courage to follow Jesus, and the persistence to stay with the choice. . . . One must even be prepared to give one's life for religion."[83] Those who choose the way of the kingdom must have great inner piety and love others. Stricker claimed that to be a member of the kingdom, one must have the "faith of Abraham," do the will of God, work justice, and feel the love of God in one's heart. "One who is a

79. Ibid., 193.
80. Ibid., 155.
81. L265, 8 February 1883, *Letters* 1:537.
82. B7, ca. 18 June 1888, *Letters* 3:492.
83. Stricker, *Jezus van Nazareth,* 190-91.

child of the Kingdom is one who has love and shows love."[84] The kingdom of God will not admit those who wear "the mask of piety" or those who have no charity. Stricker emphasized the importance of inner devotion and simple faith. The simple, humble, and "poor in spirit" have the highest place of honor in the kingdom of God. "Humility is the highest gift, and those who serve others will be rewarded in the last days."[85] Stricker warns that the life of the faithful is one of continual self-denial: "Even though accepted in the Kingdom of God, one must endure offenses and oppression. One must bear a cross to be a member of the sacred community."[86] Throughout his life, van Gogh remained true to such principles; he was a friend of the poor, seeing the tiller of the soil, the weaver, and even the street-walker as sacred, the "poor in spirit" who would one day inherit the kingdom.

Stricker's *Een Laaste Woord bij het Nederleggen zijner Evangeliebediening* (A Last Word upon Retiring as Servant of the Gospel, 1884), which was actually a farewell address to his congregation in Amsterdam, reiterates many of his life-long religious beliefs. He began his speech with a lament on the decline of religion in the later half of the nineteenth century, but claimed that although forms of religion may change, the truth of religion is constant. "The Church is not the Kingdom of God. What is now changing in form is the Church, but religion itself is unchangeable."[87] Maintaining his earlier concern with Christian ethics, he wrote, "Ethics is not religion, but religion is ethics. The religion of love is the root from which ethics grows."[88] He continued to emphasize that the Christian is called to serve in the kingdom. He used the Dutch word "Godsdienst" (servant of God) rather than the more general term "religie," noting that the word itself faithfully reflects the meaning of true religion, to be a servant of God.[89] Finally, Stricker's mystical and pietistic concerns are evident in his "definition" of religion: "Religion is not the fruit of rational contemplation and scientific investigation, but especially, the understand-

84. Ibid., 155.
85. Ibid., 156.
86. Ibid., 155.
87. Johannes Paulus Stricker, *Een Laaste Woord bij het Nederleggen zijner Evangeliebediening inzonderheid gericht tot de vrijzinninge leden der Nederlandsche Hervormd Kerk* (Amsterdam: J. H. van Heteren, 1884), 5.
88. Ibid., 6.
89. Ibid., 10.

ing of the human heart of its kindred sense of a higher world than the purely sensual and material world. Religion is a continual striving to a more and more intent communion with the Perfect."[90] He closed his address with the words, "If I have succeeded, here and there, in putting religion in its rightful, honored place in life again, then Soli Deo Gloria."[91] Johannes Paulus Stricker died during the night of August 26, 1886, just one year after the death of Vincent's father.

Vincent's own commitment to a simple Christ-centered faith, in which the Christian pilgrim abandons the physical world of decay for the everlasting heavenly Jerusalem and ultimate mystical union with God, is, in many ways, an outgrowth of the teaching he received from his spiritual fathers, Theodorus and Stricker. Since he wrote extensively of religion in his letters beginning in 1875, the story of his pilgrimage of faith must begin there.

90. Ibid.
91. Ibid., 39.

2. Pilgrims and Strangers

V AN GOGH WOULD LATER REFER TO THE YEARS BETWEEN 1875 AND 1879 as a "miserable time in my life."[1] They were difficult years of disappointment and conflict, in which his attempt to gain entrance to a university degree program, his eighteen-month trial as a missionary to the Belgian coal miners, and his employment in the family art trade all ended in failure. From 1869, van Gogh worked as an art dealer at Goupil's, first at the branch located in the Hague, then, from 1873 through 1875, in the London branch, and finally, from 1875 until 1876, in the Paris branch until he was terminated in April. While working for Goupil's, he retained his inclination to pursue the vocation of his father and grandfather, so, after losing his position as an art dealer, he actively sought a clerical post.

Sometime in 1874 or 1875,[2] he apparently experienced an evangelical conversion. His letters home from Paris are filled with biblical quotations and admonitions, including a rejection of all the secular literature he once loved: "John Bunyan's *The Pilgrim's Progress*, Thomas à Kempis, and a translation of the Bible; I don't want anything more."[3] He even instructed

1. L66, 29 December 1881, *Letters* 1:294.
2. See the introduction to the letters of 18 June 1873–18 May 1875, *Letters* 1:7. Although the introduction suggests that the shift in van Gogh's piety toward "evangelical fanaticism" occurred in July of 1874, the kind of correspondence in which Vincent quotes numerous Bible passages and begins to speak of a special calling to serve the Lord does not occur until September of 1875, when he was living in Paris.
3. Reminiscences of Mendes da Costa, 1910, *Letters* 1:170.

Theo to do away with some of their books as a kind of purging of the "old man" of sin and a putting on of the "new man" in Christ: "'Therefore, if any man be in Christ, he is a new creature: old things are passed away, all things are become new' (II. Cor. 5:17). I am going to do away with all my books by Michelet, etc. I wish you would do the same."[4]

Characteristic of this piety was an emphasis both on an all-consuming calling and on the experience of being "born again." He wrote in January, 1877, to his brother, "Is it the 'sorrowing for God' which leads us to make a choice which we never regret? . . . At such a time one may well think: 'Except a man be born again, he cannot see the Kingdom of God.'"[5] Van Gogh's sermon of 1876 uses similar language: "But though to be born again to eternal life — to the life of a Christian and a Christian workman — be a gift of God, a work of God, and of God alone. . . ."[6] Regarding a visit with a close friend in Amsterdam, Harry Gladwell, Vincent wrote to Theo, "The sorrowing unto God will bring about in him what it has brought about in many men — and is bringing about and shall bring about — that never-to-be-lamented choice of the good part, which shall not be taken away, and the one thing needful to choose; bringing forth the fruits of repentance, worthiness of conversion."[7] His central preoccupation with making a decisive choice to follow Jesus, as well as his concern with repentance and conversion, suggests an evangelical faith.

We also know that van Gogh read the work of the great evangelist, Charles Spurgeon, and attended revivalist meetings, since he wrote to Theo regretting that he was unable to attend a recent revival meeting of Dwight L. Moody. "I am also fond of that 'Tell me the Old, Old Story.' I heard it for the first time in Paris one night in a little church where I

4. L39, 25 September 1875, *Letters* 1:36.

5. L85, 7-8 February 1877, *Letters* 1:93. Van Gogh's father would have objected to the idea of rebirth or regeneration, since this was not part of the Groningen theology on which Vincent was reared. See Werner Weisbach, *Vincent van Gogh, Kunst und Schicksal* (Basel: Benno Schwabe & Co., 1949), 1:16.

6. Van Gogh's sermon, 5 November 1876, *Letters* 1:90. Van Gogh delivered this sermon in Isleworth, while in the employ of Rev. Jones. It is the only one of his sermons that survives. There is a document labeled "sermon b 1463V/1962, pp. 1-7," in the archives of the Rijksmuseum Vincent van Gogh, in Amsterdam. I have argued that it is not a sermon, however, and have published a translation and commentary on the text in "Testimony to Theo: Vincent van Gogh's Witness of Faith," *Church History* 61, no. 2 (June 1992), 206-20.

7. L109, 7 September 1877, *Letters* 1:139.

often went. . . . I am sorry indeed that I did not hear Moody and Sankey when they were in London."[8]

His father disapproved of this move to evangelical faith, concerned that Vincent might choose to abandon his academic studies in preparation for the ministry to become a lay evangelist, which he later did. Moreover, the Groningen School categorically rejected the evangelical notion of regeneration along with the language of being "born again." The idea that everyone is sinful and in need of redemption through the cross is inconsistent with the Groningen belief in the intrinsically divine nature of man. Vincent's father wrote to Theo on March 2, 1878:

> The cares regarding Vincent weigh oh so heavily and I think I can foresee that another bomb is about to burst. It seems that the beginning of the study is not too easy for him and his heart appears to be pulled by contradictory forces. This time he has made the acquaintance of English and French clergymen in Amsterdam of ultra orthodox views and the result of this is that the number of mistakes in his work has become somewhat greater again than before, when they were already considerable. I fear that he has no idea of studying and now fear that a remedy will be chosen again — the proposal for a change — such as Catechist! but that does not provide a living![9]

After embracing an evangelical faith, which was van Gogh's first religious turning point, he diligently pursued his interest in the ministry. Through a newspaper advertisement, he found a position as a tutor of French, German, and mathematics for boys in the school of a William Port Stokes in Ramsgate, England, for which he received only room and board. In July, he moved with the school to Isleworth, but shortly thereafter

8. L66, 12 May 1876, *Letters* 1:57.

9. Jan Hulsker, "1878, A Decisive Year in the Lives of Theo and Vincent," *Vincent* 3, no. 3 (1974): 15. The French and English clergymen "of ultra orthodox views" were, in fact, evangelical missionaries. Vincent wrote to Theo from Amsterdam on 18 February 1878, "I got up very early and went to the French church in the morning. A clergyman from the neighborhood of Lyons preached here — he had come to collect money for an evangelical mission. His sermon was mainly stories from the lives of the working people in the factories, and though he was not particularly eloquent and one could even hear that he spoke with some difficulty and effort, his words were still effective because they came from the heart — only such are powerful enough to touch other hearts" (L119, 18 February 1878, *Letters* 1:161).

took another position at a school headed by the Methodist minister, Rev. T. Slade Jones. Here, Vincent acted as a curate or assistant and gave his first sermons. He described his first experience of preaching in a letter to Theo, "I felt like someone who had risen from a dark vault underground into the kind light of day when I stood at the pulpit, and it is a glorious thought that from now on wherever I go, I shall preach the gospel. . . ."[10]

His plans were thwarted, however, when he returned home at Christmas, since his father insisted that he find better salaried work in the Netherlands. Theo helped Vincent secure a position as a book dealer in January, 1877, at D. Braat's in Dordrecht, but Vincent continued to hope for work in the ministry. His roommate at Dordrecht, P. C. Görlitz, explained that he did not concentrate on his work in the bookshop. Instead, "he wrote or read sermons or psalms and Bible passages while doing the bookkeeping, he tried to fight it, but it was too powerful for him."[11] In March, Vincent wrote to Theo of his desire to follow the family tradition as a minister of the Gospel. "In our family, which is a Christian family in every sense, there has always been, from generation to generation, someone who preached the Gospel."[12]

Van Gogh's family finally decided to support his decision. In May, he went to live with his uncle, Jan van Gogh. As we have seen, during this time, Stricker tutored him in theology and supervised his lessons in ancient languages with Mendes da Costa in preparation for the University entrance examinations. Van Gogh was not interested in academics, though, because he only wanted to preach the Gospel. He implored his teacher, "Mendes, do you really believe that frightful things like these are necessary to someone who wants what I want: to keep poor creatures at peace during their life on earth?" The Greek, especially, proved too much for Vincent and he abandoned his studies in July, 1878. Vincent had not completed his secondary education and therefore was attempting to bring his level of scholarship up to seminary entrance level in the course of only a few years. It is no wonder he found the task insurmountable.[13]

He turned instead to lay evangelism. He traveled with his father and

10. L79, 1-9 November 1876, *Letters* 1:73.
11. A7¹, reminiscences of P. C. Görlitz, *Letters* 3:598.
12. L89, 22 March 1877, *Letters* 1:99.
13. Reminiscences of Mendes da Costa, *Letters* 1:69. See H. F. J. M. van den Eerenbeemt, "The Unknown Vincent van Gogh, 1866-68, the Secondary State School at Tilburg," *Vincent* 2, no. 1 (1972), 2-12.

Mr. Jones, his former employer at Isleworth, to a missionary school for evangelists at Laeken, near Brussels, and visited the members of the Committee on Evangelization. His sister-in-law, Johanna van Gogh-Bonger, tells us, "Vincent explained his case clearly and made a very good impression."[14] Vincent enrolled in late August, and though we do not know why, after a three-month probationary period, he was denied the opportunity to train further at the school.

Determined to fulfill his evangelical calling, however, he set out on his own to the coal mining district of the Belgian Borinage to preach the Gospel to the poor.[15] He gave Bible readings and made calls to the sick in the village of Pâturages. Impressed with his commitment, the Comité de la Société Évangéliques Belge of the Union des Églises Protestantes Évangéliques de Belgique[16] decided to support van Gogh on a six-month trial basis, beginning in January, 1879, in the village of Wasmes.

The Union des Églises Protestantes Évangéliques de Belgique was an ecumenical Protestant organization founded in 1839 under the tolerance of Leopold I, the first Protestant king of Belgium. The organization consisted of Lutherans, Reformed, and Methodists. The Comité de la Société Évangéliques Belge was formed in 1837. It was most active among the working class, especially coal miners in the French-speaking or Walloon area of Belgium. It gave rise to the free church, the Église Chrétienne Missionaire Belge, in which van Gogh sought ordination. Its main mission was to convert to Protestantism the overwhelming number of Belgian Catholics.

Unfortunately, the Comité decided in July not to renew van Gogh's trial position. The report of the Union des Églises Protestantes de Belgique, 1879-1880, indicates that the Comité lamented its task of dismissing such a steadfast servant of the Gospel, only because he lacked persuasiveness in

14. Memoirs of Johanna van Gogh-Bonger, 1913, *Letters* 1:xxvii.

15. Ibid., xxviii. Vincent's sister-in-law tells us, "He immediately traveled to Brussels and succeeded in arranging everything. At his own risk, Vincent went to the Borinage. . . . He taught the children in the evening, visited the poor, and held Bible classes; when the committee met in January, he would try again to get another nomination." Jan Hulsker explains van Gogh's purpose, as well as the correct course of events, which apparently differs from Ms. van Gogh-Bonger's account, in *Vincent and Theo van Gogh: A Dual Biography* (Ann Arbor: Fuller Publications, 1990), 61-65.

16. See Kenneth Latourette, *Christianity in a Revolutionary Age* (Westport, Conn.: Greenwood Press, 1977), 2:235. Van Gogh went to the Borinage with the help of his father and several other Dutch Reformed and Methodist ministers.

the pulpit. "If the gift of eloquence, so indispensable to one who is placed at the head of a congregation, were added to the admirable qualities he displays at a sickbed or with the injured, to the devotion or self-sacrificing spirit, of which he gives constant proof. . . . M. van Gogh would certainly be an accomplished evangelist."[17] It seems clear why van Gogh would come into conflict with the Comité, since their view of religion placed the heaviest emphasis on the preaching of the Word while van Gogh was more concerned with the practice of faith. Still convinced of his calling, however, van Gogh continued his missionary activity in the Borinage, without support, until his abject poverty and bitter disappointment with the Church forced him to abandon his goal completely by the end of 1879.

Many historians of van Gogh's art and life portray these years as a time of religious fanaticism which van Gogh happily abandoned when he decided to leave the Church to become a full-time artist in 1880. Rather than a form of extremism, however, van Gogh's piety during this period is remarkably consistent with a long-established religious tradition. He simply embraced his "religious cause" with the same characteristic intensity with which he was later to embrace his artistic cause. His fervor at times appeared alarming, even to his contemporaries, but such high-pitched intensity was simply van Gogh's nature. Furthermore, living out his religious convictions to their fullest extent required the kind of extreme self-denial and sacrifice that he displayed. His total dedication to following the teaching of Jesus, like his radical asceticism, was not the product of madness or even eccentricity. Rather, it was a consistent living out of the religious tradition he chose to follow, the vita apostolica through the imitatio Christi.

The spirituality van Gogh embraced stems from the medieval tradition of an inward piety based first on the knowledge of the self and then on the knowledge of God. This piety had its genesis in the treatises of St. Augustine, who taught that each believer must first suffer the labor of sanctification in order to cleanse himself to know and receive God. In every sense, the spiritual journey is interior and intensely personal. Thomas à Kempis' *The Imitation of Christ* taught that one must know and even despise

17. Louis Piérard, *The Tragic Life of Vincent van Gogh,* trans. Herbert Garland (Boston: Houghton Mifflin, 1925), 35. See Pierre Secretan-Rollier, *Vincent van Gogh chez les Gueles Noires* (Lausanne: L'Age d'Homme, 1977), 7, for the report of van Gogh's review in the original French.

oneself: "The highest and most profitable learning is this: that a man have a truthful knowledge and a full despising of himself."[18] The soul must turn away from all things outward and visible to retire into itself. In this type of piety, the believer confronts the misery of his wretched unworthiness before God. Misery follows him because the more he knows himself and seeks God, the more repulsed he is by the world around him. This is why Kempis often refers to the believer as a "stranger" and a "pilgrim" in a foreign land.

Unlike novels which are usually read for pleasure, devotional literature serves as a guide to daily living with the purpose of bringing the reader to a deeper understanding and more meaningful practice of his faith.[19] It is therefore read and referred to frequently. Van Gogh used *The Pilgrim's Progress* and *The Imitation of Christ* this way, and both works had a profound impact on his life. Vincent took from them the notion that the earthly life is one of trial and ordeal, a kind of journey through the perils and pitfalls of the City of Destruction to the ultimate glorious reunion with the Lord in the Heavenly Jerusalem. He embraced absolutely the philosophy that permeates *The Imitation of Christ,* mentioning it specifically several times in his letters.[20] He apparently received a French version from his uncle, Cor van Gogh, the art dealer, and a version in the original Latin from Christoffel Vos, his Uncle Stricker's son-in-law. Kempis' work was an important part of Vincent van Gogh's family tradition, which, in keeping with the Groningen theology, celebrated the distinctive Dutch piety of Kempis and Erasmus rather than the traditional Calvinist doctrines of the Reformed Church.

Van Gogh's tutor in ancient languages, Mendes da Costa, noted how eager Vincent was to apply his primitive knowledge of Latin to translate

18. Thomas à Kempis, *The Imitation of Christ,* ed. Harold C. Gardener (New York: Image Books, 1955), 1:2.

19. Although numerous studies have been done regarding the significant role of literature in van Gogh's life — especially works by such authors as Dickens, Zola, and Michelet — none of van Gogh's biographers has studied his use of devotional literature. See A. M. Hammacher, "Van Gogh — Michelet — Zola," *Vincent* 4, no. 3 (1975): 2-21. See also Carl Nordenfalk, "Van Gogh and Literature," *London University Warburg Journal* 10 (1947-48): 132-47.

20. See L31, 5 July 1875, *Letters* 1:30; L41, 6 October 1875, *Letters* 1:39; L80, 10 November 1876, *Letters* 1:74; L108, 4 September 1877, *Letters* 1:137; L109, 7 September 1877, *Letters* 1:140; and L120, 3 March 1878, *Letters* 1:163, for direct references to different versions of *The Imitation of Christ.*

The Imitation of Christ in the original. He recounted how preoccupied Vincent was with Kempis: "He had kept quite a number of prints which he had collected in those days, little lithographs after paintings, etc. He brought them to show me repeatedly, but they were always completely spoiled: the white borders were literally covered with quotations from Thomas à Kempis and the Bible."[21] Van Gogh described the book as "sublime," relating its impact on his life to Theo: "Thomas à Kempis' book is peculiar; in it are words so profound and serious that one cannot read them without emotion, almost fear — at least if one reads with a sincere desire for light and truth — the language has an eloquence which wins the heart because it comes from the heart."[22]

The Imitation of Christ explains the dilemma of the Christian pilgrim as he comes to the knowledge of self in his pursuit of the knowledge of God, "And truly, to live in this world is but misery, and the more spiritual a man would be the more painful is it to him to live, and the more plainly he feels the defects of man's corruption. To eat, to drink, to sleep, to wake, to rest, to labor, and to serve all other needs of the body is great misery and great affliction to a devout soul. . . ."[23] The believer must completely resign himself to the will of God that he might then know and embrace God fully. The *Imitation* uses the word "resignatio" to express this absolute renunciation of the self and trusting abandonment to God. "To resign oneself is to go out of oneself and to embrace the divine will with all one's strength; it is to be firmly fixed in God by love without having greater desire for either success or reverse until all personal judgement be entirely eradicated from the heart."[24] In renunciation, the Christian experiences the conflict between God's grace, which drives the soul toward perfection, and his own nature, which weighs him down in the quagmire of sin. God, through his grace, sent Jesus, not only to save human beings from their sinful nature, but to provide a model whereby they might know God through the imitation of Christ. As *The Imitation of Christ* explains, Jesus teaches both through doctrine and example to renounce all worldly goods and pleasures to the divine will of God. "In this renunciation of the Savior, every virtue is found in a heroic degree — obedience, humility, poverty,

21. Reminiscences of Mendes da Costa, 1910, *Letters* 1:171.

22. L108, 4 September 1877, *Letters* 1:137.

23. Kempis, *The Imitation of Christ* 1:22.

24. Rev. P. Pourrat, *Christian Spirituality in the Middle Ages* (London: Burns, Oates and Washbourne, 1924), 2:299.

contempt of earthly goods, and especially patience in adversity. This perpetual resignatio is so crucifying that 'Christ's whole life is a cross and a martyrdom' (*Imitation* 2:12). So also should we, if we desire to follow Jesus, enter resolutely on the 'royal way of the cross.'"[25]

Van Gogh unhesitatingly embraced the religious asceticism of *The Imitation of Christ,* denying himself both physical pleasure and comfort. "What are we, and what distinguishes us? — one begins rather to realize why He [Jesus] said, 'If a man hate not his life, he cannot be my disciple,' for there is reason to hate that life and what is called 'this body of death.'"[26] Mendes da Costa recounts a tendency toward extreme self-deprivation and even flagellation:

> . . . whenever Vincent felt that his thoughts had strayed further than they should have, he took a cudgel to bed with him and belabored his back with it, and whenever he was convinced he had forfeited the privilege of passing the night in his bed, he slunk out of the house unobserved at night, and then when he came back and found the door double-locked, was forced to go and lie on the floor of a little wooden shed, without bed or blanket. He preferred to do this in winter. . . .[27]

This account, written some twenty years after van Gogh's death, is not corroborated elsewhere, and may be exaggerated. The character of van Gogh's humility and personal self-denial, however, is consistent with his view of Christianity.[28] In a reference to his reading of Ernst Renan's *La Vie de Jesus,* van Gogh explained his single-minded sense of purpose. "To act well in this world one must sacrifice all personal desires. The people who become the missionary of a religious thought have no other fatherland than this thought."[29] It is not simply that van Gogh carried such piety to its extreme; resignatio by its very nature is extreme. It is for those who truly wish to pursue Christianity's highest spiritual calling, the imitation of Christ, a calling which van Gogh practiced straightforwardly.

25. Ibid., 305.
26. L114, 25 November 1877, *Letters* 1:151.
27. Reminiscences of Mendes da Costa, 30 November 1910, *Letters* 1:170.
28. Jan Hulsker defends this account as completely reliable. See Hulsker, *Van Gogh's Diary: The Artist's Life in His Own Words and Work* (New York: William & Morrow, 1971), 163.
29. L26, 8 May 1875, *Letters* 1:26.

Van Gogh displayed a consistent religious character throughout this period. Although he said his religious sentiment was "far from all theology,"[30] we might call his faith a "piety of experience," an experience that was largely penitential. Retaining the emphasis of the Groningen School of his father on a deep, inner piety rather than a commitment to correct doctrine, Vincent was concerned only with experiencing the presence of God, and living out that experience in a practical "faith active in love." P. C. Görlitz reminisced that:

> When Sunday came, van Gogh would go to church three times, either to the Roman Catholic Church, or to the Protestant or Old Episcopal Church, which was commonly called the Jansenist Church. When once we made the remark, "But my dear van Gogh, how is it possible that you can go to three different churches of such divergent creeds?" He said, "Well, in every church I see God, and it's all the same to me whether a Protestant pastor or a Roman Catholic priest preaches; it is not really a matter of dogma, but of the spirit of the Gospel, and I find this spirit in all churches."[31]

His religion, like that of his father, was essentially christocentric; he wanted only to be like Jesus. He told Görlitz, "To follow what Jesus taught mankind will be the purpose of my life."[32] Yet van Gogh's Jesus was not the triumphant Christ of the Ascension, but the "Man of Sorrows" in the agony of Gethsemane, as he prayed for deliverance from his fate, and Calvary, where he died a tormented death on the cross. He viewed Jesus

30. L248, 26 and 27 November 1882, *Letters* 1:495.

31. A7[1], reminiscences of P. C. Görlitz, 1914, *Letters* 3:596. Problems exist concerning the accuracy of Görlitz' account of 1890 which was given more than thirty years after he lived with van Gogh in Dordrecht. This is the only account, for instance, that suggests that van Gogh regularly visited several different churches each week, although van Gogh himself mentions stopping in at the Catholic church when he himself was Protestant. The characteristics which Görlitz describes, however, are consistent with van Gogh's personal piety. Note that L83, 31 December 1876, *Letters* 1:85, mentions a visit to a Catholic church: "I just entered for a minute the Catholic church where evening service was being held." Also, L119, 18 February 1878, *Letters* 1:161, mentions a visit to a French church, "I got up very early and went to the French church in the morning. A clergyman from the neighborhood of Lyons preached here — he had come to collect money for an evangelical mission."

32. Ibid.

as the prototypical servant, who came to save the lost, heal the sick, feed the hungry, and bring hope to a dying world. He believed that to be a Christian meant, above all else, to imitate Christ both in his suffering and in his service to humankind. In a letter to Theo from Paris, Vincent wrote:

> "The Son of Man is not come to be served, but to serve," and we who want to become his followers, Christians, we are not greater than our Lord (see Luke 22:26-27; John 13:16). Blessed are the poor in spirit, blessed are the poor in heart.
>
> Narrow is the path which leadeth unto life, and those that find it are few. Struggle to enter by the narrow gate, for many will seek to enter, and will not be able (see Matt. 7:14).
>
> Let us ask of Him . . . that He enable us to fulfill a Christian's life; that He teach us to deny ourselves, to take our cross everyday and follow after Him; to be gentle, long-suffering and lowly of heart.[33]

Van Gogh was especially intrigued with Kempis' and Bunyan's metaphor of the pilgrim wandering in a strange and hostile land. In his sermon he quoted from the psalms, "I am a stranger on the earth, hide not thy commandments from me" (Psalm 119:19): "It is an old belief and it is a good belief that our life is a pilgrim's progress, that we are strangers on the earth, but that though this be so, yet we are not alone, for our father is with us. We are pilgrims, our life is a long walk or journey from earth to heaven."[34]

In *The Imitation of Christ,* the pilgrim purges his soul of earthly distractions through asceticism and self-sacrifice. Such purging results in the ability to see and understand God more clearly and finally leads to the ultimate goal of the Christian mystic, union of the will with God, so that the soul becomes one spirit with God. The three stages of the soul's ascent to God, the purgative, illuminative, and unitive, are represented in Kempis' prayer, "O Everlasting Light, far surpassing all created things, send down the beams of your brightness from above, and purify, gladden, and illuminate in me all the inward corners of my heart. Quicken my spirit with all its powers, that it may cleave fast and be joined to you in joyful gladness of spiritual rapture."[35]

33. L39b, 27 September 1875, *Letters* 1:37.
34. Van Gogh's sermon, 5 November 1876, *Letters* 1:87.
35. Kempis, *The Imitation of Christ* 3:34.

According to *The Imitation of Christ,* the present life on earth is fleeting and transient, a painful time of sorrow and trial as the soul is prepared for the eternal life to come. On earth, the Christian must imitate Christ in his suffering and self-denial, as *The Imitation of Christ* exhorts, "Our Master Christ was despised by men in the world, and in his greatest need, he was forsaken by His acquaintances and friends and left amid shame and rebuke. . . . If you would suffer no adversity, how can you be the friend of Christ?"[36] To be like Christ, then, a Christian must despise himself and deny all the pleasures of the world; he must daily "take up the cross" and follow Jesus. *The Imitation of Christ* demands: "Set your axe to the root of the tree, and fully cut away in you all the inordinate inclination that you have toward yourself or any personal or material thing."[37]

In so denying the world, the Christian who seeks to imitate Christ becomes separate and set apart from others, like a foreigner in an alien land who finds no solace or peace. As Kempis warns, believers will have no real peace until they are united with God after death: "You have here no place of long abiding, for wherever you have come, you are but a stranger and a pilgrim, and never will find perfect rest until you are fully joined to God."[38] Death brings the final triumph and release: "Blessed are those who have the hour of death ever before their eyes, and who everyday prepare themselves to die."[39]

Like *The Imitation of Christ, The Pilgrim's Progress* also had a deep and lasting effect both on van Gogh's understanding of religion and the active practice of his faith. The most famous literary work of seventeenth-century English Puritanism, *The Pilgrim's Progress* elaborates the theme of the Christian life as a journey, stressing the profoundly personal experience of faith. Van Gogh first received *The Pilgrim's Progress* from his friend and roommate in England and Paris, Harry Gladwell. He wrote to Theo from Isleworth, "If you ever have an opportunity to read Bunyan's *Pilgrim's Progress,* you will find it greatly worth while. For my part, I am exceedingly fond of it."[40] Elsewhere he recounted to Theo seeing a visual representation of the same pilgrimage theme:

36. Ibid., 2:1.
37. Ibid., 3:53.
38. Ibid., 2:1.
39. Ibid., 1:23.
40. L82, 25 November 1876, *Letters* 1:78.

Did I ever tell you about a picture by Boughton, "The Pilgrim's Progress"? It is toward evening. A sandy path leads over the hills to a mountain, on the top of which is the Holy City, lit by the red sun setting behind the gray evening clouds. On the road is a pilgrim who wants to go to the city; he is already tired and asks a woman in black, who is standing by the road and whose name is "Sorrowful yet always Rejoicing":

Does the road go uphill all the way? Yes, to the very end.
And will the journey take all day long? Yes, from morn till night, my friend.

Truly, it is not a picture, but an inspiration.[41]

In *The Pilgrim's Progress,* the emphasis is on process and potentiality, in which the pilgrim initiate enters into a new, deeper level of existence.[42] Unique to Protestant pilgrimage is the lack of physical movement; the journey is interior in location and spiritual in nature. Unlike the Catholic pilgrim on the road to Rome or Lourdes, the Protestant pilgrim does not perform a good work for the purpose of securing his salvation; justification by faith is his assurance. Rather, he strives for a higher spiritual knowledge, a mystical union with God. The striving is continual and self-perpetuating, for with each new ascent, there lies beyond the horizon a new challenge, a new hill to climb as the Glorious City of God beckons in the distance. The pilgrim's vision grows in gradual stages, as he advances along the way. From House Beautiful, he sees only to the Delectable Mountains, from the Delectable Mountains, he sees the gate of Heaven, and from Beulah, he sees the Heavenly City itself.[43] The allegorical form of *The Pilgrim's Progress* provides the perfect stage in which to act out the drama of the soul's struggle with evil and self-aggrandizement in search of the heavenly prize.

The Pilgrim's Progress parallels *The Imitation of Christ* both in its portrayal of the Christian pilgrim and its characterization of the spiritual

41. L74, 26 August 1876, *Letters* 1:66.
42. "Homologous with the ordeals of tribal initiation are the trials, tribulations, and even temptations in the pilgrim's way" (Edith and Victor Turner, *Image and Pilgrimage in Christian Culture* [New York: Columbia University Press, 1978], 8).
43. Roland Frye, *God, Man and Satan — Patterns of Christian Thought and Life in Paradise Lost, Pilgrim's Progress and the Great Theologians* (Princeton: Princeton University Press, 1960), 113.

journey. First, just as in *The Imitation of Christ,* the pilgrim is humble, poor, and disheartened. "*Pilgrim's Progress* opens with the vision of a man clothed in rags, symbolic of the ultimate poverty of humanity, and weighed down by the burden of guilt which he carries on his back."[44] Also, because of his deliberate rejection of the material world around him, the pilgrim is a stranger in a foreign land, whose loyalty lies with the Heavenly City. He has given up the pursuit of material wealth for the pursuit of spiritual wealth, and in so doing, he finds himself increasingly isolated. The Puritans perceived themselves as a community set apart from the rest of the world, temporary pilgrims in a strange and hostile land. In *The Pilgrim's Progress,* Christian's awareness of his depravity and need for grace alienates him from his family and community, compelling him to push on alone in search of his heavenly reward. "Secular society without grace has become a City of Destruction."[45]

Bunyan, like all Puritan writers, draws heavily on the Bible, particularly for his central theme that the Christian life is a difficult and often isolated spiritual quest. The "straight and narrow way" which Christian must follow in contrast to the "crooked lane" by which Ignorance finds his way recalls the distinction in Old Testament wisdom literature between the straight way of the righteous and the crooked way of the wicked, a metaphor that acquired a specifically Christian significance when Jesus declared, "I am the Way" (John 14:6).

The way, to be sure, is an ordeal and a trial of faith, with danger, sorrow, and despair encroaching on all sides. Mr. Worldly-Wiseman, in trying to discourage Christian from attempting the journey, warns, "I see the dirt of the Slough of Despond is on thee; but that Slough is the beginning of the sorrows that do attend those that go on in that way; hear me, I am older than thou! Thou art like to meet with in the way which thou goest, Wearisomeness, Painfulness, Hunger, Perils, Nakedness, Sword, Lions, Dragons, Darkness; and in a word, Death. . . ."[46] Like the pilgrim (the believing Christian) of Kempis' *Imitation of Christ,* Christian,

44. Ibid., 95.

45. For example, when Christian and Faithful are taken before the magistrates in the worldly village of Vanity, they explain that they are "pilgrims and strangers" in the world, and that they are going to their own country, which is the heavenly Jerusalem (John Bunyan, *The Pilgrim's Progress,* World Classics edition [Oxford: Oxford University Press, 1984], 74).

46. Ibid., 15.

the protagonist of *The Pilgrim's Progress,* must experience an agonizing and harrowing voyage through a world in which he is an unwelcome intruder, in the ever-present shadow of humiliation and impending death.

In *The Pilgrim's Progress,* just as in *The Imitation of Christ,* death is a welcome escape from the pain of earthly existence, a quicker route to the Celestial City. If Christian is to "take up the cross and follow Jesus," he must not only suffer, but he must make the ultimate sacrifice of giving up his own life in order to save it in the end. It is the hope that suffering will turn to jubilation and death will bring eternal life that keeps Christian pushing onward, "sorrowful, but always rejoicing."

Although the Christ of *The Pilgrim's Progress* reigns triumphant in the Celestial City, the event of the cross remains normative and awareness of the suffering and sacrifice of the Lord is ever-present in Christian's mind, just as it is for the writer of *The Imitation of Christ.* At the House of the Porter's Lodge, Christian recounts to Piety his conversion experience where he lost the burden of guilt which he had carried on his back from the beginning of his pilgrimage: ". . . I saw one, as I thought in my mind, hang bleeding upon the Tree; and the very sight of Him made my burden fall off my back."[47] Christian recalls with joy that it was Christ's sacrifice that made possible his own pilgrimage to the Heavenly City: "He hath given me rest, by his sorrow; and life by his death."[48] "I perceived that he had been a great Warrior, and had fought with and slain him that had the power of Death, but not without great danger to himself, which made me love him the more."[49] Christian explains that Christ, who is "such a lover of poor Pilgrims, . . . had stript himself of his glory that he might do this for the Poor."[50] He tells Piety that it is the expectation that he will see Christ in glory that keeps him on the straight and narrow path. When asked, "What makes you desirous to go to Mt. Zion?" he replies, "There I hope to see him alive, that did hang dead on the Cross."[51] So just as Christ's suffering and death had a glorious purpose, so too does Christian's.

The impact of the "piety of experience," which van Gogh read in *The Pilgrim's Progress* and *The Imitation of Christ,* permeates his letters and

47. Ibid., 40.
48. Ibid., 31.
49. Ibid., 43.
50. Ibid.
51. Ibid., 41-42.

particularly his preaching. He took from his devotional reading the notion that the Christian is a stranger in a transitory world, which he must deny as foreign, as well as the belief that the Christian experience is a difficult passage of trial and sorrow in which the goal is the Heavenly Jerusalem. Van Gogh believed that for the Christian self-sacrifice and self-denial should be normative; his convictions are borne out in the numerous accounts of his personal asceticism as well as his unfailing commitment to bring the Gospel to the poor. He believed, likewise, that death is not only the inevitable conclusion of the pilgrimage but a necessary and even welcome passage to one's eternal home with Christ. Finally, van Gogh shared the goal of the Christian in these two works, the ultimate union of the soul with the Infinite God, a goal which was also fundamental to the mystical theology of the Groningen School.

Van Gogh's one English sermon, delivered at Isleworth in 1876, focuses on many of the themes he found in his devotional reading, such as the association of spiritual progress with a journey, the alienation and suffering of the Christian pilgrim, and the ultimate meaning of suffering and death in the Christian's reward of eternal life. He wrote, "We are pilgrims on the earth and strangers — we come from afar and we are going far. The journey of our life goes from the loving breast of our Mother on earth to the arms of our Father in Heaven. Everything on earth changes — we have no abiding city here."[52] Van Gogh believed that it was the Christian's lot to accept his trials and rejoice in his sorrow:

> Sorrow is better than joy, and even in mirth the heart is sad, and it is better to go to the house of mourning than to the house of feasts, for by the sadness of the countenance, the heart is made better. Our nature is sorrowful, but for those who have learnt and are learning to look at Jesus Christ, there is always reason to rejoice.
>
> It is a good word, that of St. Paul: as being sorrowful yet always rejoicing. For those who believe in Jesus Christ, there is no death or sorrow that is not mixed with hope — no despair — there is only a constant being born again, a constantly going from darkness into light.[53]

52. Van Gogh's sermon, 5 November 1876, *Letters* 1:87. A more complete and accurate version of van Gogh's sermon appears in Josephine Leistra, *George Henry Boughton: God Speed! Pilgrems op Weg naar Canterbury* (Amsterdam: Rijksmuseum Vincent van Gogh, 1987), 56-63.

53. Ibid.

Just as in *The Pilgrim's Progress,* Christian's painful journey had a glorious end in the Celestial City, van Gogh believed that any Christian would achieve eternal life if willing to sacrifice his own life in order to save it. There was no real despair, not even in death, since he viewed death as a passage from the material, decaying world of this life to the glorious, ever-lasting life with Christ in the Heavenly City. "There is sorrow in the hour of death, but there is also joy unspeakable when it is the hour of death of one who has fought a good fight. There is one who has said: 'I am the Resurrection and the Life, if any man believe in Me though he were dead, yet shall he live.'"[54] Also, from Amsterdam, he wrote to Theo, "May all of us someday enter the Kingdom which is not of this world . . . where the sun shall no longer be the light of day, and the moon shall no longer shine to be brightness, but where the Lord will be a light eternal, and God our glory. . . ."[55]

As important as *The Pilgrim's Progress* was for van Gogh, *The Imitation of Christ* had perhaps the deepest impact, since it was central to his whole religious upbringing. It was from Kempis' work that van Gogh had his understanding of Christ as the "Man of Sorrows" whose mission of service and humility he would strive to imitate. He wrote from the Borinage:

> Jesus Christ is the Master who can comfort and strengthen a man, a laborer and working man whose life is hard — because he is the Great Man of Sorrows who knows our ills, who was called a carpenter's son, though he was the Son of God, who worked for thirty years, in a carpenter's shop to fulfill God's will. And God wills that in imitation of Christ man should live humbly and go through life not reaching for the sky, but adapting himself to the earth below, learning from the Gospel to be meek and simple of heart.[56]

It was the meekness of Jesus that van Gogh most admired; his christology consistently placed the emphasis on the humanity and the passion of Christ rather than on the divinity or triumphal ascension of the Lord. For van Gogh, Jesus was the supreme example. That he hoped rigorously to follow

54. Ibid.

55. L112, 30 October 1877, *Letters* 1:147.

56. "At a meeting this week, my text was Acts 16:9" (L127, 26 December 1878, *Letters* 1:184). The quotation regarding "The Man of Sorrows" was apparently part of the Bible lesson van Gogh presented to the miners.

Jesus' teaching and life of humility shines through in his prayer, "Fill my soul with a holy bitterness as it may please Thee, and I shall spend all the years of my life in Thy service, O Man of Sorrows and acquainted with grief."[57]

Although both *The Imitation of Christ* and *The Pilgrim's Progress* deal with the interior spiritual pilgrimage of the individual Christian, emphasizing the contemplative life, each claims that a true faith must be active and show itself in works of mercy to the poor. As Bunyan's Christian instructs Faithful on the practice of faith, "For as the Body without the Soul, is but a dead Carkass; so, Saying, if it be alone, is but a dead Carkass also. The Soul of Religion is the practick part: Pure Religion and undefiled is this, To visit the Fatherless and Widows in their affliction, and to keep himself unspotted from the World."[58]

Nowhere is van Gogh's commitment to this teaching more apparent than in his work among the coal miners of the Borinage. Van Gogh arrived at the small Belgian village of Petit-Wasmes in December of 1878. He apparently preached and gave Bible lessons to the children in the old Salon de Bébé in the Borinage, but he did not seek to be treated with the usual respect afforded a pastor. Instead he set out immediately to place himself on the same level of poverty and humility as the peasant miners, among whom he had come to preach the Gospel. As Rev. Bonte recalled some years later:

> The family which had taken Vincent in had simple habits, and lived like working people. But our evangelist very soon showed toward his lodgings the peculiar feeling which dominated him: he considered the accommodation far too luxurious; it shocked his Christian humility, he could not bear being lodged comfortably, in a way so different than that of the miners. Therefore he left these people who had surrounded him with sympathy and went to live in a little hovel. There he was all alone; he had no furniture, and people said he slept crouched down in a corner of the hearth. Faced with the destitution he encountered on his visits, his pity had induced him to give away nearly all his clothes; his money had found its way into the hands of the poor, and one might say that he had kept nothing for himself. His religious sentiments were very ardent, and he wanted to obey the words of Christ to the letter. He felt

57. L112, 30 October 1877, *Letters* 1:147.
58. Bunyan, *The Pilgrim's Progress,* 65.

obliged to imitate the early Christians (the vita apostolica), to sacrifice all he could live without, and he wanted to be even more destitute than the majority of miners to whom he preached the Gospel.[59]

Rev. Bonte also recalled van Gogh's extreme self-denial, both in his total devotion to his ministry and in his lack of attention to his own physical needs, which often made him a bizarre sight. Bonte does not attribute such behavior to masochism or eccentricity, as many others have, but explains that it was consistent with van Gogh's commitment to his ideal of following Christ whole-heartedly.

> I should add that the cleanliness of the Dutchman was also abandoned. Soap was discarded as a sinful luxury and so if he was not entirely covered by a layer of coal, our evangelist's face was even dirtier than those of the miners. Exterior details did not concern him, for he was absorbed in his passion for renunciation. He showed, however, that his attitude was not merely one of carelessness but was dictated by a strict adherence to ideas prompted by his conscience.
>
> His deep sensitiveness extended further than humanity, Vincent respected the lives of even the lowest of animals; he felt no repugnance for an ugly caterpillar. It was a living thing and therefore must be protected. The family with whom he lived told me that if he saw a caterpillar on the ground in the garden, he would pick it up and gently lay it on a tree. Apart from this side to his character, which may be thought insignificant perhaps, or even stupid, I treasure the impression that Vincent van Gogh was imbued with a fine ideal: forgetfulness of self and devotion to all living creatures. He accepted this dominating ideal with all his heart.[60]

Jean Baptiste Denis, a baker who boarded van Gogh at his home, had similar recollections. He also explained that van Gogh was following a religious ideal of poverty and humility, after Jesus. ". . . Having arrived at the stage where he had no shirt and no socks on his feet . . . (he had given away all his clothes), my kind-hearted mother said to him, Monsieur Vincent, 'Why do you deprive yourself of all your clothes like this — you

59. Reminiscences of Rev. Bonte, 1914, *Letters* 1:224.
60. Piérard, *The Tragic Life of Vincent van Gogh*, 46.

who are descended from such a noble family of Dutch pastors?' He answered, 'I am a friend of the poor like Jesus was.'"[61] M. Denis, who was fourteen years old when van Gogh came to work in the Borinage, had vivid recollections of his selfless character, even thirty years later. "1879 was a tragic year. An epidemic of typhus . . . broke out, and a great catastrophe, the explosion from fire-damp at l'Agrappe à Frameries, plunged the country into mourning. Vincent devoted himself untiringly to the care of the sick and the burned men with their black, puffed faces. A strike followed. The revolting miners would now listen to no one except 'Le Pasteur Vincent,' in whom they felt entire confidence."[62]

The miners had apparently accepted van Gogh completely and he seemed to enjoy a reasonably successful mission among them, no doubt due in part to the example he set himself of imitatio Christi. Rev. Bonte recalled:

> Van Gogh made many sensational conversions among the Protestants of Wasmes. People still talk of the miner whom he went to see after the accident in the Marcasse mine. The man was a habitual drinker, "an unbeliever and a blasphemer," according to the people who told me the story. When Vincent entered his house to help and comfort him, he was received with a volley of abuse. He was called especially a macheux d'capelets [rosary chewer], as if he had been a Roman Catholic priest. But van Gogh's evangelical tenderness converted the man.[63]

Van Gogh might have had a long, productive ministry in the Borinage except for the members of the Consistory,[64] who, alarmed by his lack of attention to his physical appearance as well as his ineloquent style of preaching, abruptly withdrew his support. Having expended all he had in the service of the Gospel but without the recognition or even the gratitude of the Church, he was by the end of 1879 physically, emotionally, and spiritually spent. When his father came from Etten to visit him, he found him in a state of complete exhaustion:

61. Reminiscences of Jean Baptiste Denis, 1914, *Letters* 1:225.
62. Piérard, *The Tragic Life of Vincent van Gogh*, 55.
63. Reminiscences of Jean Baptiste Denis, 1914, *Letters* 1:226.
64. The Consistory is the governing body of the Dutch Reformed Church, which was one of the Protestant denominations represented in the Union des Églises Protestantes Évangéliques de Belgique.

An epidemic of typhoid fever had broken out in the district. Vincent had given everything, his money and his clothes, to the poor sick miners. An inspector of the Evangelization Council had come to the conclusion that the missionary's "excès de zèle" bordered on the scandalous, and he did not hide his opinion from the Consistory of Wasmes. Van Gogh's father went from Nuenen [sic] to Wasmes. He found his son lying on a sack filled with straw, horribly worn out and emaciated. In the room, dimly lit by a lamp hanging from the ceiling, some miners with faces pinched with starvation and suffering crowded around Vincent.[65]

Vincent went back to live with the Denis family and tried to continue his work, but the Consistory's withdrawal of support had effectively ended his attempt to imitate the life and teachings of Jesus as a minister of the Gospel in the Borinage.

While van Gogh's vita apostolica was rigorous, it was never intended as an end in itself, but as part of a whole spiritual process. It may have been extreme in its self-abnegation, but it was exemplary in attempting to model the life of Christ as part of the way of achieving a most intimate communion with the One Infinite God. In the mystic, there is also an ascetic, since denial of the self and the material world is the first step in the soul's journey to God.[66]

True mysticism is active and practical, not passive and theoretical. Its aims are wholly transcendental and spiritual. It is in no way concerned with adding to, exploring, re-arranging, or improving anything in the visible universe. The mystic brushes aside that universe. . . . His heart is always set upon the changeless One. This One is, for the mystic, not merely the Reality of all that is, but also a living and personal Object of Love; never an object of exploration. It draws his whole being homeward, but always under the guidance of the heart. Living union with this One — which is the term of his adventure — is a definite state or form of enhanced life. . . . It is arrived at by an arduous psychological process — the so-called Mystic Way.[67]

65. Reminiscences of Jean Baptiste Denis, 1914, *Letters* 1:226.

66. See Brenier de Montmorand, "Ascétisme et Mysticisme: Étude Psychologique," *Revue Philosophique* 57 (March 1904): 242-62.

67. Evelyn Underhill, *Mysticism: a Study in the Nature and Development of Man's Spiritual Consciousness* (New York: Meridian, 1955), 81.

The kind of asceticism that van Gogh practiced is not an aberration to the religious man. "Asceticism is not a rare, exceptional and nearly abnormal fruit of the religious life, as some have supposed it to be; on the contrary, it is one of its essential elements. Every religion contains it, at least in germ. . . ."[68]

Christian asceticism begins with Jesus' call to discipleship, "If any man come after me, let him deny himself and take up his cross daily and follow me."[69] This command encompasses the two fundamentals of Christian asceticism, the renunciation of self and the commitment to imitate the life of Christ. The decision to follow Christ is motivated by the love of God and manifests itself in Christ-like service to others. Jesus taught that the whole law could be summed up in the two great commandments: to love God wholly and to love one's neighbor as oneself.[70]

The apostle Paul continued this tradition of the renunciation of the things of the world: "The world is crucified to me and I to the world."[71] The Christian denies the world and himself by putting off the "old man" of sin and putting on the "new man" of Christ in baptism.[72] For the apostle Paul, the example of Christ is normative: "Be imitators of me, as I am of Christ."[73] Paul expresses the desire to give up all personal gain and to share the suffering of Christ, even unto death, in order to know him and to finally participate in the resurrection of the dead. "For His sake, I have suffered the loss of all things, and count them as refuse, in order that I may gain Christ . . . that I may know Him and the power of His resurrection, and may share His sufferings, becoming like Him in death."[74] In suffering the pains of discipleship, Paul's hope is the ultimate union with Christ through death.

Asceticism was a prominent feature of Christian spirituality in the medieval period, particularly in the monastic ideal of the Benedictines. The kind of piety van Gogh embraced flowered in the many medieval reform movements from the twelfth through the fourteenth century, per-

68. Emile Durkheim, *The Elementary Forms of the Religious Life: A Study in Religious Sociology* (New York: Macmillan, 1915), 311.

69. Luke 9:23.

70. Matthew 22:36-40.

71. Galatians 6:14.

72. 2 Corinthians 5:17, Romans 6:4.

73. 1 Corinthians 11:1.

74. Philippians 3:7-11.

haps best exemplified by the life of St. Francis of Assisi and his mendicant brothers: "The friars must be careful not to accept churches or poor dwellings for themselves, or anything else built for them, unless they are in harmony with the poverty which we have promised in the Rule; and they should occupy these spaces only as strangers and pilgrims."[75]

The Rev. J. Chrispeels, who knew van Gogh while he trained briefly at the School for the Evangelists in Belgium, described him as a kind of medieval ascetic, "By way of self-chastisement, he never used a table in writing, but kept his copybook on his knees. In certain ways, he often made one think of a legalist of the Middle Ages."[76]

Although van Gogh does not mention St. Francis, it was a Franciscan type of piety that inspired the Dutch mystic, Gerhard Groote, who founded the Brethren of the Common Life, and which produced, in turn, Thomas à Kempis and *The Imitation of Christ*. It was also this type of piety that inspired John Bunyan as he wrote from his prison cell. The Christian of Bunyan's *Pilgrim's Progress* begins by separating himself from the world before he launches his journey toward the Heavenly Jerusalem.

The renunciation of self and the imitation of Christ's life of humility also came to van Gogh through the Methodist doctrine of holiness, a pietistic tradition that is echoed in the theology of Schleiermacher. Van Gogh came into contact with the Methodists not only in England but also in the Borinage, since Methodists were among the members of the Union des Églises Protestantes Évangéliques de Belgique. The founder of the Methodists, John Wesley, recounted his own insights upon reading Kempis' *Imitation of Christ*:

> He [Wesley] saw for the first time that true religion must be seated in the heart and that God's laws must extend to a man's thoughts as well as to his words and actions. He knew now what Thomas à Kempis, that "person of great piety and devotion," meant in regard to both sincerity and purity; and from his work he learned "that simplicity of intention and purity of affection, one design in all we do, and one desire ruling all our tempers, are indeed the wings of the soul, without which she can never ascend to the mount of God." But more than this, Thomas à

75. Julius Kirshner and Karl F. Morrison, *Readings in Western Civilization, Western Europe* (Chicago: University of Chicago Press, 1986), 4:288.
76. Reminiscences of Rev. J. Chrispeels, 1927, *Letters* 1:181.

Kempis reaffirmed what Wesley had already been taught at home. The true Christian must seek to imitate his Lord.[77]

In every period of the Christian Church, then, and particularly in the traditions that influenced van Gogh, from early and medieval Christianity through Dutch Mysticism, Puritanism, and Methodism, the spirituality he practiced is pervasive. Far from being peculiar or eccentric, van Gogh was actually a traditional disciple of the cross. In choosing to center his spiritual life on *The Imitation of Christ* and *The Pilgrim's Progress,* moreover, van Gogh chose two of the most popular and influential devotional works in the Christian tradition. Like many Christians before him, he found them profoundly insightful and exemplary guides. In his self-denial, in his commitment to spiritual pilgrimage, in his active ministry to the poor, van Gogh sought to follow Jesus and imitate his life of humility, to the letter. Rather than pathological or even irrationally fanatical, he was entirely consistent with the tradition he chose, the imitatio Christi. Although thwarted in his efforts to live out his religious commitment and forced in disgust to abandon the institutional church, van Gogh did not bury his piety. As profoundly as these ideas had influenced him in the first twenty-eight years of his life, he did not forget them but took them with him on his pilgrimage to make art his next all-consuming work.

77. William Ragsdale Cannon, *The Theology of John Wesley* (New York: Abingdon-Cokesbury Press, 1956), 56.

3. Religion and Modernity

1880 WAS A PIVOTAL YEAR IN VAN GOGH'S LIFE. IT WAS THE YEAR when he left the Church and began developing his vision as an artist. While not a categorical break with the past, it was a major turning point. From 1880 onward, he left behind the evangelical views he espoused as a missionary and focused instead on the struggle to reconcile the traditions of the past with the concerns of the modern man. Actually, this process had begun in his youth. His uncle Stricker had exposed him to modernist theology at an early age, but he also encountered modernist religious thought through reading such works as Renan's *La Vie de Jésus*. Rather than a radical "conversion," van Gogh's interest in finding a modern religion to replace the institutional Christianity of the Church and its traditional doctrines was an outgrowth of his early religious training. He left the Church, moreover, not because he preferred naturalism, the belief that one knows and understands God best through nature rather than doctrine or revelation, but because the Church, particularly its ministers, had failed him. As is the case with many believers who fall away from the Church, his break was not a theological but a deeply personal one, rooted in a fundamental mistrust of the clergy. This mistrust began with his dismissal from the Borinage by the Committee on Evangelism and extended to the two clergymen van Gogh had most admired and trusted, his uncle, Stricker, and his father, Theodorus.

As we have seen, van Gogh was dismissed unjustifiably from his work with the coal miners in the Borinage. He did not surrender his

missionary post voluntarily; the Consistory of the Union des Églises de Belgique decided to terminate his support. It is understandable that such a devastating turn of events, after so many years of pursuing his goal of preaching the Gospel, would cause him to give up in disgust. A far more important factor in van Gogh's turning away from the institutional Church was his disillusionment with the two individuals who had until this time been his spiritual guides, his father and his uncle. Repulsed by the hypocrisy he perceived in both men, he projected that perception of "Pharisaism" onto the clergy and the institutional Church as a whole. Within a year of leaving the Borinage and his life as a Christian missionary, van Gogh wrote to his brother, ". . . God perhaps really begins when we say the word with which Multatuli finishes his 'Prayer of an Unbeliever: O God, there is no God!' For me, that God of the clergymen is dead as a doornail. But am I atheist for all that? The clergymen consider me so — so be it — but I love, and how could I feel love if I did not live and others did not live; and then if we live, there is something mysterious in that. Now call it God or human nature or whatever you like, but there is something which I cannot define systematically, though it is very real, and see that as God, or as good as God."[1]

In another letter written to Theo at about the same time, he insists on his continued belief in God, which compels him to love despite his negative experiences with the clergy. "You must not be astonished when, even at the risk of your taking me for a fanatic, I tell you that in order to love, I think it absolutely necessary to believe in God (that does not mean that you should believe all the sermons of the clergymen) . . . far from it. To me, to believe in God is to feel that there is a God, not dead or stuffed, but alive, urging us toward aimer encore [steadfast love] with irresistible force."[2] He had set up a dichotomy in his mind between "good" and "bad" religion, which he would later describe as the "rayon blanc" and the "rayon noir" (the white light and the black light).

He began to view the institutional Church and its ministers as cold and unfeeling. Stricker was a principal target of his reproach. As mentioned earlier, Vincent had fallen in love with Stricker's only surviving daughter, Kee. His persistent pursuit of Kee, in the face of her "never, no, never," had caused a rift between himself and Stricker. He painfully relayed the

1. L164, 21 December 1881, *Letters* 1:288.
2. L161, 23 November 1881, *Letters* 1:274.

experience to Theo: "It was too much for me, especially when they spoke of my wanting to coerce her and I felt that the crushing things they said to me were unanswerable. . . ."[3] Whether correctly or not, Vincent believed that Kee's rejection was based on her father's perception of him as a poor marital prospect due to his lack of financial security. He explained to Theo, "Kee herself thinks she will never change her mind, and the older people [Kee's parents] try to convince me that she cannot; yet they are afraid of that change. The older people will change in this affair, not when Kee changes her mind, but only when I have become somebody who earns at least a thousand guilders a year."[4] While Stricker preached on the importance of rejecting the material world in search of the spiritual wealth of the kingdom of God, in practice he viewed financial status as desirable, even necessary. It is no wonder van Gogh, who himself categorically embraced the distinction between spiritual and material wealth, viewed Sticker's attitude as hypocritical, often referring to him thereafter sarcastically as "the Right Rev. Stricker."

Two aspects of van Gogh's own temperament exacerbated the awkward situation with Kee: first, his tendency to take his beliefs to the limit (as his sister-in-law said, "he never did anything by halves"); and second, his complete inability to see the other point of view in a disagreement. While Stricker's concern with van Gogh's lack of financial stability might have seemed hypocritical to Vincent, it was certainly a reasonable concern, since Kee had been recently widowed and had a young boy to support. Naturally, her father would be concerned for their welfare. It seems likely that Vincent's own father discouraged such a match as well, because of what he saw of his son's tendency to "choose a life of poverty." We do not know, however, if any of these concerns came into play at all because Kee seems to have had absolutely no interest in a liaison with her cousin. All of the bitterness that Vincent developed against Stricker may well have been the result of his own inability to accept rejection.

Even in the face of Kee's categorical rejection, van Gogh busied himself preparing work for sale. He had already begun to send drawings to Theo, an art dealer, with the expectation that he might sell them, and thus begin earning a respectable living. In so doing, he might then become acceptable to Stricker, and hopefully to Kee as well. "I sent you a few

3. L160, 19 November 1881, *Letters* 1:271.
4. L153, 3 November 1881, *Letters* 1:253.

drawings because I thought you might find something of Brabant in them. Now tell me, why don't they sell, and how can I make them saleable? For now and then I should like to earn some money for a railroad ticket so as to go and fathom that 'never, no, never.' But you must not tell this intention of mine to the Right Rev. Mr. J. P. Stricker. For if I come very unexpectedly, possibly he would not be able to do anything but close his eyes to it. As far as one of the parties is concerned, such as a Right Rev. Mr. J. P. S. becomes quite a different person than before when one falls in love with his daughter."[5] Van Gogh explained to Theo that he tried pleading his case with Uncle Stricker in a registered letter, "It is a very 'undiplomatic' letter, very bold, but I am sure it will at least make an impression on him. But perhaps at first it will cause him to use a certain expletive which he certainly would not use in a sermon. There really are no more unbelieving and hard-hearted and worldly people than clergymen and especially clergymen's wives. . . . But even clergymen sometimes have a human heart under three layers of steel armor."[6]

Although Stricker's apparent "pharisaism" offended him, van Gogh continued to hold him in high esteem as a theological teacher. For example, during the summer of 1881, long after van Gogh's supposed abandonment of Christianity in December of 1879, he continued to read Stricker's books. He remarked to Theo, "Do you know that Uncle Stricker is really a very clever man, in fact an artist? This summer I read a little book he had just published on the 'minor prophets' and a few of the other less known books in the Bible. So I certainly hope that after some time has passed, there will be more sympathy between us than there has been hitherto."[7]

Van Gogh's hope for a reconciliation with Stricker shattered when he returned to Amsterdam to attempt another visit with Kee. He wrote Theo in December, "I have been to Amsterdam. Uncle Stricker was rather angry, though he gave vent to it in more polite words than 'God damn you.'" For the three days van Gogh remained in Amsterdam, Kee completely refused to see him. Stricker read him a letter, which he apparently had intended as a reply to Vincent's "undiplomatic" letter, asking that Vincent cease his correspondence and relinquish his romantic quest

5. L156, 10-11 November 1881, *Letters* 1:261.
6. L161, 23 November 1881, *Letters* 1:272.
7. Ibid., 273. Van Gogh was most likely referring to Stricker's *De Schriftelijke Nalatenschap der Oud-Israelitische Profeten, Wijzen en Dichters* (The Literary Inheritance of the Old Hebrew Prophets, Wise Men and Poets), published in 1879.

for Kee entirely. He described that bitter experience to Theo later, "At last the reading of the letter was finished. I just felt as if I were in Church and after the clergyman's voice had pranced up and down, had heard him say, 'amen;' it left me just as cool as an ordinary sermon."[8]

Amazingly, van Gogh still refused to accept Kee's categorical "never, no, never," and went once again to plead his case with Stricker, claiming, ". . . I see in her a true woman with a woman's passions and moods, and I love her dearly, and that is the truth and I am glad of it." He told Theo about Stricker's response, "Uncle hadn't much to say in reply; he muttered something about a woman's passions — I don't quite remember what — and then he went to church. No wonder one becomes hardened there and turns to stone; I know it from my own experience. And so your brother 'in question' did not want to be stunned, but nevertheless he had a stunned feeling, a feeling as if he had been standing too long against a cold, hard whitewashed church wall."[9]

The "whitewashed wall" of a church, specifically its interior, became van Gogh's symbol for clerical hypocrisy. When he painted *Starry Night,* for example, the church is the only building in the landscape that does not reflect the brilliance of the stars above. It is completely dark. He mentioned the "white wall" again some three years later in a letter from Etten: "One must be careful not to fall back on opaque black — on deliberate wrong — and even more one has to avoid the white of a whitewashed wall, which means hypocrisy and everlasting Pharisaism."[10] In this instance, the reference to clerical hypocrisy reflects a terrible crisis with his father, Theodorus.

Van Gogh's quarrels with his father began after his attempts at missionary work in the Borinage failed, forcing him to go back to living with his parents, who now had a parish in Etten. An unpublished letter from Theodorus to Theo indicates the strife between Vincent and his father, but also incidentally reveals Vincent's continued ties to his evangelical past, since he speaks of going back to London again to see the Rev. Jones: "Vincent is still here — but alas! it is nothing but worry. Now he is talking about going to London in order to speak with the Reverend Jones. If he

8. L164, 21 November 1881, *Letters* 1:284.

9. Ibid., 285.

10. L306, 27 July 1883, *Letters* 2:94. Also, see Tsukasa Kōdera's *Vincent van Gogh: Christianity versus Nature* (Amsterdam: John Benjamins, 1990), 81-84, on the symbolism of the interior wall of the church.

sticks to that plan, I'll enable him to go, but it is hopeless."[11] When van Gogh had initially taken the position with Rev. Jones, his father expressed disapproval because such a position as catechist had no financial future. Theo tried to intervene, sending Vincent 50 francs and pleading with him to resolve his differences and also to find gainful employment. Vincent sent this melancholy reply in July, 1880:

> I am writing you with some reluctance, not having done so for such a long time, for many reasons. . . . Perhaps you know, I am back in the Borinage. Father would rather I stay in the neighborhood of Etten. I refused, and in this I think I acted for the best. Involuntarily, I have become more or less a kind of impossible and suspect personage in the family, at least somebody whom they do not trust, so how could I in any way be of use to anybody? Therefore above all, I think the best and most reasonable thing for me to do is to go away and keep a convenient distance, so that I cease to exist for you all.[12]

Van Gogh had associated his fate, as well as the troubles with his father, with religious hypocrisy, as he states in the same letter, "I must tell you that with evangelists it is the same as with artists. There is an old academic school, often detestable, tyrannical, the accumulation of horrors, men who wear a cuirass, a steel armor of prejudices and conventions; . . . Their God is like the God of Shakespeare's drunken Falstaff, le dedans d'une église [the inside of a church]. . . ."[13]

Vincent went on, in the same letter, to tell Theo that he had been occupying his time with his "passion for books," reading the Bible, Michelet, Shakespeare, Victor Hugo, and Harriet Beecher Stowe. He explained his view that all that is sublime and beautiful, especially love, emanates from God. ". . . I think that everything which is really good and beautiful — of inner moral, spiritual and sublime beauty in men and their works — comes from God, and that which is bad and wrong in men and in their works is not of God, and God does not approve of it. But I always think that the best way to know God is to love many things. Love a friend, a

11. Quoted in Jan Hulsker, *Vincent and Theo van Gogh: A Dual Biography* (Ann Arbor: Fuller Publications, 1990), 85.

12. L133, July 1880, *Letters* 1:193.

13. Ibid., 195.

wife, something — whatever you like — you will be on the way to knowing more about Him."[14]

Van Gogh had forever turned away from the zealous evangelical missionary who had earlier suggested to Theo that he destroy all of his books except the Bible. His faith was now more existential than evangelical, but still centrally concerned with the ethic of love. This belief echoes the Groningen theology, which taught that the divine good is immanent in all human beings as a reflection of God's indwelling spirit and manifests itself in love.

After Theo received Vincent's letter, Theodorus wrote back to Theo, expressing his frustration in dealing with Vincent: "Indeed that letter Vincent wrote you gave me some pleasure. But oh! what will become of him, and isn't it insane to choose a life of poverty and let time pass without looking for an occasion of earning one's own bread — yes, that really is insane." Until recently, van Gogh's biographers have assumed that Father van Gogh's equation of his son's choice of "a life of poverty" with insanity was a simple figure of speech. With the 1990 publication of the Dutch edition of van Gogh's letters, passages which were previously omitted from the 1958 English edition reveal that Theodorus, who clearly found the extremes of van Gogh's vita apostolica distasteful, actually intended to have Vincent committed to an insane asylum in Belgium. This intention, in addition to Vincent's disappointment in the Borinage and the perceived hypocrisy of his uncle, is what led to his bitter denouncement of institutional Christianity.

The rift in the family was so deep that all of the correspondence between members of the van Gogh family during this period was destroyed so that this terrible "secret," that Vincent's father, Theodorus, had attempted to have him committed to an insane asylum in Belgium, at Gheel, might never come out. But

> in a letter of November 1881 (L158), as well as in two letters of May 1882 (L193 and L198), Vincent reminded his brother of the fact that their father had wanted to put him in an asylum. . . . The omitted passage in the letter of 1881 reads as follows, "I can't believe that a father is right who curses his son and, think of last year, wants to send him to a madhouse." In May, 1882, he referred to it with the words, "I

14. Ibid., 198.

don't accept that one attacks my personal freedom; I had told my father that clearly enough at the time of the Gheel-affair when he wanted to put me away in a madhouse." We know for sure that it was an event of 1880, and we may probably narrow that down to the spring of that year when Vincent had stayed in his parents' house in Etten. . . .[15]

After the spring of 1880, Vincent's enthusiasm for serving the Church as a minister of the Gospel completely vanished from his letters, indicating that this bitter feud with his father was probably the decisive event that turned Vincent away from institutional Christianity.

Although he mentioned religion and the Bible in his letters after 1880, his views were those of a modern seeker, not a Bible preacher. He read Stricker's book on the minor prophets during the summer of 1881 and also mentioned reading the Bible in conjunction with modern writers, such as Michelet and Hugo. Van Gogh replaced the former fundamentalist, "I am going to do away with all my books by Michelet, etc. I wish you would do the same," of 1875 with the more moderate, "As for me, I could not do without Michelet for anything in the world. It is true the Bible is eternal and everlasting, but Michelet gives such very practical and clear hints, so directly applicable to this hurried and feverish modern life . . ." of 1881.[16] After the crisis with his father and the subsequent fallout with the Strickers over Kee, however, van Gogh never again mentions attending a church service. In fact, van Gogh reported to Theo that just a few weeks after the "Stricker affair," he had an argument with Theodorus concerning his refusal to attend church, that was so intense he felt compelled to leave home. Writing from his studio in the Hague, he explained the situation:

> On Christmas day, I had a violent scene with Father, and it went so far that Father told me I had better leave the house. Well, he said it so decidedly that I actually left the same day.
>
> The real reason was that I did not go to church, and also said that if going to church was compulsory and if I was *forced* to go, I certainly

15. Quoted from "The Borinage Episode and the Misrepresentation of Vincent van Gogh," presented by Jan Hulsker at the van Gogh Symposium, held 10 and 11 May 1990, at the Rijksmuseum Vincent van Gogh, Amsterdam. Mr. Hulsker kindly sent me the typed manuscript of his speech.

16. L39, 25 September 1875, *Letters* 1:36 and L161, 23 November 1881, *Letters* 1:273, respectively.

should never go again out of courtesy, as I had done rather regularly all the time I was in Etten. But oh, in truth, there was much more at the back of it all, including the whole story of what happened this summer between Kee and me.

I do not remember ever having been in such a rage in my life. I frankly said that I thought their whole system of religion horrible, and just because I had gone too deeply into those questions during a miserable period in my life, I did not want to think of them anymore, and must keep clear of them as of something fatal.[17]

Clearly, by December, 1881, van Gogh's attitude toward religion had changed. Rather than a categorical rejection of religion, or even of Christianity, however, it was a rejection of the hypocrisy he had experienced at the hands of the clergy, both in the Borinage and within his own family. Because he projected the perceived "pharisaism" of Stricker and Theodorus on the whole Christian clergy, he could no longer worship in the community of the Church. He abandoned the institutional expressions of faith, as well as the evangelical Christianity he had embraced from September of 1875. Those art historians who have seen van Gogh's oeuvre as incompatible with religion, or at least Christianity, have fundamentally misconstrued this religious turning point in 1881. Typical of this misunderstanding is the statement that van Gogh's "existence as an artist started with his rejection and abandonment of Christianity."[18] An artist who painted more than thirty representations of sowers, as well as the overtly religious subjects of the raising of Lazarus, the Good Samaritan, and the Pietà, in which he depicted the face of Christ with the features of his own face, cannot be understood in terms of an absolute rejection of religion or Christianity.

In many respects, van Gogh's piety after he became an artist is quite consistent with his Christian background. First, he continued to hold the same respect for the simple and the humble, "the poor in spirit" of the Beatitudes. In May, 1882, van Gogh explained his continued identification with the poor: "Being a laborer, I feel at home in the laboring class, and more and more I will try to live and take root there."[19] "I feel that my

17. L166, 29 December 1881, *Letters* 1:294.
18. Kōdera, *Vincent van Gogh: Christianity versus Nature*, 89.
19. L194, 4-12 May 1882, *Letters* 1:359.

work lies in the heart of the people, that I must keep close to the ground, that I must grasp life in its depths, and make progress through many cares and troubles."[20] Van Gogh experienced this reverence for the "poor in spirit" in religious terms: "I prefer to see diggers digging, and have found glory outside Paradise, where one thinks more of the severer: 'Thou shalt eat thy bread in the sweat of thy brow.'"[21] He continued to respect the simple country parson, and, in 1883, even expressed a wish to return one day to his original calling: "The figure of a poor country clergyman is to me, in type and character, one of the most sympathetic sights I know, I should not be true to myself if I didn't try it someday."[22]

In keeping with his continued desire to help the poor, van Gogh took under his care a pregnant prostitute and her young daughter, Maria, while living on his own in the Hague. Knowing that his action would meet with great disapproval from his family, including Theo, he kept his relationship secret for a brief period of time. In the following letter to Theo from May, 1882, van Gogh revealed his "secret" and informed Theo that it was his intent to marry the woman he called "Sien." In so doing, he not only risked the rejection of his parents but also risked Theo's withdrawal of financial support, which he desperately needed:

> Last winter I met a pregnant woman, deserted by the man whose child she carried.
>
> A pregnant woman who had to walk the streets in winter, had to earn her bread, you understand how.
>
> I took this woman for a model, and have worked with her all winter. I could not pay her the full wages of a model, but that did not prevent my paying her rent, and thank God, so far I have been able to protect her and her child from hunger and cold by sharing my own bread with her. . . . It seems to me that every man worth a straw would have done the same in such a case.
>
> What I did was so simple and natural that I thought I could keep it to myself. Posing was very difficult for her, but she has learned; I have made progress in my drawing because I had a good model. The woman is now attached to me like a tame dove. For my part, I can only

20. L197, 12 or 13 May 1882, *Letters* 1:365.
21. L286, 21 May 1883, *Letters* 2:36.
22. L299, 11 July 1883, *Letters* 2:77.

marry once, and how can I do better than marry her? It is the only way to help her; otherwise misery would force her back into her old ways, which end in a precipice.[23]

Their union was never realized, however. Not only were all of van Gogh's family, Theo included, completely opposed to such a marriage, but Sien's mother, who herself had eleven illegitimate children, could not accept Vincent as a suitable husband. Because van Gogh was a painter living in poverty himself, she felt Sien would be better off making her own way as she had before she began living with Vincent. It is also clear from the way van Gogh described Sien (her actual name was Clasina Maria Hoornik) and his relationship with her that although he loved her, it was a different kind of love than he felt for Kee.

They parted company permanently in September, 1883. The following year, during which he desperately missed his newly found "family," was one of the loneliest times of van Gogh's life.[24] Sadly, Sien's fate was no better than Vincent's. Both her daughter, Maria, and her son, Willem, fell to the care of her mother and brother after she left van Gogh. She finally married at the age of fifty-one, in 1901, for the sole purpose of legitimizing her children. Marriage did not end her sorrows, and tragically, November 12, 1904, she took her own life by drowning. Ironically, Vincent had once quoted her, in a letter to Theo, as saying, ". . . the only end for me will be to drown myself."[25]

Van Gogh viewed his caring for Sien and her children as his responsibility to help the unfortunate, something he felt his "good Christian" parents should understand. His continued tendency to apprehend the divine presence in the simplest and most mundane of life's experiences shines through in his description of the birth of Sien's child. Defending himself against his parents' charges of impropriety, van Gogh wrote to Theo, "And just listen, entre nous soit dit [what has been said between us] — without preaching a sermon, it may be true that there is no God here, but there must be one not far off, and at such a moment [a reference to the birth of Sien's son] one feels His presence — which is the same as

23. L192, 3-12 May 1882, *Letters* 1:349.

24. Jan Hulsker has published a great deal about van Gogh's "Sien" in the journal, *Vincent*.

25. L317, 22 or 23 August 1883, *Letters* 2:123.

saying, and I readily give this sincere profession of faith: I believe in God. . . ."[26]

Van Gogh, who experienced Willem's birth as a sacred event, rendered a touching charcoal sketch of Sien's older daughter, Maria, attending the baby's cradle, *Girl Kneeling in Front of a Cradle* (1883, fig. 6). His description of the baby's cradle and Sien's hospital room show van Gogh's continued association of the event of childbirth with the birth of Christ and the incarnation:

> I cannot look at this last piece of furniture without emotion, for it is a strong and powerful emotion which grips a man when he sits beside the woman he loves with a baby in the cradle near them. And though it was only a hospital where she was lying and where I sat near her, it was always the eternal poetry of the Christmas night with the baby in the stable — as the old Dutch painters saw it, and Millet and Breton — *a light in the darkness, a star in the dark night.* So I hung the great etching by Rembrandt over it, the two women by the cradle, one of whom is reading from the Bible by the light of the candle, while great shadows cast a deep chiaroscuro all over the room. I have hung a few other prints there too, all very beautiful ones — "Christus Consolator" by Scheffer; a photograph of a picture by Boughton; "The Sower" and "The Diggers" by Millet.[27]

Even in the prints van Gogh chose to decorate Sien's room, there is a definite religious presence. *The Consolator* is a religious print and the other subjects, the sower and the digger (especially those by Boughton and Millet), are typically representative of the kingdom of God. Van Gogh continued to find meaning in such religious images.

Van Gogh's account of the birth of Sien's child is reminiscent of his description of the birth of a calf which he witnessed while a missionary to the Belgian coal miners; he had described it too as a holy event, analogous to the birth of Christ, with the numinous quality of a beautiful painting: "Once I saw this in reality, not of course the birth of Christ, but

26. L213, 6 July 1882, *Letters* 1:401.
27. L213, 6 July 1882, *Letters* 1:399. Jules Breton (1827-1906) was a French painter who painted agricultural scenes, particularly religious rituals such as funeral processions. Jean-François Millet's (1814-75) paintings of peasants are known for their monumental quality, giving the simple digger, sower, weaver etc. an almost heroic status.

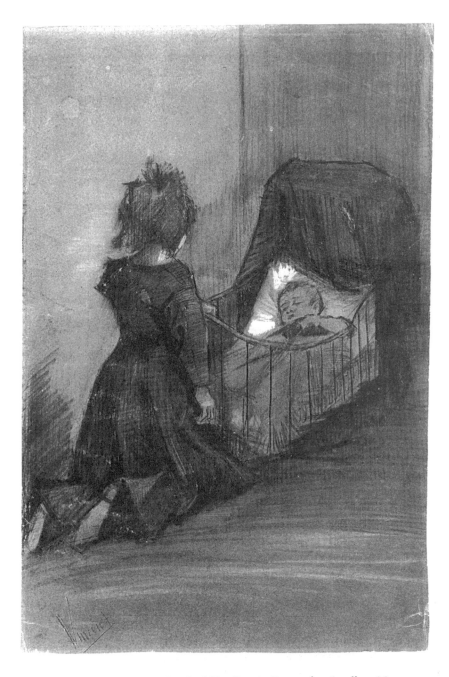

6. Vincent van Gogh, *Girl Kneeling in Front of a Cradle*, 1883,
charcoal heightened with white

the birth of a calf. And I remember exactly how the expression was. There was a little girl in the stable that night — in the Borinage — a little brown peasant girl with a white night cap: she had tears of compassion in her eyes for the poor cow when the poor thing was in throes and was having great trouble. It was pure, holy, wonderful, beautiful, like a Correggio, a Millet, or an Israëls."[28]

The expression of the infinite in the mundane, van Gogh's experience of the numinous quality of day to day human existence, pervades his work. Rather than choosing the subject matter and the iconography of traditional religious painting to express the divine presence, van Gogh instead tried to capture what he saw of the infinite in the commonplace subjects of everyday life.[29] He explained: "I prefer painting people's eyes to cathedrals, for there is something in the eyes that is not in the cathedral, however solemn and imposing the latter may be — a human soul, be it that of a poor beggar or of a street walker, is more interesting to me."[30] His numerous depictions of peasants, often with church steeples in the background, or with other overt Christian symbols, such as the Crucifixion and the Eucharist, reflect his continuing admiration for Christian humility. Like other artists whom van Gogh admired, such as Millet and Israëls before him, van Gogh imbued the simple figures of sowers, diggers, peasant children, and even prostitutes with a sacred quality. Van Gogh incorporated this reverence for the piety of the simple, poor, and meek in the first major work of his Dutch period, *The Potato Eaters* (1885, plate 1).

Even after leaving the Church, van Gogh retained the Christian ethic that faith must reflect itself in Christian service, based on imitation of the example of Jesus Christ. He had been taught from his youth that ethics

28. L181, 11 March 1882, *Letters* 1:325. Jozef Israëls (1824-1911) was the best-known of the Dutch painters of the nineteenth century. As leader of the Hague-school painters, he was noted for his paintings of rural landscapes and peasant life, which he often imbued with subtle religious overtones.

29. In the academy art of the nineteenth century, subjects were ranked as to their importance. The most desirable and acceptable subjects for the artist to paint, according to the rules of the academy were biblical and mythological subjects, followed by landscapes and still-lifes. The genre painting of peasants was considered the basest of subjects. Van Gogh, in depicting such subjects, went against the accepted norms of painting in his times, but he took that rebellion much further in that he tried to paint laborers, peasants, and miners as realistically as possible, not scrubbed and dressed as if they were china dolls.

30. L441, 19 December 1885, *Letters* 2:462.

was the foundation of religion. Thus he viewed his guardianship of Sien and her two illegitimate children as entirely consistent with, and indeed a practical application of, his past Christian belief:

> But in really serious things, one must not act according to public opinion, nor according to one's own passions. One must keep to the ABC which is the foundation of every morality. "Love thy neighbor as thyself" — act so that you can answer for it to God.[31]

> Once I nursed for six weeks or two months a poor miserable miner who had been burned. I shared my food for a whole winter with a poor old man, and heaven knows what else, and now there is Sien. But so far I have never thought all this foolish or wrong. . . . I have always believed that "Love thy neighbor as thyself" is no exaggeration, but a normal condition.[32]

Underlying van Gogh's belief in this maxim of Christian morality was his faith in a transcendent, sovereign God guiding humanity. He explained, ". . . man proposes and God disposes. Above our doing the right thing and doing the wrong thing, there is an infinitely powerful force."[33] He illustrates this conviction in one of the most beautiful and moving paintings of the St. Rémy period, *The Good Samaritan* (1890, plate 8).

If van Gogh's religious past continued to inform the ethical dimensions of his art, it also afforded many of the artistic symbols — such as sowers, reapers, and wheatfields — that dominated his oeuvre. These images from the parables of Jesus, with their connotations of death and rebirth, are central in van Gogh's works, *The Sower* (1888, plate 3), painted at Arles, as well as *Wheatfield with a Reaper* (1889, plate 11) and *Crows over the Wheatfield* (1890, plate 12), both of which van Gogh painted during his recuperation from his mental crisis in the asylum at St. Rémy.

His preoccupation with the Bible also continued. Gauguin tells us that "his Dutch brain was afire with the Bible."[34] Rather than dismissing

31. L198, 14 May 1882, *Letters* 1:367.

32. L219, 23 July 1882, *Letters* 1:420.

33. L338, ca. 29 October–15 November 1883, *Letters* 2:196.

34. Quoted in John Rewald, *Post-Impressionism from van Gogh to Gauguin* (New York: The Museum of Modern Art, 1978), 222.

the Bible as a relic of an old, dying religion, he in fact continued to hold it in great esteem, although, consistent with the biblical criticism to which he was exposed during his study with his Uncle Stricker, he esteemed it as a moral guide rather than the inerrant word of God. His painting of the *Still-life with Open Bible,* which art historians have consistently inter-preted as a rejection of van Gogh's former Christian faith, actually reflects his continued respect for the Scriptures.

He continued, moreover, to have the greatest admiration for the person of Jesus. In contemporary novels with antiheroes, such as Zola's Pauline in *La Joie de Vivre* and Hugo's Jean Valjean in *Les Misérables,* he found embodied his notion of the Christ who suffers and sacrifices himself in the service of others. Van Gogh explored new ways to represent the presence of Christ as he sought to become a modern painter, often depicting him as a glowing light or a blazing sun. The color yellow itself often implied a divine presence. Within van Gogh's life as well as his work, one finds a constant tension between preservation of the past and the quest for modernity. While *The Sower* and his numerous paintings of sunflowers and olive groves represent his modern artistic vocabulary in depicting the presence of the divine, his St. Rémy painting of the tortured Christ, languishing in the arms of Mary, represents a return to traditional religious iconography.

As he attempted to broaden his notions of religion, through reading Renan and Tolstoy for example, van Gogh began to experience the infinite more through a mystical union with nature. He did not worship nature, as many have suggested, nor did he view God as equivalent to the creation. Rather than the pantheist some historians such as Kōdera have imagined, van Gogh was more of a panentheist, someone who has a profound expe-rience of the divine through the natural world, but still views God as separate from nature. Van Gogh's God remained the Creator, omnipotent and above his creation, awesome and transcendent. He wrote to Theo: ". . . all Nature seems to speak; and going home, one has the same feeling as when one has finished a book by Victor Hugo, for instance. As for me, I cannot understand why everybody does not see it and feel it; Nature or God does it for everyone who has eyes and ears and a heart to understand. For this reason I think a painter is happy because he is in harmony with Nature as soon as he can express a little of what he sees."[35] Again, in a

35. L248, 26 and 27 November 1882, *Letters* 1:495.

subsequent letter: "What life I think best? Oh, without the least shadow of a doubt it is a life consisting of long years of intercourse with Nature in the country — and something on High — inconceivable, 'awfully unnameable' — for it is impossible to find a name for that which is higher than Nature."[36]

Van Gogh's appreciation of the creation as a revelation of the infinite is less a departure than an extension of his earlier religious belief. The notion that nature is revelatory of the divine was the view of the Dutch mystics, the pietists, the German Romantics, including Schleiermacher, and the followers of the Groningen School. In a letter from 1876, during van Gogh's "evangelical period," Vincent recounted to Theo a mystical experience of nature: "I spent three months on the moors, you know that beautiful region where the soul retires within itself and enjoys a delicious rest, where everything breathes calm and peace, where the soul, in the presence of God's immaculate creation, throws off the yoke of conventions, forgets society and loosens its bonds with the strength of renewed youth; where every thought forms a prayer, where everything that is not in harmony with fresh, free nature disappears from the heart. Oh, there the tired souls find rest, there the exhausted man regains his youthful strength."[37] While he had experienced God through his study of the Bible during his evangelical period, he would now embrace Nature as the mediator of his mystical journey to attain knowledge of the divine.

While van Gogh sought a meaningful experience of faith within a modern context, many of his religious convictions remained fundamentally consistent. He explained to Theo that the basic belief of Christianity could remain constant in him, even though the form of expression might change. He was fond of quoting Hugo's dictum, "Religions pass, but God remains." Schleiermacher argued, similarly, that dogmas, ecclesiastical institutions, and formularies of worship were merely the outward manifestations of religion, not its substance. For van Gogh, adherence to forms often obscured a sense of the infinite, something he believed fundamental to the religious experience. Van Gogh represented such ideas artistically in his sketch of a man saying grace, *Prayer Before the Meal* (1882, fig. 7), and another of a man reading his Bible:

36. L339a, ca. 29 October–15 November 1883, *Letters* 2:204.
37. L76, 9 October 1876, *Letters* 1:69.

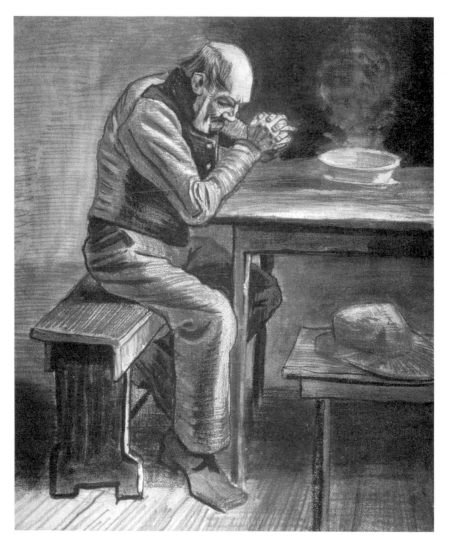

7. Vincent van Gogh, *Prayer Before the Meal,* 1882, pencil, chalk, and ink

I have two new drawings now, one of a man reading his Bible, and the other of a man saying grace before dinner, which is on the table. Both are certainly done in what you may call an old-fashioned sentiment — they are figures like the little old man with his head in his hands [a reference to *At Eternity's Gate*]. The "Benedicte" is, I think, the best,

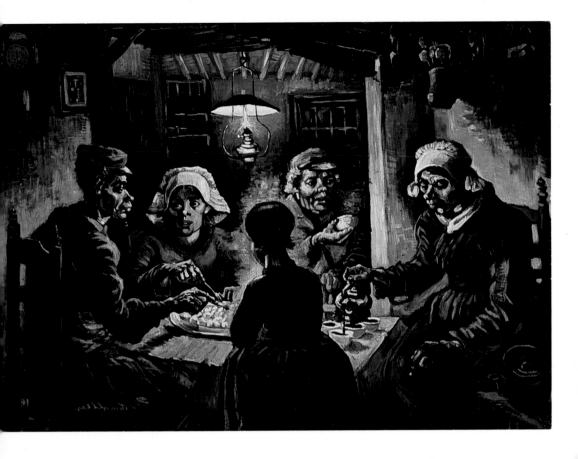

1. Vincent van Gogh, *The Potato Eaters,* 1885, oil on canvas

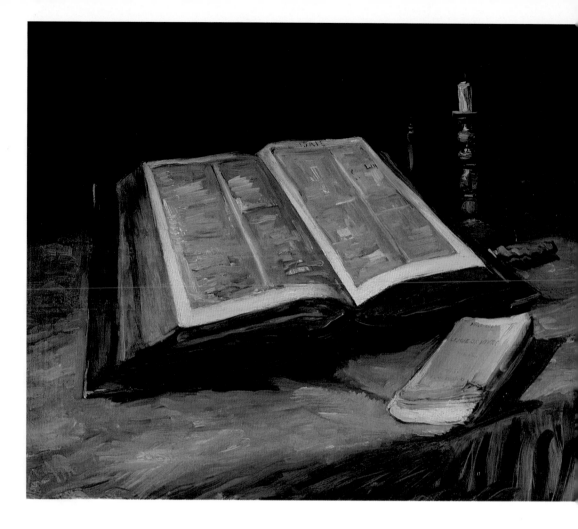

2. Vincent van Gogh, *Still-life with Open Bible,* 1885, oil on canvas

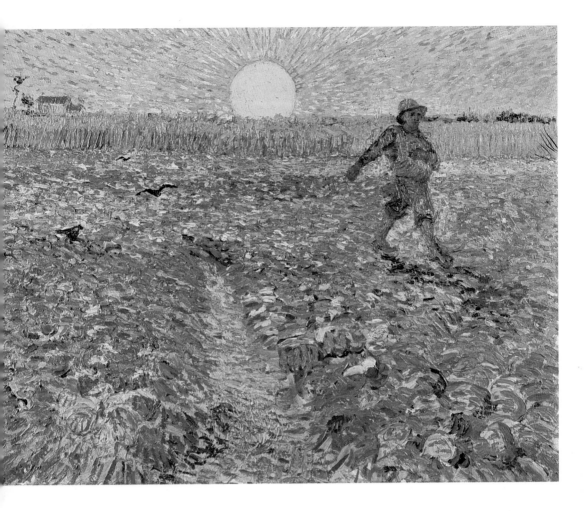

3. Vincent van Gogh, *The Sower,* 1888, oil on canvas

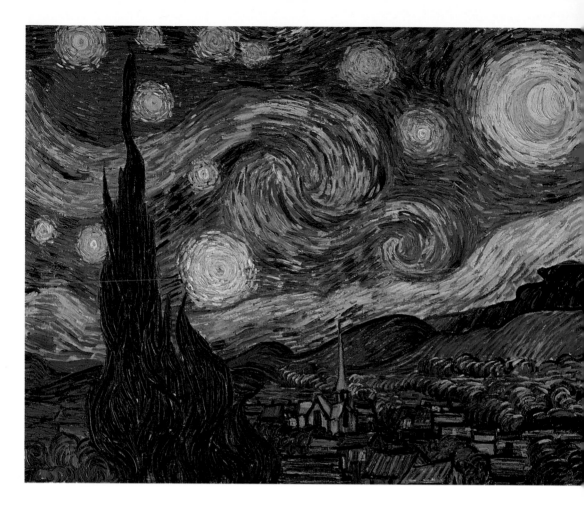

4. Vincent van Gogh, *The Starry Night,* 1889, oil on canvas,
29 × 36 ¼ (73.7 × 92.1 cm.)

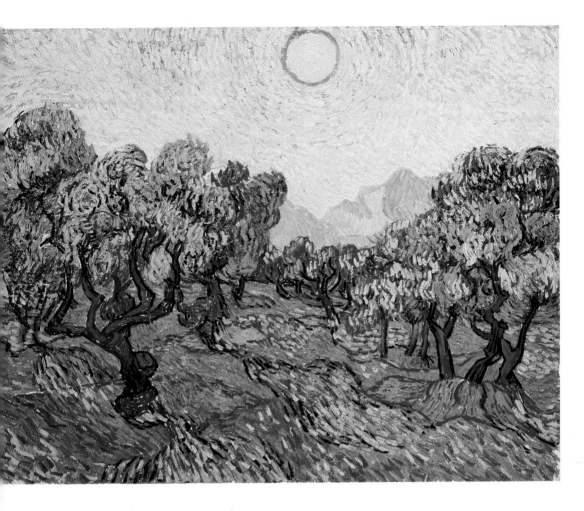

5. Vincent van Gogh, *Olive Trees,* 1889, oil on canvas

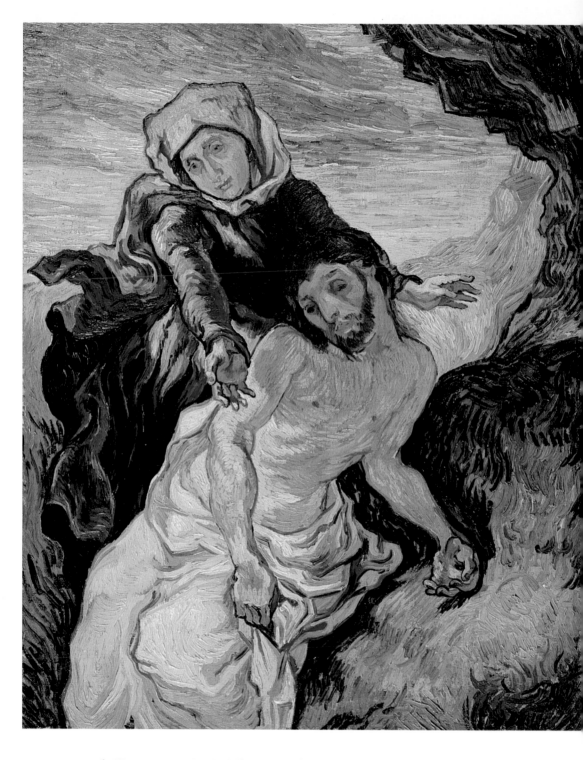

6. Vincent van Gogh, *The Pietà* (after Delacroix), 1889, oil on canvas

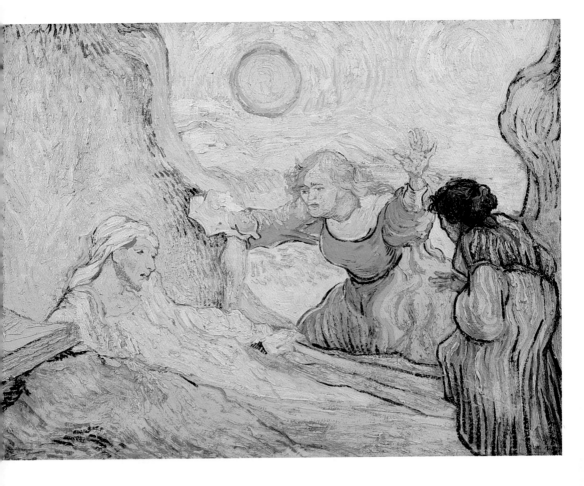

7. Vincent van Gogh, *The Raising of Lazarus* (after Rembrandt), 1890, oil on canvas

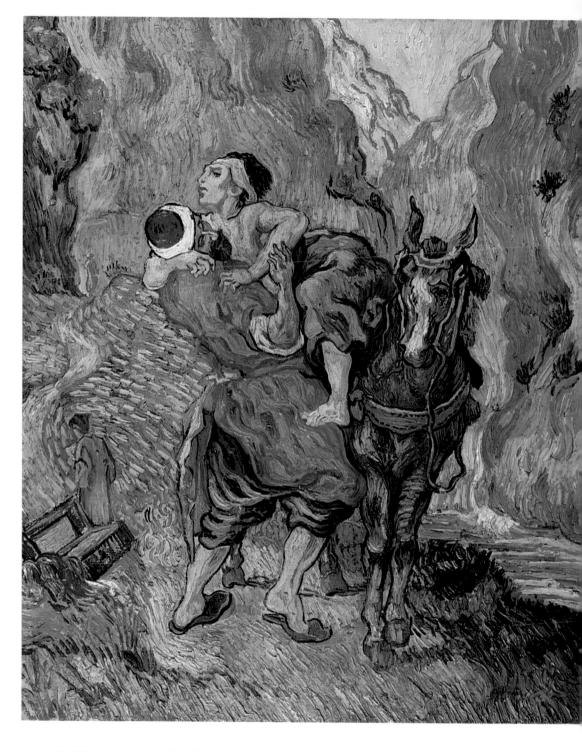

8. Vincent van Gogh, *The Good Samaritan* (after Delacroix), 1890, oil on canvas

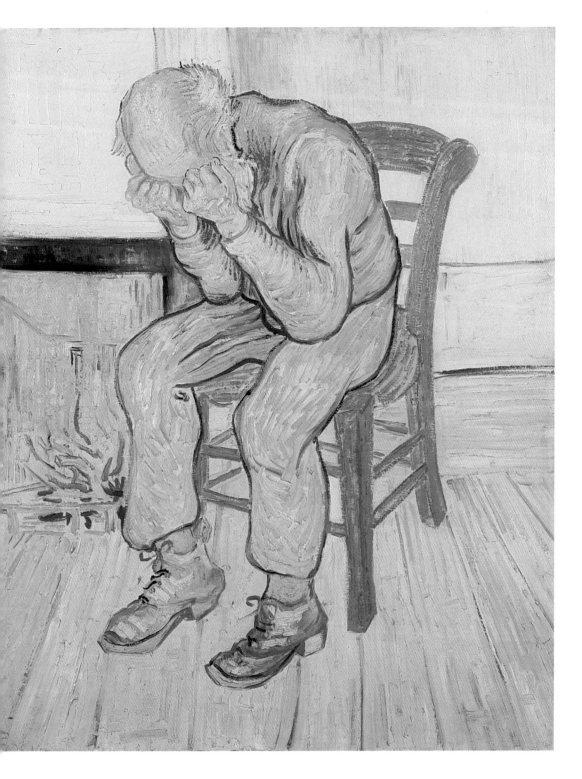

9. Vincent van Gogh, *At Eternity's Gate,* 1890, oil on canvas

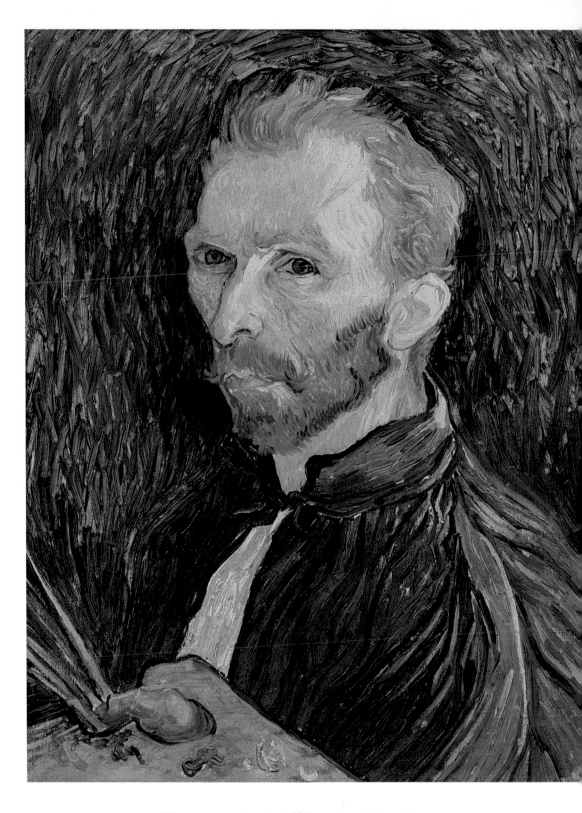

10. Vincent van Gogh, *Self-Portrait,* 1889, oil on canvas

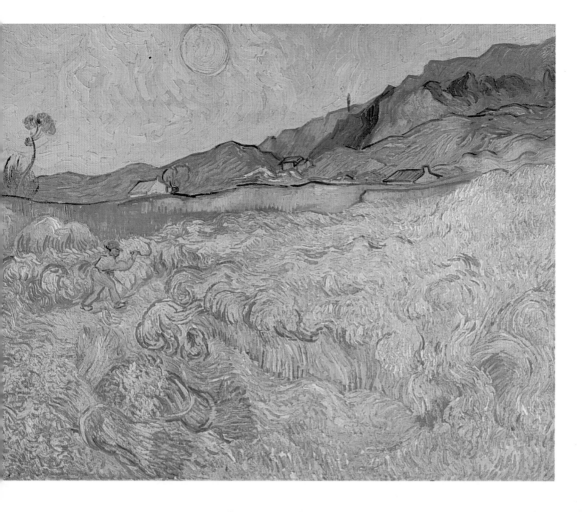

11. Vincent van Gogh, *Wheatfield with a Reaper,* 1889, oil on canvas

12. Vincent van Gogh, *Crows over the Wheatfield*, 1890, oil on canvas

but they complement each other. In one there is a view of the snowy fields through the window. My intention in these two, and in the first little old man, is one and the same — namely to express the peculiar sentiment of Christmas and New Year's. Both in Holland and in England [where van Gogh hoped to sell the prints], this is always more or less religious, in fact it is that way everywhere, at least in Brittany and in Alsace too.

Now one need not exactly agree with the form of that sentiment, but if it is sincere, it is a feeling one must respect. And personally, I can fully share in it and even need it, at least to a certain extent, just the way I have a feeling for such a little old man and a belief in a quelque chose là-haut, even though I am not exactly sure how or what it may be. I think it a splendid saying of Victor Hugo's "les religions passent, mais Dieu demeure" [religions pass away, but God remains] and another beautiful saying of Gavarni's is "Il s'agit de saisir ce qui ne passe pas dans ce qui passe" [what matters is to grasp what does not pass away in what passes away].[38]

While van Gogh acknowledged the many different forms of religious expression outside of worship within the institution of the Church, he still believed the function of religion was to bring healing and consolation. In the face of his own often unspeakable suffering, he still hoped that his pilgrimage toward God would ultimately find its peace in an afterlife. Van Gogh's paintings, *The Raising of Lazarus* (1890, plate 7) and *The Pietà* (1889, plate 6), both deal with themes of suffering and deliverance, while *Starry Night* (1889, plate 4) sums up his religious journey in a triumphant vision of the mystical union with God.

As noted previously, after van Gogh left the Church, he began consciously to distinguish between a "true" and "false" religion, which — following Hugo — he represented, respectively, by a white and a black ray of light: "With an unutterable feeling, I see God, who is the White Ray of Light, who has the Last Word; what is not good through and through is not good at all, and will not last — He, in whose eyes even the Black Ray will have no plausible meaning."[39] He equated the clergy, his father and Uncle Stricker particularly, with this black ray and the

38. L253, ca. 12-18 December 1882, *Letters* 1:513.
39. L337, ca. 29 October–15 November 1883, *Letters* 2:193.

modern spirituality of Millet and Hugo with the white ray of light: "I think what Hugo says so true: Il y a le rayon noir et il y a le rayon blanc [there is a black ray and there is a white ray]. In my opinion, Father has more the rayon noir and Corot has more the rayon blanc, but both have a rayon d'en haut [light from on high]. As to Millet, he is above all others, the man who has this white light. Millet has a gospel, and I ask you, isn't there a difference between a drawing of his and a nice sermon? The sermon becomes black by comparison, even supposing the sermon to be good in itself."[40]

Van Gogh was firmly aware of the turmoil and change going on around him, particularly with regard to religious faith. He explained to Theo, "This one thing remains — faith; one feels instinctively that an enormous number of things are changing and that everything will change. We are living in the last quarter of a century that will end again in a tremendous revolution."[41] Not only was van Gogh convinced of the inevitability of change, but he felt morally responsible to God to help bring it about. "Have no doubt of God's help if you do what God wants you to do, and God wants us in these days to reform the world by reforming morals, by renewing the light and the fire of eternal love. By these means, you will succeed and at the same time, have a good influence on those around you, be the number large or small, according to your circumstance."[42] He turned to many contemporary artists, such as Daubigny and Millet, and writers, such as Hugo and Zola, in his search for a modern faith.[43]

Van Gogh's reading of Ernst Renan's *La Vie de Jésus* (1863) may be seen as a bridge between his life as a Christian minister and his life as an artist. He read it prior to his evangelical conversion and then again after he left the Church. For van Gogh, Renan was the prototype of the modern Christian, a man of faith who, when confronted with the inconsistencies raised by modern biblical criticism as well as the hypocrisy and failures of the institutional Church, left the Church but retained a profound faith in Christ and the message of the Gospel. Consistent both with the Groningen theology of van Gogh's father as well as the modernist aims of Stricker's

40. L326, 22 September 1883, *Letters* 2:150.
41. L451, early February 1886, *Letters* 2:491.
42. L160, 19 November 1881, *Letters* 1:271.
43. L339a, ca. 29 October–15 November 1883, *Letters* 2:206.

Jezus van Nazareth, Renan emphasized the fundamental ground of Christianity in the person of Jesus Christ, but denied his divine origin. Van Gogh's reading of Renan provides a key to his religious experience. He first quoted from Renan in May, 1875, in his last letter written from London, "To act well in this world, one must sacrifice all personal desires. The people who become the missionary of a religious thought have no other fatherland than this thought. Man is not on this earth to be merely happy, nor even to be simply honest. He is there to realize great things for humanity, to attain nobility and to surmount the vulgarity of nearly every individual."[44] In a letter written from Paris, dated October 11, 1875, during his "evangelical period," just a few months after he quoted Renan with admiration, he had a complete reversal, reminding Theo once again to destroy his modern literature. "Have you done as I suggested and destroyed your books by Michelet, Renan etc.? I think that will give you rest."[45] Later, van Gogh reversed himself once again, reverting to his prior esteem for Renan. In a letter written from Arles in 1889, van Gogh embraced Renan's idea of Christ, contrasting it with the false Christ which he believed the Church preached. "Isn't Renan's Christ a thousand times more comforting than so many papier mâché Christs that they serve up to you in the Duvall establishments called Protestant, Roman Catholic or something or other churches?"[46]

His renewed interest in Renan reflects his rejection of the fundamentalist notions of his evangelical period, but also his bitterness toward church and clergy, which characterized his spirituality after 1880:

> I haven't reread the excellent books by Renan, but how often I think of them here, where we have olive trees and other characteristic plants, and the blue sky. . . . Oh, how right Renan is, and how beautiful that work of his, in which he speaks to us in a French that nobody else speaks. A French that contains, in the sound of the words, the blue sky and the soft rustling of the olive trees, and finally a thousand true and explanatory things which give his History the character of a Resurrection. One of the saddest things I know is that prejudice of people who in their self-conceit oppose so many good and beautiful things which were

44. L26, 8 May 1875, *Letters* 1:26.
45. L42, 11 October 1875, *Letters* 1:41.
46. L587, 25-28 April 1889, *Letters* 3:158.

created in our own time. Ah, the eternal "ignorance," the eternal mis-
understandings — and how much good it does one to come across a
word which is really serene. . . .[47]

Van Gogh employed the intense blue of the sky as a symbol of the divine
and infinite presence, particularly in his masterpiece, *Starry Night,* as well
as the olive tree, which symbolized the presence of Jesus Christ in the
many paintings depicting groves of olive trees from his St. Rémy period.

If Kempis and Bunyan formed the foundation of van Gogh's
devotional reading prior to 1880, Renan's *La Vie de Jésus,* in many ways,
was his modern devotional text after 1880. Van Gogh's anti-clericalism,
religious asceticism, understanding of Christian ethics, and notion of the
kingdom of God, as well as his admiration for the person of Jesus Christ,
are all prevalent themes in Renan's *La Vie de Jésus.* Van Gogh found in
Renan a kindred spirit, someone who had, like him, left the Church, but
had not abandoned his faith.

Renan's idea that true religion has nothing to do with external form,
but must be based on purity of heart, echoes van Gogh's own simple piety
as well as his disgust with the clergy and institution of the Church:

> Never has anyone been less a priest than Jesus, never a greater enemy
> of forms, which stifle religion under the pretext of protecting it. By
> this, we are all his disciples and his successors; by this he has laid the
> eternal foundation-stone of true religion; and if religion is essential to
> humanity, he has by this deserved the Divine rank the world has ac-
> corded to him. An absolutely new idea, the idea of a worship founded
> on purity of heart, and on human brotherhood, through him entered
> into the world — an idea so elevated that the Christian Church ought
> to make it its distinguishing feature, but an idea which in our days only
> few minds are capable of embodying.[48]

Like van Gogh, Renan defined Christianity in terms of the example and
teachings of Jesus, disregarding the orthodox proclamations of the Church.
"Whatever may be the transformations of dogma, Jesus will ever be the
creator of the pure religion; the Sermon on the Mount will never be

47. WII, 30 April 1889, *Letters* 3:451.
48. Ernst Renan, *The Life of Jesus* (New York: Carlton House, 1927), 132.

82

surpassed. Whatever revolution takes place will not prevent us from attaching ourselves in religion to the grand intellectual and moral line at the head of which shines the name of Jesus. In this sense, we are Christians, even if we separate ourselves on almost all points from the Christian tradition which has preceded us."[49]

For van Gogh as well as Renan, the essence of religion is piety and praxis, a simple faith based on the life of Jesus, and the practice of Christian charity and brotherhood. As Renan wrote, "In morals, as in art, precept is nothing, practice is everything."[50] "Jesus despised all religion which was not of the heart. The love of God, charity and mutual forgiveness, were his whole law. Nothing could be less priestly."[51]

One of the most striking parallels between van Gogh's idea of Christian faith and Renan's is the emphasis on extreme asceticism and self-abnegation, based on the imitation of Christ. Renan pointed out, "The first condition of becoming a disciple of Jesus was to sell one's property and to give the price of it to the poor. Those who recoiled from this extremity were not admitted into the community."[52] Van Gogh must have taken comfort in Jesus' admonition to hate one's father and mother, and even one's own life for the sake of discipleship, since his own quest for Christian perfection had created great discord within his family. Renan points out the utter extreme to which Jesus had taken this ideal. "There was at such times, something strange and more than human in His words; they were like a fire utterly consuming life, and reducing everything to a frightful wilderness. The harsh and gloomy feeling of distaste for the world, and of excessive self-abnegation which characterizes Christian perfection. . . . We should almost say that, in these moments of conflict with the most legitimate cravings of the heart, Jesus had forgotten the pleasure of living, of loving, of seeing, and of feeling."[53] Renan explains that such a rigid standard was impossible for most Christians, but monasticism created a place for the Christian who chose this path to realize, as much as possible, the Christian ideal of self-denial and personal holiness. In one of van Gogh's best-known self-portraits, he depicted himself with the shaven head of an ashen monk. "I have in the first place aimed at the

49. Ibid., 385.
50. Ibid., 134.
51. Ibid., 227.
52. Ibid., 190.
53. Ibid., 288.

character of a simple bonze worshiping the Eternal Buddha," he explained to Gauguin, for whom he had painted the portrait.[54] It was the simple ascetic spirituality of the monk van Gogh admired, not Buddhism as such. In reality, van Gogh knew almost nothing about Buddhism, except for what he read about the Orient in popular nineteenth-century novels, such as *Madame Chrysanthème*.

Perhaps most compelling for van Gogh in his reading of *La Vie de Jésus* was Renan's notion that the Christian ideal was so extreme and difficult to follow that anyone who chose the imitatio Christi would be despised by society and rejected as insane. Renan wrote, "Which of us . . . could do what the extravagant Francis d'Assisi or the hysterical saint Theresa has done? Let medicine have names to express these grand errors of human nature. . . . The narrow ideas which are spread in our times respecting madness, mislead our historical judgments in the most serious manner, in questions of this kind. A state in which a man says things of which he is not conscious, in which thought is produced without the summons and control of the will, exposes him to being confined as a lunatic. Formerly, this was called prophecy and inspiration." Renan's words "exposes him to being confined as a lunatic" must have struck van Gogh with particular poignancy, in the light of his father's wish to have him confined to the madhouse at Gheel for the excesses of his vision of Christian humility.

For both Renan and van Gogh, the notion of the kingdom of God implied a separated community of the faithful, characterized by humility and simple piety. In effect, one cannot be both of the world and of the kingdom. As Renan explained, "The foundation of the Kingdom of God are the simple, not the rich, not the learned, not priests; but women, common people, the humble and the young. . . . The idea which has made 'Christian' the antithesis of 'worldly' has its full justification in the thoughts of the Master."[55]

Both Renan and van Gogh expected that the establishment of the kingdom of God would involve a violent upheaval, a moral revolution. As Renan wrote:

> The reign of goodness will have its turn. The advent of this reign of goodness will be a great and sudden revolution. The world will seem

54. L544a, 3 October 1888, *Letters* 3:64.
55. Renan, *The Life of Jesus*, 159.

to be turned upside down. . . . The germ of this great revolution will not be recognizable in its beginning. It will be like a grain of mustard-seed, which is the smallest of seeds, but which thrown into the earth, becomes a tree under the foliage of which the birds repose; or it will be like the leaven which, deposited in the meal, makes the whole to ferment. A series of parables, often obscure, was designed to express the suddenness of this event, its apparent injustice, and its inevitable and final character.[56]

Van Gogh believed that the revolution of humanity was imminent and that the survival of religion would depend on the ability of individuals of faith to recover the original truth of Christianity. He wrote to Theo, "Victor Hugo says, 'God is an occulting lighthouse' (the French call it an eclipsing lighthouse), and if this should be the case, we are passing through the eclipse now."[57]

The same type of message came from his reading of Tolstoy, as he noted in a letter to Theo: "It seems that in the book, *My Religion*, Tolstoy implies that whatever happens in the way of a violent revolution, there will also be a private and secret revolution in men, from which a new religion will be born, or rather something altogether new, which will have no name, but which will have the same effect of comforting, of making life possible, which the Christian religion used to have."[58]

While Renan emphasized the "modern revolution" and the kingdom of God on earth and rejected the supernatural in religion, he never abandoned his notion of an afterlife. In fact, for Renan, such a belief in eventual eternal bliss was fundamental to Christian notions of morality. If God is just, he argued, then he cannot allow the virtuous to simply perish. Without the promise of an afterlife, the arduous journey of the Christian seeking to imitate the Lord is an impossible imposition without compensation. Both Renan and van Gogh believed that suffering had a purpose and virtue must ultimately find its reward.[59] The tension between these two aspects of van Gogh's religious journey, his continuity with the past, apparent in his tenacious belief in an afterlife, and his hunger for a

56. Ibid., 150.
57. L543, 29 September 1888, *Letters* 3:57.
58. L542, 25 and 26 September 1888, Letters 3:52.
59. Herman Brauer, *Bulletin of the University of Wisconsin,* vol. 2, *The Philosophy of Ernst Renan* (Madison: University of Wisconsin, 1903), 251.

meaningful modern faith, apparent in his hope for a revolution to bring about the kingdom of God on earth, was at the heart of his artistic vision.

Belief in a "life beyond the grave" is central to one of van Gogh's first accomplished lithographs, *At Eternity's Gate* (1882, fig. 8). Executed at the Hague in 1882, it depicts an old man seated by a fire, his head buried in his hands. Near the end of his life, van Gogh recreated this image in oil, while recuperating in the asylum at St. Rémy. Bent over with his fists clenched against a face hidden in utter frustration, the subject appears engulfed in grief. Certainly, the work would convey an image of total despair had it not been for the English title van Gogh gave it, *At Eternity's Gate*.[60] It demonstrates that even in his deepest moments of sorrow and pain, van Gogh clung to a faith in God and eternity, which he tried to express in his work:

> . . . There is something noble, something great, which cannot be destined for the worms. . . . This is far from all theology, simply the fact that the poorest little woodcutter or peasant on the hearth or miner can have moments of emotion and inspiration that give him a feeling of an eternal home, and of being close to it.[61]

As van Gogh pointed out, the sentiment in this painting is "far from all theology." He nevertheless wanted to show that, although he had rejected the dogma of the institutional religion of his past, he remained profoundly religious and firmly believed in a spiritual life after death. Van Gogh saw in the care-worn, unkempt old man of *At Eternity's Gate* a soul at the end of his earthly journey, on the edge of immortality.

Whether an elderly man sitting by the fire, or peasants digging, sowing, and harvesting in the fields, or a simple frugal meal, van Gogh's depictions of peasants are often imbued with a numinous quality, a sense of the divine presence. The most important work of van Gogh's Dutch period, *The Potato Eaters* (1885, plate 1) shows van Gogh's continued respect for the simple piety of the peasants, which he had also admired in the Borinage. Here, van Gogh tried to depict the spiritual quality of labor in the ritualistic sharing of a meal, under the light of a glowing lantern.

60. Van Gogh gave this print an English title because he was expecting Theo to sell it to an English-speaking buyer.
61. L248, 26 and 27 December 1882, *Letters* 1:495.

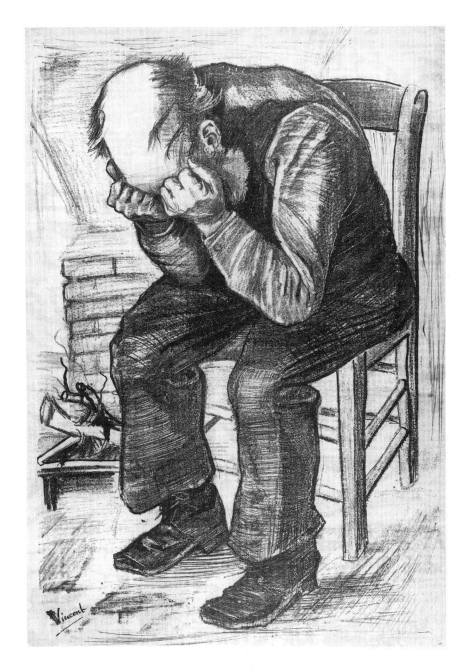

8. Vincent van Gogh, *At Eternity's Gate,* 1882, lithograph

It was a painting on which he concentrated a great deal of artistic effort, preparing head studies for months prior to final execution. It was the first painting which he himself considered a finished work and not merely a preparatory study. Although panned by other artists, particularly van Rappard, *The Potato Eaters* remained one of van Gogh's favorite works throughout his life. In the history of Dutch painting, it remains a landmark, which many consider to be the first truly realistic peasant painting in western art. This was van Gogh's intent, as he explained at length in an oft-quoted passage:

> I have tried to emphasize that those people eating their potatoes in the lamplight, have dug the earth with those very hands they put in the dish, and so it speaks of *manual labor,* and how they have honestly earned their food.
>
> . . . We must continue to give something real and honest. Painting peasant life is a serious thing, and I should reproach myself if I did not try to make pictures which will rouse serious thoughts in those who think seriously about art and about life.[62]

The Potato Eaters depicts a family crowded around a small table, sharing a simple meal of potatoes and coffee by the dim light of a lamp burning overhead. Van Gogh wrote that he had painted the figures in the dark colors of a "very dusty, unpeeled potato."[63] The mood of the painting is deeply somber and the sharing of their meager repast suggests the sacred and solemn sharing of the sacramental elements of bread and wine in a eucharistic observance.

The association of religious themes with the sharing of food was common in the realist art of the nineteenth century, such as the Dutch painter, Jozef Israëls' *Frugal Meal* (1876). It was an attempt to show that the sacred, depicted in the most mundane acts of human experience, conveyed the presence of the divine with far more poignancy than the traditional subjects of cross and cathedral. Van Gogh's artistic allusion to the eucharist, however, and the primitive simplicity of the peasants sharing a meal has heightened significance. While the Church, the New Testament canon, the sacrament of baptism, the priesthood, and Christian dogma were all insti-

62. L404, 30 April 1885, *Letters* 2:370-71.
63. L405, May 1885, *Letters* 2:372.

tuted after the death of Jesus, the eucharist was the one rite inaugurated by Christ himself. Van Gogh's notion of the pristine quality of the eucharist came through Renan, who wrote, "Had the sect [Christianity] no sacrament, no rite, no sign of union? It had one which all tradition ascribes to Jesus. One of the favorite ideas of the Master was that he was the new bread, bread very superior to manna, and on which mankind was to live."[64] The potatoes in van Gogh's painting, which resemble small, rounded loaves of bread passed from one individual to the next, recall the simple piety of the early Christians "gathered together in his name," to "break bread." Their simple meal is an indirect reference to the presence of the divine, paralleling the overt reference of the somber crucifix hanging on the darkened wall.

Rather than pointing to the unity and brotherhood of the early Christian community, however, *The Potato Eaters* speaks more to the modern experience of faith, van Gogh's own experience of separation and solitude. The figures do not engage each other, as if in conversation, but seem preoccupied with the act of serving the meal. The man seated in the chair which bears van Gogh's signature, "Vincent," stares into infinity with an expression of profound loneliness. The painting might seem rather discordant except for its one unifying element, the lamp, with its warm glow piercing the atmosphere of isolation. The lamp, with its yellow light, was van Gogh's symbol of love and recalls the light of the Gospel which both he and his father had brought into the huts of peasants and miners. One is reminded of Vincent's description of his father as one "who so often goes long distances, even in the night with a lantern, to visit a sick or dying man, to speak with him about One whose Word is a light, even in the night of suffering and agony."[65] In *The Potato Eaters,* the lamp represents the "Ray of Light from On High," such as van Gogh saw in the literature of Victor Hugo and the paintings of Corot and Millet. With its symbols of bread and the light, then, *The Potato Eaters* attempts to depict the presence of Christ with a more modern artistic vocabulary.

In the other major work of van Gogh's Dutch period, *Still-life with Open Bible* (1885, plate 2), van Gogh continues to be concerned with the tension between tradition and modernity. The painting depicts a large family Bible, open to Isaiah 53, juxtaposed to a small, tattered copy of Emile Zola's *La Joie de Vivre,* with a snuffed out candlestick in the back-

64. Renan, *The Life of Jesus,* 280.
65. L110, 18 September 1877, *Letters* 1:140.

ground. The extinguished candle is a typical memento mori (symbol of death) of the seventeenth-century Dutch vanitas tradition, which emphasized the fleeting nature of human existence. Because van Gogh's father, Theodorus, died suddenly on March 26, 1885, virtually all critics of this painting view it as a type of memorial to Theodorus. Recently, Father van Gogh's Bible was discovered; its clasp is identical to the Bible van Gogh painted and it also shows considerable wear throughout the book of Isaiah.[66] When van Gogh sent the Bible to Theo, he wrote, "I enclose the book by Ch. Blanc in the box with the studies, also a Bible which those at home gave me for you, of which I painted the still life."[67]

The Bible in the still life does not read "Jesaija," the Dutch word for Isaiah, but the French "Isaie," which van Gogh apparently changed intentionally to appeal to potential Parisian buyers whom Theo would solicit.[68] While this could have been Theodorus' Bible, we do not know that it was, nor does van Gogh ever imply that this painting was intended to be a memorial to his father. Yet, virtually all of the interpretations of this work are based on this assumption. Van Gogh did, however, paint a still-life in memory of his father, depicting his father's pipe and tobacco pouch in front of a vase of honesty. This is far more sympathetic than the *Still-life with Open Bible* that many have viewed as a condemnation of his father. A recent critique of *Still-life with Open Bible,* in the catalogue of the 1990 exhibit of van Gogh's paintings in Amsterdam, continues the traditional view that van Gogh painted it as a criticism of his father.

> Shortly after his death, feelings of piety had prompted Vincent to add his father's pipe and tobacco pouch to a still-life with a vase of honesty. Now, however, he felt free to criticize his father by clearly contrasting the Bible, which stands for the latter's traditional faith, with Zola's *La Joie de Vivre.* . . .[69]

66. The Bible, which is thought to be the Bible from which the Rev. Theodorus van Gogh preached, bears the hand-written inscription, "Johannes Duyser, Predikant te Helvoirt; Ths. van Gogh, Laast Predikant te Neunen 1885." It had been owned by the Remonstrant Community, with which the van Gogh family had always sympathized, in Leiden. See Louis van Tilborgh, "De Bijbel van Vincent's vader," *Van Gogh Bulletin* 3 (1988) [publication of the Rijksmuseum Vincent van Gogh].

67. L430, early November 1885, *Letters* 2:430.

68. Jan Hulsker, *The Complete van Gogh* (New York: Harry N. Abrams, 1980), 206.

69. Evert van Uitert, Louis van Tilborgh, Sjraar van Heugten, *Paintings, Vincent van Gogh* (Milan: Arnoldo Mondadori Arte and Rome: De Luca Edizioni D'Arte, 1990), 54.

Yet, there is nothing to suggest, either in the painting itself, or in van Gogh's letters, that this was his intention. When he described the painting to Theo he wrote, "In answer to your description of the study by Manet, I send you a still-life of an open — so a broken white — Bible bound in leather, against a black background, with yellow-brown foreground, with a touch of citron yellow. I painted that in one rush, in one day."[70] Van Gogh's reference to Manet was to Manet's use of color in his painting of the dead toreador, particularly the use of black and white. This is his only recorded comment on the painting.

Rather than a criticism of Theodorus and a rejection of the Bible in favor of French naturalist literature, *Still-life with Open Bible* is a symbolic representation of the reconciliation between van Gogh's traditional Christian past and his present interest in modern literature. It does not depict a substitution of literature for the Bible, but the supplementation of the Bible with literature. If van Gogh had intended a reference to his father, it was most likely a reference to his attempts to open Theodorus' eyes to the value of modern literature in conjunction with the Bible. In this, he was never successful, since both of his parents vehemently objected to modern French literature, as Vincent had explained to Theo: "But Father and Mother are getting old, and they have prejudices and old-fashioned ideas which neither you nor I can share anymore. When Father sees me with a French book by Michelet or Victor Hugo, he thinks of thieves and murderers, or of 'immorality'; but it is too ridiculous, and of course, I do not let myself be disturbed by such opinions. So often I have said to Father, 'Then just read it, even a few pages of such a book, and you will be impressed yourself;' but Father obstinately refuses."[71] In the same letter in which Theodorus had complained to Theo of Vincent's "choice" of poverty, his mother had added a note concerning Vincent's literary tastes. Apparently, Vincent had sent them one of the books he was currently reading, probably Victor Hugo's *Les Misérables,* in an attempt to show them the value of modern literature. His mother was unimpressed with Hugo, declaring, "but if reading books gives such practical results, can it then be called right? and for the rest, what kind of ideas his reading gives him. He sent us a book by Victor Hugo, but that man takes the side of the criminals and doesn't call bad what really is bad. What would the world

70. L429, October 1885, *Letters* 2:429.
71. L159, 18 November 1881, *Letters* 1:268.

look like if one calls the evil good? Even with the best of intentions, that cannot be accepted."[72]

Long after van Gogh had established a life as an artist, living on his own, he continued to be deeply hurt by the crisis with his father that had led him to leave home, and continued to associate the unfortunate incident with his disdain for clerical hypocrisy. In a letter written in December, 1883, he explained to Theo:

> Now to revert to the fact that I told Father it was wrong that two years ago we quarreled so violently that I was locked out of the house afterward. . . . and what does father say to this? — "Yes, but I cannot take back anything of what I did then; what I have done I have always done for your good, and I have always followed my sincere convictions." To this I replied that it may happen that a person's conviction is at complete variance with conscience; I mean what one thinks one should do may be diametrically opposed to what one ought to do.
>
> I told Father that in the Bible itself maxims can be found by which we may test our "convictions," to see whether they are reasonable and just.
>
> . . . There is no need for Father to say that he committed an error in my case, but Father should have learned what I learned in these two years — that it was an error in itself, and that it should be rectified immediately, without raising the question of whose fault it was. Look, brother, in my opinion, Father is forever lapsing into narrow-mindedness, instead of being bigger, more liberal, broader and more humane. It was clergyman's vanity that carried things to extremes at the time; and it is still that same clergyman's vanity which will cause more disasters now and in the future.[73]

While van Gogh continued to study the Bible and hold it in high esteem, he no longer believed that it alone would suffice as a guide to daily living. This was a departure from his thought when he was a missionary as well as a rejection of his father's orthodoxy. Although the Groningen School was unorthodox in many of its beliefs, it maintained the inerrancy of scripture, as Vincent himself did during his "evangelical period." *Still-life*

72. Quoted in Hulsker, *Vincent and Theo*, 85.
73. L345a, 7-8 December 1883, *Letters* 2:230.

with Open Bible may represent van Gogh's attempt to reconcile the Bible with contemporary literature, in order to make it more applicable to life in a modern society. He explained his concern to Theo, "I too read the Bible occasionally, just as I read Michelet or Balzac or Eliot; but I see quite different things in the Bible than Father does, and I cannot find at all what Father draws from it in his academic way."[74] In explaining his "passion for books" to Theo, he mentioned the Bible first in the list of literary works he was currently reading. In another letter, written shortly thereafter, van Gogh explained how he combined his interest in modern literature with his reading of the Bible:

> The Bible consists of different parts and there is growth from one to the next; for instance, there is a difference between Moses and Noah on the one hand, and Jesus and Paul on the other. Now take Michelet and Beecher Stowe: they don't tell you the Gospel is no longer of any value, but they show how it may be applied in our time, in this our life, by you and me for instance. Michelet even expresses completely and aloud things which the Gospel whispers only a germ of.[75]

Earlier in the same letter he stated that the Bible is "eternal and everlasting," and that the Gospel still has value if it is applied properly to the concerns of modern society. Six years later, in a letter written to his sister Wilhelmina, van Gogh still expressed the same notion, and spoke of his reading of the French naturalists, including Zola, as a supplement to the foundation he gained from reading the Bible.

> The work of the French naturalists, Zola, Flaubert, Guy de Maupassant, de Goncourt . . . is magnificent. . . . Is the Bible enough for us? In these days, I believe Jesus himself would say to those who sit down in a state of melancholy, It is not here, get up and go forth. Why do you seek the living among the dead?
>
> If the spoken or written word is to remain the light of the world, then it is our right and our duty to acknowledge that we are living in a period when it should be spoken and written in such a way that — in order to find something equally great, and equally good, and equally

74. L164, 21 December 1881, *Letters* 1:283.
75. L161, 23 November 1881, *Letters* 1:274.

original, and equally powerful to revolutionize the whole of society — we may compare it with a clear conscience to the old revolution of the Christians.

I myself am always glad that I have read the Bible more thoroughly than many people nowadays, because it eases my mind somewhat to know that there were once such lofty ideas.[76]

The juxtaposition of the Bible and Zola's novel in van Gogh's *Still-life with Open Bible* clearly implies a connection between the suffering servant of Isaiah and the protagonist of *La Joie de Vivre.* Virtually all of van Gogh's biographers have ignored this correlation. The passage to which the Bible in the painting, *Still-life with Open Bible,* is open is the familiar Isaiah 53:3-5, read by Christians as foretelling the suffering of Christ as the sacrificial lamb:

> He was despised and rejected by men; a man of sorrows and acquainted with grief, and as one from whom men hide their faces, he was despised, and we esteemed him not. Surely, he has borne our griefs and carried our sorrows, yet we esteemed him stricken, smitten by God, and afflicted. But he was wounded for our transgressions, he was bruised for our iniquities; upon him was the chastisement that made us whole, and with his stripes, we are healed.

This text recalls the Bible lesson that van Gogh had taught the coal miners as a Christian missionary in the Borinage: "Jesus Christ is the Master who can comfort and strengthen a man, a laborer and working man whose life is hard — because he is the great man of sorrows who knows our ills . . . and God wills that in imitation of Christ, man should live humbly and go through life not reaching for the sky, but adapting himself to the earth below, learning from the Gospel to be meek and simple of heart."[77]

It was this suffering and sorrowing Jesus that van Gogh admired, even as an artist. In 1884, he wrote, "Oh, I am no friend of the present Christianity, though its founder was sublime."[78] He described Jesus as

76. W1, summer or fall 1887, *Letters* 3:426.
77. L127, 26 December 1878, *Letters* 1:184.
78. L378, October 1884, *Letters* 2:309.

"the supreme artist, more of an artist than all others, disdaining marble and clay and color, working in the living flesh."[79] Long after leaving the Church, Vincent wrote to his brother of his continued respect for Jesus: "First, he was an ordinary carpenter, but raised himself to something else, whatever it may have been — a personality so full of pity, love, goodness, seriousness, that one is still attracted by it."[80] Van Gogh's own attraction to Jesus was evident in his tendency to artistic imitatio Christi; he depicted the crucified Christ with the red hair and beard characteristic of his self-portraits in two of the religious paintings of the St. Rémy period, *The Pietà* and *The Raising of Lazarus*.

Pauline, the protagonist of the Zola novel depicted in *Still-life with Open Bible,* reflects the same values that van Gogh admired in Christ, charity and concern for the poor, patience and perseverance in the face of insurmountable grief and pain, and a heart full of "pity, love, and goodness." Much like Jean Valjean, the hero of Hugo's *Les Misérables,* another of van Gogh's cherished modern French novels, Pauline is a kind of modern Christ figure. Van Gogh's juxtaposition of Isaiah 53, which describes the "man of sorrows, acquainted with grief," with Zola's novel, ironically titled *La Joie de Vivre,* actually expresses the continuity of his religious values. Having abandoned the institutional Church, he was seeking a new form, a modern context in which to express these values in a more meaningful way.

In one of his most colorful "peasant paintings," *The Sower* of 1888 (plate 3), van Gogh represented the cycle of death and rebirth in imagery drawn from his early religious instruction on the kingdom of God. We know from a letter written to his closest friend, the artist Emile Bernard, that van Gogh associated the sowing and harvesting of wheat with religious symbols of his past. He saw in these simple icons, reflecting the routines of bucolic life, prototypes of the infinite. We are reminded of van Gogh's recollections to Emile Bernard of his youth in rural Holland: ". . . I won't hide from you that I do not dislike the country, having been brought up there — gusts of memories of former times, aspirations toward the Infinite of which the sower, the sheaf are the symbols still enchanting me, as formerly."[81]

79. B8, 23 June 1888, *Letters* 3:496.
80. L306, 27 July 1883, *Letters* 2:94.
81. B7, ca. 18 June 1888, *Letters* 3:492.

The image of the sower, from one of the most familiar of Jesus' parables of the kingdom of God, came to van Gogh from the biblical teaching of his childhood, from Stricker's *Jezus van Nazareth,* and doubtless from other sources as well. As recorded in the Gospel of Mark itself:

> A sower went out to sow. As he sowed, some seed fell along the path, and the birds came and devoured it. Other seed fell on rocky ground, where it had not much soil, and immediately it sprang up, since it had no depth of soil; and when the sun rose it was scorched, and since it had no root it withered away. Other seed fell among thorns and the thorns grew up and choked it, and it yielded no grain. And other seeds fell into good soil and brought forth grain, growing up and increasing and yielding thirtyfold, and sixtyfold and a hundredfold (Mark 4:3-8).

On his print, *Funeral Procession in the Wheatfield,* a lithograph of J. J. van der Maaten's painting, which van Gogh had given to Mendes da Costa, the following inscription appears:

> The Kingdom of God is as if a man should scatter seed upon the ground, and should sleep and rise night and day, and the seed should sprout and grow he knows not how. The earth produces of itself, first the blade, then the ear, then the full grain in the ear. But when the grain is ripe, at once he puts in the sickle because the harvest has come (Mark 4:26-29).

Van Gogh was living in a tempestuous time and in a society which he believed was on the verge of a spiritual revolution that would leave the traditional form of Christianity behind. The notion of establishing a new society, with the basic sentiment of Christianity and the teachings of Jesus intact, reflects van Gogh's continued belief in the possibility of realizing a utopic kingdom of God. As he had taught in his Bible lessons, "One does not expect to get from life what one has already learned it cannot give; rather, one begins to see more clearly that life is only a kind of sowing time, and the harvest is not here."[82]

The notion of laboring and struggling for the kingdom of God is apparent also in van Gogh's renditions of diggers and plowmen. Van Gogh

82. L265, 8 February 1883, *Letters* 1:537.

drew from Jesus' saying, "No man having put his hand to the plow, and looking back, is fit for the Kingdom of God" (Luke 9:62). The digger and the plowman are further examples of the way in which van Gogh employed symbols of agricultural labor to represent the Christian notion of the struggle to realize the kingdom of God. Such symbols are tied to the symbol of the wheat: whether in the form of fields of ripening wheat or sheaves of harvested wheat, it is an image which dominated van Gogh's oeuvre from its inception until the end of his life.

The color yellow features very prominently in van Gogh's depictions of sowing and harvesting. In his painting, *The Sower*, van Gogh explained his intention of representing the presence of Christ through the symbolic use of color, particularly a golden citron-yellow:

> This is the point. *The Christ in the Boat* [*Christ Asleep During the Tempest*] by Eugène Delacroix and Millet's *Sower* are absolutely different in execution. *The Christ in the Boat* — I am speaking of the sketch in blue and green with touches of violet, red and a little citron-yellow for the nimbus, the halo speaks a symbolic language through color alone. Millet's *Sower* is a colorless gray, like Israëls' pictures. Now, could you paint the sower in color, with a simultaneous contrast of, for instance, yellow and violet?[83]

After van Gogh's Dutch period, he became increasingly concerned with the problem of color, particularly with lightening his palette. During the one and a half years he spent working in Paris, he had developed a vibrant and dynamic palette. The paintings of the Arles period, of which *The Sower* is a magnificent example, reflects this change in van Gogh's work. Van Gogh had based his new use of brilliant color on Delacroix's theory of primary and complementary colors.

> So in accordance with antiquity it must be acknowledged that there are only three colors which are truly elementary in nature, and which, when they are mixed two at a time, produce three more composite colors which may be called secondary, to wit: orange, green, and violet.
>
> These rudiments, developed by modern scientists, have led to the conjecture of certain laws that form an illuminating theory of colors, a

83. L503, 28 June 1888, *Letters* 2:597.

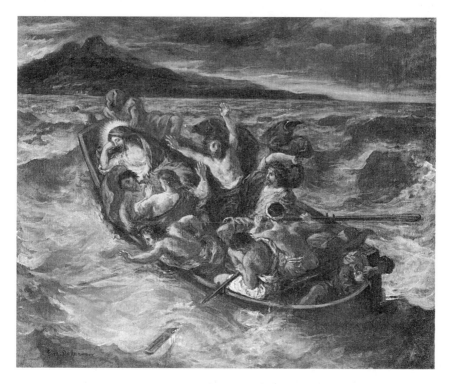

9. Eugène Delacroix, *Christ Asleep During the Tempest,*
ca. 1854, oil on canvas

theory which Eugène Delacroix commanded scientifically and thor-
oughly, after grasping it instinctively. If one combines two of the pri-
mary colors, for instance yellow and red, in order to produce a secondary
color — orange — this secondary color will attain maximum brilliancy
when it is put close to the third primary color not used in the mixture.
In the same way, if one combines red and blue in order to produce violet,
this secondary color, violet, will be intensified by the immediate prox-
imity of yellow. And finally, if one combines yellow and blue in order
to produce green, this green will be intensified by the immediate
proximity of red. Each of the three colors is rightly called complemen-
tary with regard to the corresponding secondary colors. Thus, blue is
the complementary color of orange; yellow the complementary color of
violet; and red, the complementary color of green. Conversely, each of
the combined colors is the complementary color of the primitive one

98

not used in the mixture. The mutual intensification is what is called the law of simultaneous contrast.[84]

Van Gogh used Delacroix's theory of color repeatedly in his work, contrasting red and green in paintings such as *The Night Café,* yellow and violet in many of his landscapes of the French countryside, and blue and orange in his 1888 version of the sower.

Van Gogh produced over thirty paintings of sowers during his artistic career. While his sower of 1888 is a reprise after François Millet, whose monumental peasant figures as sacred prototypes continued to be a source of artistic inspiration, its meaning comes through in van Gogh's symbolic use of color. The flecks of blue and orange in the plowed field, as well as the use of violet and gold in the glowing spring wheat behind the sower, show van Gogh's careful attention to Delacroix's theory of simultaneous contrasts. In depicting both the sowing of the wheat as well as mature wheat in the background of the painting, van Gogh alludes to the cycle of death and rebirth of which the wheatfield became his prototypical symbol. The dominant feature of van Gogh's painting, however, which sets it apart from Millet's subdued and somber work, is the radiant sun, a vibrant glowing disk of citron-yellow which draws the viewer's eye into the painting. From van Gogh's letter to Emile Bernard, explaining his wish to take the golden color of the nimbus in Delacroix's *Christ Asleep During the Tempest,* ca. 1854, fig. 9) and employ it as the dominant color in his reprise of Millet's *Sower,* we know that the sun was intended to be a reference to the presence of Christ. As noted previously, van Gogh had used the color yellow and the symbol of a light, such as the burning lamp in *The Potato Eaters,* as an artistic device to convey the presence of the divine. But the prominent placement of the sun, with its rays emanating to fill the whole sky, juxtaposed with the flecks of blue, violet, and orange in the earth where the sower casts his seeds, is an artistic device to add dramatic emphasis to the symbol of Christ.

Van Gogh was reluctant to paint a realistic representation of Christ because he felt Christ to be too important a figure to paint without proper models,[85] so adopted a symbolic vocabulary. The sun has been a figure for Christ from ancient times; the first recognized example is the third-century

84. L401, ca. 13-17 April 1885, *Letters* 2:365.
85. See L505, 8 July 1888, *Letters* 2:601, and 540, ca. 22 September 1888, *Letters* 3:46, respectively.

tomb of the Julii, where Christ is represented as Helios in a chariot bearing a nimbus with a cross inside. Such Christian symbolism was at the heart of van Gogh's depiction of the sun (as well as sunflowers).[86] The sun is central to van Gogh's oeuvre, as a source of warmth, light, and creativity. Van Gogh did not worship it as God, but employed it as a powerful symbol of God's presence in nature. Van Gogh's *Sower* of 1888 is in essence *Christ Asleep During the Tempest* without the figure of Christ, and as such is an affirmation of van Gogh's experience of the divine in the natural world. The context in which the golden sun appears, radiating over a sower within a wheatfield, is a reference to the teaching of Christ, his admonition to prepare the way for the kingdom of God. Sowers, reapers, seeds, and ripening wheat also allude to the cycle of life and van Gogh's notion of journeying, which he gleaned from his reading of Kempis and Bunyan. Van Gogh continued to explore these themes in two related works of the St. Rémy-Auvers period, *Wheatfield with a Reaper* (1889, plate 11) and *Crows over the Wheatfield* (1890, plate 12).

As van Gogh continued to search for a modern artistic vocabulary to express ideas associated with the traditional Christianity of his past, he moved closer to a synthesis of his past Groningen and evangelical faith with the "new religion" of the modern writers, such as Tolstoy. He continued to value the Bible but only as one among many important texts, to be supplemented with the modern literature of Michelet, Renan, and Zola. He continued to admire Christ, not as the Savior from sin, but as the "supreme example" of a human being. He continued to believe in the Christian ethic of love as the foundation of the kingdom of God, but expected this would come about as a kind of earthly utopia, not as an outworking of the institution of the Church, which he completely rejected. Rather than worshiping within the "white-washed" walls of a cold, dark institution, he began to experience the divine through nature and painted the world around him as if it was a revelation of the divine presence. Whether peasants plowing, planting, harvesting, or sharing a simple meal by the light of a burning lamp, he imbued his subjects with a numinous, almost sacred, quality. Finally, in the face of suffering, he found meaning in his hope for a "life beyond the grave." In the last years of his life, he would call upon his religious faith many times for the solace it brought him in his time of tragic pain. We now turn to the supreme ordeal of van Gogh's life, his monumental test of faith, the mental crisis that led to his self-mutilation and eventual suicide.

86. Kōdera, *Vincent van Gogh: Christianity versus Nature,* 35.

4. Crisis

WHILE VIRTUALLY ALL WHO HAVE HEARD THE NAME "VAN GOGH" are aware of his struggle with mental illness, there is no aspect of his life that is so confusing and shrouded in misconceptions. We cannot, of course, know with absolute certainty why van Gogh suffered the fate of mental torment and eventual suicide. This chapter will present the facts of his illness, garnered from his letters as well as from the accounts of his friends and his doctor's reports. It will review the various diagnoses and theories put forth over the years to explain van Gogh's behavior, and, finally, will explain this author's reasons for agreeing with the original diagnosis of the doctor who examined him, concluding that van Gogh suffered from a type of psychomotor epilepsy resulting from a dysfunction in the temporal-lobe region of the brain. Such a diagnosis would appear to account for nearly all of van Gogh's psychological disturbances.

One important question remains unanswered, however: why did van Gogh commit suicide? His suicide, unlike the mutilation of his ear, was not an unintended occurrence but a premeditated and deliberate act, which is not typical of individuals suffering from temporal-lobe epileptiform illness. Such an action is indicative, instead, of severe depression, from which van Gogh suffered throughout his life.

Since the fundamental concern of this book is with van Gogh's religious experience, I will also explore how the epilepsy and the depression affected van Gogh's religious life. Here, two observations are critical: First, in the rich variety of the Christian experience, different types of religious

expression appeal to different types of individuals. Because of van Gogh's intrinsically melancholic nature, he was temperamentally drawn to the "vale of tears" perception of the spiritual journey and to the "man of sorrows" portrait of Christ. In the years from 1875-1880, as we have seen, van Gogh identified with Jesus in the agony of Gethsemane and Calvary, not with the triumphant Lord enthroned at the right hand of the Almighty. This explains why he was drawn to the writings of Kempis and Bunyan, since both *The Imitation of Christ* and *The Pilgrim's Progress* underscore the difficulty inherent in the Christian journey toward ultimate union with God in paradise. Such a perception of the Christian life afforded van Gogh a way of coping with the grief and pain that at times seemed to engulf him. His religious vision gave purpose to his suffering. His emphasis on the penitential religious experience was, I have argued, not an aberration, but was actually consistent with a long-standing tradition within Christianity, a tradition with which van Gogh was intimately familiar. This emphasis on the suffering of the Christian servant was expressed in the subjects of his paintings done at the asylum of St. Rémy, his self-portrait as Christ, as well as his depictions of Lazarus and the Good Samaritan.

Secondly, while temperament explains much of the religious character of van Gogh's life and art, epileptiform illness might account for its extraordinary intensity. While religious enthusiasm is not necessarily a symptom of temporal-lobe dysfunction, individuals who suffer from this disorder are often hyper-religious, experiencing in particular auditory and visual hallucinations of a religious nature. This may explain why van Gogh became so preoccupied with religious images at the end of his life, as his illness progressed.

The threads of van Gogh's life, his artistic vision, his religious journey, and his psychological struggles weave together to reveal a compelling portrait of a very complex man. At the outset it is perhaps prudent to state a few of my own assumptions. First, unlike some who have written about van Gogh's religious life in passing, I do not view religion as pathology. While believers can certainly express their religious faith in destructive ways, it does not follow that simply because van Gogh was religious, he was insane. In fact, I would argue that van Gogh's attempt to reconnect with the religious experience of his past, through prayer, Bible reading, and artistic representation of traditional biblical subjects, such as his *Raising of Lazarus* (1890, plate 7), was a healthy way of coping with a terrifying situation, the increasing severity of his illness.

In exploring the intricacies of van Gogh's personality, one character trait stands out, his pronounced struggle with his identity. His tendency to "role-model" or follow the paths of others, such as his attempt to copy Monet's style in works such as *Le Moulin Rouge,* was also reflected in his religious journey. In the early years of his life, he claimed that he wanted to be just like his father and his Uncle Stricker in preaching the Gospel to the poor. As soon as he broke away from their influence, however, moving out to London and the Borinage, for example, he embraced the revivalist Christianity of his Methodist colleagues and even the evangelicalism of the famous preachers Spurgeon and Moody. We might then be somewhat suspicious of his early attachment to the Groningen theology, which he eventually perceived as nominalist, and place more emphasis on his own appropriation of Christianity through his devotional literature — the evangelicalism of Bunyan and the mysticism of Kempis. In the end, both artistically and spiritually, van Gogh found his identity and unique voice in the synthesis of the traditional and the modern — an artistic synthesis of Dutch Realism and French Post-Impressionism and a religious synthesis between Groningen theology, evangelicalism, Catholic mysticism, and French modernism.

Another of the most important questions raised in connection with van Gogh's illness is the effect it had on his art, particularly stylistically. Van Gogh evidently went through many stylistic changes in his work from 1880 to 1890, from the dark, somber works of his "Dutch Period" to the bright contrasting colors of his work at Arles, to the undulating rich tones of his latest works, such as *Crows over the Wheatfield.* In evaluating the influence of his illness on his changing style, I have followed one simple principle: any change in style that was a deliberate working out of an aesthetic problem, such as his attempts to lighten the colors in his paintings, I attribute to artistic choice, not illness. For example, much is made of the dizzying perspective of van Gogh's works painted in France, such as his painting of his bedroom at Arles, with its distorted perspective of a shortened foreground and unrealistically expanded background. It actually appears to have been painted from several different perspectives. Many art historians, such as Meyer Schapiro, as well as many physicians who have examined van Gogh's biography, attribute this varying perspective to mental disturbances such as schizophrenia and toxic brain poisoning from absinthe. If this stylistic change were attributable to mental illness, one would assume that van Gogh would have no control over it and would

perhaps be unaware of it. Yet, in drawings done of the same subjects, executed at the same time, this distortion of perspective is decidedly absent from his work.[1] We know that in van Gogh's early works of the Dutch period, he employed a perspective frame commonly used by Renaissance painters to achieve realistic perspective. When he came to Paris, however, and made the acquaintance of innovative young artists such as Emile Bernard, who was particularly interested in changing perspectives, van Gogh began to experiment with the distortion of perspective to create unusual effects in his work. It became a tool for artistic expression much like exaggerated and unrealistic use of color became a tool to express emotion. Distortion of perspective was one way in which van Gogh attempted to "modernize" his painting.

Van Gogh did not usually paint when he was under the aura of an epileptic seizure, nor even for some weeks after he experienced an attack. It would therefore be difficult to argue that the stylistic changes in his art were the result of his epilepsy. Toward the end of his life, however, when his attacks became alarmingly frequent, he did talk of painting, then experiencing the aura of an attack and subsequently losing consciousness; we will explore the possible impact these episodes had on his art when we discuss one of his latest works, *Crows over the Wheatfield.*

His illness actually had more of an impact on his selection of subject-matter than it did on his style, prompting a habitual choice of images of Christian suffering and redemption. Van Gogh's affliction made him more acutely aware of the need for solace that the Christian experience provides, the acceptance of earthly suffering as a temporary struggle in hope of eternal release after death. In finding himself care-worn and plagued with an inexplicable illness, he came to Eternity's Gate with the hope of everlasting peace, a blissful consummation of a life that was not "destined for the worms."

Van Gogh's first medical crisis, the self-mutilation of his ear, occurred after he left Paris, while he was living in Arles, a small town in the south of France; the story of his illness begins there.

The months van Gogh spent in Arles brought great progress in his work. He successfully incorporated the lighter, brighter colors of the French artists, such as Delacroix's luminous sapphires and crimsons and Monet's oscillating pastel pinks and greens, into his palette. While he had

1. See sketches in letters 554 and B22.

struggled in Paris to find a style, often attempting to copy the works of the Impressionists, in Arles he became comfortable with his own unique way of painting, a style that was at once brilliant in color and profound in expression. He explained to his sister, "the young school of painting concentrates particularly on getting sunshine into their pictures." This contrasted sharply with the lack of color in Paris: "you will easily understand that the gray days we were having offer few subjects for painting."[2] Van Gogh had gained the confidence to pursue his dream of creating an artists' studio in the south of France. He perceived his community in religious terms, as he referred to the artists who might join him there as the "Apostles of Art." In preparing for the arrival of the first "apostle," Paul Gauguin, van Gogh purchased twelve chairs to decorate his house. For Gauguin's room, he painted a portrait of the postman Roulin's wife rocking a baby cradle, which he intended to flank on either side with two sunflower paintings, forming a triptych of pious devotion, the portrait recalling the Madonna's devotion to the baby Jesus and the sunflowers (recalling the myth of the flower following the course of Apollo's chariot across the sky) symbolizing devotion to God. With Theo's financial support, he rented his "yellow house" in Arles, furnished it modestly, and invited Gauguin to come and live with him there. Unfortunately, Gauguin, who arrived on October 20, 1888, was not a compatible housemate. Gauguin fancied himself van Gogh's mentor, suggesting he learn to paint from the imagination. He expressed disgust at van Gogh's viscous, heavily layered canvases and complained about the inhospitable environs of Arles. On December 23, 1888, the two quarreled and Gauguin threatened to leave the "yellow house." Although van Gogh's biographers have suggested that he was very upset at the idea of Gauguin's departure, a note to Theo, on December 23, 1888, suggests he was resigned to the idea. "I think that he will definitely go, or else definitely stay. I told him to think it over again. Gauguin is very powerful and strongly creative, but just because of that, he must have peace. Will he find it anywhere if he does not find it here? I am waiting for him to make a decision with absolute serenity."[3]

The same evening, however, after the two argued at a local cafe, van Gogh became agitated, and for an unknown reason, he mutilated himself

2. Unpublished letter to Wil, 24 February 1888, quoted in Jan Hulsker, *Vincent and Theo van Gogh: A Dual Biography* (Ann Arbor: Fuller Publications, 1990), 260.
3. L565, 23 December 1888, *Letters* 3:110.

by cutting off a portion of his ear. The police found him the next morning in the yellow house, unconscious, bleeding to death. He was then admitted to the hospital in Arles. A local newspaper, *Le Forum Republican,* printed the following account of the incident on December 30, 1888.

> Last Sunday night, at half past eleven, a certain Vincent van Gogh, painter, native of Holland, appeared at the Maison de Tolerance No. 1, asked for a girl called Rachel, and handed her . . . his ear saying, "Keep this object carefully." Then he disappeared. The police, informed of these facts which could only be attributed to a poor madman, looked the next morning for this individual, whom they found in his bed, barely showing a sign of life. The unfortunate man was urgently admitted to the hospital.[4]

This was van Gogh's first psychotic episode and the beginning of a debilitating illness that would lead to his treatment in the asylum at St. Rémy and eventually culminate in his suicide.

No aspect of van Gogh's life is more misrepresented or misunderstood. Why did he sever his ear? Controversy persists as to whether van Gogh cut off his entire ear or simply a portion of it. Gauguin and the policeman from Arles who recovered the ear from the prostitute, Rachel, claim that van Gogh cut off his entire ear; while the painter, Paul Signac, as well as Dr. Gachet, who treated van Gogh much later, and his sister-in-law, Johanna, say that he cut off a "piece of his ear." The first physicians to evaluate van Gogh's mental illness posthumously, Doctors Doiteau and Leroy, concluded that van Gogh severed the lower half of his ear, using a diagonal incision from the top of the ear to the lower portion, which he cut away from his neck.[5]

Many still raise the question as to why van Gogh offered his ear as a gift to a prostitute. One of the most historically interesting theories is that van Gogh was mimicking the practice of the bullfighter. In the bullfights that took place in Arles, it was customary for the matador to sever the ear of the defeated bull, parade around the arena with his "prize," and then offer it to his lady in the stands.[6] The problem with this and

4. Hulsker, *Vincent and Theo,* 322.

5. Victor Doiteau and Edgar Leroy, "Vincent van Gogh et le drame de l'oreille coupée," *Aesculape* 36 (1936): 169-92.

6. See Albert J. Lubin's discussion of Olivier's theory in *Stranger on the Earth: A Psychological Biography of Vincent van Gogh* (New York: Henry Holt, 1972), 158.

many other theories attempting to explain van Gogh's peculiar act is that it assumes he acted deliberately with full knowledge of what he was doing, but this is not the case in a temporal-lobe seizure. Van Gogh awoke, wounded, confused and alarmed at what he had done, but with no memory or knowledge of the events that occurred, so we cannot know his motivation, if he had any. Nor did he ever speculate about it himself.

Another puzzling question in van Gogh's history is, what drove him to suicide? Most have claimed that such actions were the product of a deranged mind, perhaps schizophrenic or manic depressive, but a close examination of the original accounts from van Gogh's doctors, as well as the information he provided in his letters, reveals one important fact: van Gogh was not insane. Rather, he suffered from a type of epilepsy that led to his self-mutilation, something his own physicians diagnosed from his first hospitalization in Arles. Still, van Gogh became a mythic figure in the century after his death, and doctors clamored posthumously to offer new theories explaining his bizarre behavior during the last years of his life, as well as his untimely death. The history of how the myth of his insanity came about is almost as interesting as van Gogh's enigmatic illness itself.

Since van Gogh's death, many have taken up the issue of his mental illness in an attempt to explain his life, his work, and his suicide. These approaches fall into three basic categories: the psychoanalytic and the psychological, which would include "diagnoses" of schizophrenia and manic depression; analysis of psychomotor disturbance, such as epilepsy; and finally, in recent years, speculation about a physiologically induced breakdown, possibly syphilitic dementia, toxic brain poisoning, or Menière's syndrome.

The first approach, the psychoanalytic, is based on the notion that van Gogh was a "replacement child," and thus suffered severe identity confusion. Prior to Vincent van Gogh's birth, his mother, who was already thirty-three at the time, had given birth to a still-born child, named Vincent Willem. Exactly one year later, on March 30, 1853, Vincent, bearing the same name as his deceased sibling, was born. Vincent's parents had erected a gravestone inscribed with the name "Vincent" in the Protestant cemetery of Zundert, very close to the presbytery where the van Gogh family lived. The family could see the gravestone whenever they entered the church building.[7] Some have suggested that seeing the gravestone bearing his own name was so deeply disturbing to the young Vincent

7. Marc Edo Tralbaut, *Vincent van Gogh* (Lausanne: Edita, 1969), 23.

that he developed a severe identity crisis, which led to his later erratic behavior, self-mutilation, and suicide.[8] This theory argues that the "replacement child," who is conceived as a substitute for a dead sibling, experiences a distorted sense of identity and a fragmented ego, often with low self-esteem. This results in a life-long difficulty with relationships, beginning with the child's mother.[9]

While it may have been somewhat disconcerting to pass by a dead sibling's grave bearing one's own name, van Gogh never mentioned this in any of his letters. We actually know very little about his childhood. We do know that the practice of giving a second child a name which had initially been chosen for a preceding child who died at birth was rather commonplace in the nineteenth century. Also, Vincent was not merely the first child's name, it was a family name, the name that van Gogh's uncle and grandfather bore. It would seem, then, that the young Vincent would not have associated the name "Vincent" solely with his dead brother. Some of van Gogh's biographers argue that Vincent carried around such an extreme burden of guilt, feeling that he was somehow responsible for the death of his sibling, that it eventually led to his suicide. "If we read between the lines of the uninterrupted confession which Vincent's letters provide, we find that his life was governed by various processes of repression, and that moreover, fantasies of guilt caused by the death of the first child frequently appear right up to the very end of his life. This feeling of guilt showed itself for the last time, at a subconscious level, in the suicide which liberated him from the world, and indeed was one of the motives for it."[10] If van Gogh harbored such guilt, he never showed it. Also, those who have attempted retrospectively to psychoanalyze van Gogh consistently overlook an important aspect of the van Gogh family's life, its faith. Both Vincent's parents believed deeply in the sovereignty of God. Although certainly grief-stricken with the loss of their first child, they would most surely have accepted it as God's will. Certainly, when Vincent's mother conceived again within a few short months of their loss, she would have been overjoyed. Both events, the initial loss of the first "Vincent" and the birth

8. A 1989 study by Andrea Sabbadini in *La Psychiatrie de L'enfant* compared the impact of the phenomenon of the "replacement child" on both Salvador Dali and Vincent van Gogh.

9. Andrea Sabbadini, "L'enfant de Remplacement," *La Psychiatrie de L'enfant* 32, no. 2 (20 November 1989): 519-41.

10. Ibid., 523.

of the second "Vincent," would have been understood as acts of God's providence and supreme grace.

Although it is unlikely that van Gogh carried any real burden of guilt for the death of his brother, the "replacement" phenomenon might have had some effect in the development of his apparent confusion about his identity, particularly in his tendency to adopt the styles, goals, and personalities of others he admired. This pattern is evident from early on; when van Gogh pursued the vocation of the Christian ministry, he adopted his father as a role model to what might seem an excessive degree. Later, as an artist, he showed the same tendency. Van Gogh so admired the work of Adolphe Montecelli (1824-1886), who lived in the neighboring city of Marseilles, that he not only attempted the practice of applying thick layers of jewel-toned impasto to the canvas, Montecelli's "signature" style, but he donned the large-brimmed straw hat and blue artist's smock (*Self-Portrait with Straw Hat,* 1887) for which Montecelli was known, as if wearing the costume would somehow bring the artist to life in van Gogh. Vincent remarked in a letter, as he prepared his "artists' studio," that a resident of Arles had told him that Montecelli was the artist that should head the "Studio in the South." He explained, ". . . sometimes I thought that I was continuing Montecelli's work here. Well don't you see, that studio in question, we are founding it. What Gauguin does, what I do, will be in line with that fine work of Montecelli's. And we will try to prove to the good people that Montecelli did not die sprawled over the café tables of the Cannebière, but that the good old boy is still alive."[11] As previously noted, van Gogh also emulated the styles of other artists, particularly Monet, while he was living in Paris, and Gauguin, while they lived together in Arles.

Indeed, when van Gogh lived in Arles with Gauguin, he adopted much of Gauguin's artistic vision. His own identity seems to have been swallowed up for a time in Gauguin, so that many of his paintings from this period, October to December of 1888, such as his *Red Harvest,* appear to be copied after Gauguin's work.

Van Gogh also exhibited a rather passive, approval-seeking attitude with others. This pattern often showed itself in the way he represented his work in artist sketches. Van Gogh varied the sketches of his works for different individuals, depending on their particular tastes. There were, for example, major differences in the sketches van Gogh sent to Emile Bernard

11. L542, 24 September 1888, *Letters* 3:55.

and John Russell of the same works, demonstrating his need to cater to the tastes of others.

Eventually, however, van Gogh found a style of his own, rejecting both the Impressionist and Symbolist style of painting. He returned to the thick impasto of his Dutch heritage, insisted, against Gauguin's instruction, on painting from nature, and adopted a vibrant expressionist use of color, which far surpassed the impressionist palette that had been his starting point in Paris. Within a two-year period, from 1886 to 1888, van Gogh established himself as a unique artist in his own right, whose highly personal and emotive style remains his distinguishing characteristic to this day.

Van Gogh also had difficulty in forming lasting adult relationships; he never married nor had the family he longed for all his life. His relationship with his parents, which had been at first intensely close, became fraught with bitter discord. The circumstances of van Gogh's birth may account for some of this difficulty. His inability to maintain relationships with women in particular, however, was in large part affected by the circumstances of his own poverty. Never self-supporting, he was certainly not able to support a wife and children. While he longed to have a family, his poverty kept him isolated. He believed it was his lack of a secure financial future that made him an unacceptable prospect for Stricker's daughter, Kee. We do not know whether this was actually the reason Kee rejected him, but we do know it played a role in his breakup with Sien and her two children, the only "family" Vincent ever had. Sien's mother made it clear to Vincent that she felt her daughter would be better off living as a prostitute on the street than trying to make a life in abject poverty with Vincent.

In many ways, though, van Gogh was able to rise above his isolationist tendencies. One need only point to the symbiotic life-long relationship between Vincent and his brother Theo, as well as the warm friendships he enjoyed with other artists, such as Emile Bernard and Paul Signac, to challenge the notion that he was unable to form lasting bonds with others. Tales of the isolated mad genius, beginning with Aurier's critique, "Les Isoles: Vincent van Gogh," published in *Le Mercure de France* in 1890, are greatly exaggerated.[12]

12. G. Albert Aurier, who published the first critical review of van Gogh's work, was himself a young artist. He became essentially the "mouthpiece" of the Symbolists, a group of late nineteenth-century writers, poets, and artists, who deliberately employed paradox and ambiguity, making their works less accessible to the general public.

Finally, while the "replacement" phenomenon might explain some of van Gogh's struggle with identity, it offers no explanation for his self-mutilation and suicide, the two most significant "symptoms" of pathology. While none of van Gogh's siblings experienced the "replacement" phenomenon, several suffered mental illness. Van Gogh's sister, Wil, suffered depression as well. Institutionalized in 1902, she eventually died in an asylum in 1941. Theo suffered rapid mental deterioration after Vincent's death and died himself six months later, on January 25, 1891. Finally, Vincent's youngest brother, Cor, committed suicide while serving in the military in South Africa in 1900. Like Vincent, the other van Gogh siblings may have suffered some type of physiologically induced behavioral psychosis, which would account for the tragic course of their lives, but the "replacement" theory of behavior would not explain their similar fates.

After van Gogh's death and subsequent fame, several studies attempted to explain his mental deterioration and suicide. The first of these studies argued that van Gogh did not have epilepsy but suffered from a degenerative psychosis, most probably schizophrenia. The well-known German philosopher from the University of Heidelberg, Karl Jaspers, published a highly influential study comparing the psychosis of the Swedish author, August Strindberg, with that of, among others, Vincent van Gogh. Jaspers' work, published in 1922, argued that van Gogh suffered from schizophrenia, which Jaspers "diagnosed" from a study of van Gogh's art. Although long outdated, Jaspers' theory remains influential even today.

Most important, though, in his profile of van Gogh's personality, Jaspers notes the fundamental role religion played throughout van Gogh's life. "Already in his youth he is deeply religious and is sustained in all he does by a religious consciousness without adherence to a church or dogma. From the beginning, his mind is directed toward the core, the essential, the meaning of existence."[13] Jaspers also points out the connection between van Gogh's illness and his bent toward religion. Quoting van Gogh, he writes, "I am not sick, but I surely shall become so if I do not eat better and quit painting for a few days. I almost fell victim to the kind of madness of Hugo van der Goes in Emile Wauter's painting, and were it not for his dual nature, half monk, half painter, I would have gone to the dogs a long

13. Karl Jaspers, *Strindberg and van Gogh: An Attempt at a Pathographic Analysis with Reference to Parallel Cases of Swendenborg and Holderlin*, trans. Oskar Grunow and David Woloshin (Tucson: The University of Arizona Press, 1977), 155.

time ago, just as he did. Certainly, I do not believe that my type of insanity could be persecution mania, because my mind, in a state of excitement, always concerns itself with infinity and with everlasting life."[14]

From the time of van Gogh's crisis in Arles throughout his confinement in St. Rémy, he experienced an aura of religious exaltation and was increasingly drawn to the religion of his youth for solace and strength. Jaspers, while acknowledging this distinctive characteristic of van Gogh's illness, makes no attempt to draw inferences from this pattern. Overlooking it has contributed to much of the misunderstanding and "misdiagnosis" of van Gogh's illness. Jaspers argues that van Gogh suffered a progressive psychotic breakdown, beginning in 1887, which manifested itself fully in his self-mutilation of December, 1888. He suggests that the clue to understanding van Gogh's schizophrenia lies in his work, which underwent a dramatic change when he began living in Arles in 1888, a change which Jaspers attributes to van Gogh's worsening psychosis. He points out that van Gogh began to use color more expressively, that he started painting on larger canvases and showed a preference for painting portraits over landscapes. Also at St. Rémy, he demonstrated an interest in copying the works of great artists such as Rembrandt and Delacroix and presenting religious subjects. Jaspers remarks on van Gogh's religious intensity, "Actually, van Gogh wanted to paint Christ, saints, and angels. He did decide against it because it excited him too much. Instead he chose the simplest objects. But the religious impulse can be detected in them, even if one is not aware of the motives expressed in his letters. . . ."[15] Finally, especially in the paintings done at Auvers, in the final months of van Gogh's life, Jaspers notes the change in brush strokes, "the reduction of the perspective plane into brush strokes of geometrically regular, but enormous, forms."

Jaspers does not consider these developments to reflect artistic choices, but instead to be accidents of van Gogh's illness. He, much like Aurier had done before him, links van Gogh's mental illness with his artistic creativity, as if his art was a product of his mental collapse. He explains, ". . . I would consider it rather curious if it were to be a coincidence that the psychosis were to begin at the very time at which we also witness the incredibly fast unfolding of the 'new style!' . . . Schizophrenia helps to create something out of the original telos which would never have

14. Ibid., 158.
15. Ibid., 175.

come into being without psychosis."[16] Jaspers goes on to argue that van Gogh's artistic career reached its zenith during the summer of 1888, in Arles. He sees increasing deterioration during van Gogh's late Arles period, coinciding with his mental breakdown of December, 1888, and continued decline during van Gogh's St. Rémy and Auvers periods. "The pictures look poorer, details seem more coincidental. At times, the violence turns into wild daubing without form. Energy without meaning, despair and shuddering without expression. No longer new 'formation of concepts.'"[17]

According to Jaspers' theory, one would place van Gogh's *Starry Night, Irises,* and *Crows over the Wheatfield* in the category of his "weaker canvases." Jaspers persistently attributes van Gogh's artistic progress to psychological decline, without considering the goals which van Gogh had set for himself as an artist. He seems unaware that van Gogh made a decisive effort to brighten the colors of his paintings and to use color expressively. As he was developing his "new style," as Jaspers calls it, van Gogh was particularly attracted by the dramatic color of Delacroix's romantic style and followed his color theory in such works as *The Night Café.* Also, van Gogh studied in Paris at the Studio Cormon, where he made the acquaintance of other artists working toward a new style, such as Henri Toulouse-Lautrec and Emile Bernard. His experimentation with perspective, simplification of forms, symbolic and emblematic use of subjects, as well as his expressive and imaginative style all grew out of his intense efforts while in Paris to contribute to the new movement in art. While Delacroix had the greatest impact on van Gogh's color theory, Bernard contributed significantly to van Gogh's aesthetics. It was Emile Bernard who helped van Gogh to achieve his unusual use of perspective and cloisonist flattening and simplification of shapes and figures, often outlined in black, within his paintings. It was also Bernard who helped van Gogh achieve the foreshortening of the foreground, causing the subject to appear flattened against an infinite background. Gauguin, of course, contributed to van Gogh's use of the imagination in his work, which freed him from a strictly realistic style. The suggestion that van Gogh began using larger canvases in Arles is erroneous, since *The Potato Eaters,* done in 1885, was van Gogh's largest canvas. Van Gogh did, however, gain considerable confidence in himself as an artist while in Arles and thus availed himself

16. Ibid., 178.
17. Ibid., 180.

of the funds Theo provided to paint larger canvases. Rather than a product of a schizophrenic breakdown, this too was simply an artistic choice.

The paintings of van Gogh's St. Rémy and Auvers periods show the way in which he reconciled all the new influences of the Impressionists and Post-Impressionists with his own background as a Dutch painter. His brushwork, particularly the thick impasto built up in layers on the canvas, as well as the introduction of subdued golds, ochers, and browns recall his years as a "Hague School" painter. While he felt free to interpret what he saw in the natural world, he still remained, at least in part, the realist he was when he began painting. Van Gogh's "new style," as Jaspers calls it, was not a result of a progressive schizophrenic psychosis but a conscious working through of various influences to the development of his own unique body of work, which he explains in detail in his prolific correspondence.

Finally, Jaspers notes a unique feature in van Gogh's schizophrenia, his awareness of his illness. Yet, the most distinguishing characteristic of schizophrenic psychosis is the inability to distinguish illusion from reality. Patients experiencing audio and visual hallucinations, for example, are not aware that they have hallucinated, nor would they describe themselves as "sick" because they do not have the ability to perceive the difference between normal and irrational behavior.[18] In describing his "attacks," however, van Gogh wrote:

> To begin with, because I come face to face with the actual life of the insane and of the various types of insane people in this menagerie [the asylum St. Paul-de-Mausole], I lose that vague fear, the horror of the illness. Gradually I bring myself to look at insanity like any other illness.
>
> I observe that others also hear strange sounds during their crises and that the things around them seem to undergo a change. That reduces the shock which I once experienced when I passed through my crisis. . . . But when one actually understands the true nature of the illness, one can deal with it better.[19]

While Jaspers concedes that van Gogh's resolute attitude toward his

18. See Raymond D. Adams, M.D., and Maurice Victor, M.D., *Principles of Neurology*, 4th ed. (New York: McGraw-Hill, 1989), 1224-44.
19. Quoted in Jaspers, *Strindberg and van Gogh*, 184.

illness was unusual for one suffering from schizophrenia, he persists in seeing "no justification for the diagnosis of epilepsy which was offered by the doctors who treated van Gogh, because of the absence of epileptic seizures. . . . To me, schizophrenia seems overwhelmingly probable."[20]

It is astounding that Jaspers made such an error, which inaugurated the myth of the mad schizophrenic genius of Vincent van Gogh. Fortunately van Gogh's doctors, who treated him beginning in 1888, were more familiar with the various types of epilepsy. They were well aware that many individuals who suffer from epilepsy never experience convulsive seizures. Moreover, van Gogh's calm attitude and attempts to understand his illness would almost certainly exclude a diagnosis of schizophrenia. It is not unusual, however, for the patient suffering from psychomotor epilepsy to be misdiagnosed as schizophrenic. Indeed, ninety percent of psychomotor epileptics present with symptoms that mimic schizophrenia, leading to frequent misdiagnosis.[21] The two illnesses have many similarities. For example, schizophrenia, like epileptiform illness, may follow a pattern of psychotic episodes followed by periods of remission; unlike the patient suffering from a temporal lobe epileptiform illness, however, the schizophrenic maintains his disconnection with reality and inability to function socially. Even in remission, the schizophrenic displays the characteristics of full-blown illness: an inability to "think in the abstract, to fully understand figurative statements such as proverbs, and to separate relevant from irrelevant data" and to "attend to the task at hand." Such people experience frequent auditory hallucinations, which seem very real, consisting of voices that are "usually accusatory or threatening, or in control of the patient's actions." "Finally, patients may feel that the world about them is changed or unnatural, not in a brief episode like the jamais vu [never seen, referring to the epileptic's lack of memory after an episode] of a temporal lobe seizure, but continuously."[22]

The behavioral and psychological characteristics of schizophrenia occur in many other diseases, including chronic alcoholism and temporal lobe epilepsy, but the schizophrenic does not experience the classic lapse of consciousness, nor the aura preceding an attack that van Gogh experi-

20. Ibid., 187.

21. Henri Gastaut, "La Maladie de Vincent van Gogh Envisagée a la Lumière des Conceptions Nouvelles sur L'epilepsie Psychomotrice," *Annales Médico-Psychologiques Revue Psychiatrique: Bulletin Officiel de la Société Médico-Psychologique* 114 (1956): 236.

22. Adams and Victor, *Principles of Neurology,* 1224.

enced. Also, many of the aforementioned characteristics of schizophrenia clearly do not apply to van Gogh's medical history. He did not believe in the reality of his hallucinations, and while we do not know the nature of his hallucinations, except to say that they were often religious, he was clearly aware that they were abnormal occurrences. Other than the uncertain details of the incident of self-mutilation, we know little of van Gogh's behavior during his episodes, but the hundreds of letters, as well as the numerous artistic works he produced during the years from 1888 until his death in 1890 reveal a man who is coherent, calm, and infinitely able to attend to the "tasks at hand."

While many have taken up Jaspers' theory that van Gogh suffered from schizophrenia, those arguing that van Gogh suffered from a type of psychomotor epilepsy are more numerous; yet the notion that van Gogh suffered a schizophrenic psychosis still persists.[23] The recent work of Dr. Khoshbin, from Harvard Medical School, concludes that van Gogh had temporal lobe epilepsy. Khoshbin termed the interictal (between seizures) personality disorder as Geschwind's syndrome. Named after the late neurologist, Dr. Norman Geschwind, the syndrome's characteristics are: hyper-religiosity, hyposexuality (diminished sexual drive), episodic aggression, and hypergraphia (extensive writing). Van Gogh exhibited all of these characteristics consistently throughout much of his life, but especially in the last few years, from 1886-1890. These are common characteristics of patients who suffer from temporal lobe dysfunction, though not necessarily symptoms of the illness since no cause and effect relationship has been established. Dr. Khoshbin found that patients he tested who exhibited these characteristics all showed dysfunction in the temporal lobe region

23. Gastaut cites two studies, "Die Psychologische Entwisklung Vincent van Gogh," *Imago* 10 (1924): 389, and "Le Development Psychologique de Vincent van Gogh," from the unpublished text of a medical conference held in 1955. See Gastaut, "La Maladie de Vincent van Gogh Envisagée a la Lumière des Conceptions Nouvelles sur L'epilepsie Psychomotrice," 238. Gastaut cites W. Riese, 1925-26; Everson, 1926; Thurer, 1927; Doiteau and Leroy, 1928; Minkowska, 1933, 1949, 1951; and Catesson, 1943, as supporters of Dr. Rey's initial diagnosis of epilepsy. A number of others could be added to this list, notably the detailed discussion of Dr. Steiner in 1959, which appeared in *Psychiatrie Neurologie und Medizinische Psychologie,* and the work of the neurologist, Shahram Khoshbin, from Harvard Medical School, which appeared in *Psychology Today* in November of 1985. Unfortunately, Dr. Khoshbin's discussion of van Gogh's illness was limited to one page, so the need for a systematic discussion of the problem for English readers remains.

of the brain and were often misdiagnosed as manic-depressive or schizo-phrenic. Patients improved when their treatment was changed from an-tipsychotic drug therapy to anti-epileptic drug therapy.[24]

Van Gogh's doctors did not have the technology of mapping the brain waves to confirm their diagnosis, so the theory that van Gogh suffered from epilepsy remains somewhat speculative. But the fact that all three of van Gogh's own attending physicians — Dr. Rey, Dr. Peyron, and Dr. Gachet — diagnosed van Gogh as epileptic, and that van Gogh's recorded symptoms seem to match what we now know about temporal lobe epileptiform illness, commends it as the most probable explanation for his illness.[25] His symp-toms, including the progress of his disease, which seemed to begin around 1886, when van Gogh was thirty-four (studies show that the personality disorder he exhibited usually begins in the mid-thirties), are consistent with psychomotor epilepsy caused by temporal lobe dysfunction. Most who have studied van Gogh's medical history confirm this diagnosis and argue con-vincingly against Jaspers' notion that van Gogh suffered from schizophrenia. Nonetheless, Jaspers' hypothesis was taken up and repeated in the literature and still remains the single most influential theory on the nature of van Gogh's illness. His idea that van Gogh's art was, at least in part, a product of his schizophrenia has led to significant misreading of van Gogh's works, particularly one of his last works, *Crows over the Wheatfield*.

Although no new evidence has come forth to dispel the original diagnosis of Dr. Rey, it has become fashionable in recent years to speculate that van Gogh suffered from a physiological disorder that led to his episodic psychotic behavioral disturbances. Numerous medical articles have argued that van Gogh may have suffered from digitalis, toxicity, thujone addic-tion, syphilitic dementia, a disorder of the inner ear called Menière's syndrome or even acute intermittent porphyria.[26] Almost all such articles

24. Linda Garmon, "Of Hemispheres, Handedness and More," *Psychology Today* 19 (November 1985): 40-48. See page 46 for Dr. Khoshbin's discussion of van Gogh.

25. Most recent is the work of the Dutch neurologist, Dr. Piet Voskuil in 1989, who also concluded that van Gogh suffered from temporal lobe dysfunction. Piet Voskuil, M.D., presented his findings regarding van Gogh's temporal lobe epileptiform illness at the van Gogh Symposium, held at the Rijksmuseum Vincent van Gogh, May 10-11, 1990.

26. I have reviewed two articles for JAMA, one arguing that van Gogh suffered from temporal lobe epilepsy (with no reference to the vast body of literature that has already drawn this conclusion) and the other arguing that van Gogh suffered from acute intermittent porphyria. Both articles contained significant historical errors.

have emanated from a single source, *JAMA, the Journal of the American Medical Association.* They have not distinguished themselves for raising new questions or providing new information, but for generating immense publicity, resulting in the widespread dissemination of misinformation about van Gogh's life and illness. Several of these articles are superficial, selectively researched, and historically inaccurate.[27]

Unfortunately, the *JAMA* articles continue to proliferate. A recent article, entitled "Van Gogh Had Menière's Disease and Not Epilepsy," claims to dispel the notion that van Gogh suffered from psychomotor epilepsy.[28] The authors argue that van Gogh experienced nausea, vomiting, tinnitus (noise intolerance) and aural pressure (a feeling of fullness in the ear), and disabling attacks of vertigo, followed by intervals free of these symptoms. They consequently conclude that van Gogh was misdiagnosed by Dr. Peyron (actually, as we have noted, the original diagnosis was made by Dr. Rey, not Dr. Peyron) and that he suffered from the inner-ear disorder now known as Prosper Menière's syndrome. Many of the symptoms that van Gogh experienced, however, could apply to a number of disorders and are not exclusively indicative of either Menière's or epilepsy. In addition, the authors often misrepresent van Gogh's descriptions of his symptoms or draw incorrect inferences from what van Gogh wrote. Most disturbing, however, are the numerous misquotations and falsifications of van Gogh's letters. The article, for example, falsely equates van Gogh's dislike of the noise and bustle of Paris (he remarked on his disdain for urban life and his longing for the restful quiet of the country[29]) with the noise intolerance of Menière's patients. Van Gogh's rather vague description of his "feeling of emptiness or fatigue in the head" is taken to indicate the fullness in the ear of Menière's, which it surely does not. Nor does van Gogh ever complain of fluctuating hearing loss.[30] The authors' contention that van

27. As noted previously, Jan Hulsker has written an excellent critique of Wilfred Arnold's article, "Vincent van Gogh and the Thujone Connection" (*JAMA* 260, no. 20 [25 November 1988]: 3042-44), whereby he concludes that the inaccuracies in Arnold's work and his misrepresentation of the degree to which van Gogh drank alcohol seriously undermine his thesis that van Gogh's behavioral disturbances resulted from the excessive consumption of absinthe. See Arnold, "Vincent van Gogh and the Thujone Connection." For Hulsker's critique, see *Vincent and Theo,* 401-4.

28. Kaufman Arenberg, M.D., et al., "Van Gogh Had Menière's Disease and Not Epilepsy," *JAMA* 264, no. 4 (25 July 1990): 491-93.

29. L643 (to Gauguin), 17 June 1890, *Letters* 3:284.

30. W11, 30 April 1889, *Letters* 3:452.

Gogh severed part of his ear because he experienced otalgia (discomfort and fullness in the ear) is ludicrous; the article fails to cite a single example of a Menière's patient who cut off his ear. This type of self-mutilation, however, has occurred with patients suffering from temporal lobe epilepsy, as van Gogh himself related: "Most epileptics bite their tongues and injure themselves. Dr. Rey told me that he had seen a case where someone had mutilated his own ear."[31] Van Gogh seemed to find this reassuring because it provided him with a reason, other than insanity, for his erratic behavior, and offered him some hope that he might be able to keep his illness under control. Finally, the fact that van Gogh experienced long symptom-free intervals between attacks is inconclusive; such symptom-free intervals are also typical of patients who suffer epileptiform illness.

The theory that van Gogh suffered from Menière's disease therefore rests primarily on the notion that he experienced disabling attacks of vertigo. Evidence for this, supposedly taken from van Gogh's letters, is often misrepresented, misquoted, and even fabricated. For example, while the article in question quotes van Gogh as stating, "an attack of vertigo comes on in the long run" (supposedly from letter 638), what he actually wrote was, "Only I think that all the talk that has been stated on account of the high prices paid for Millets, etc. lately has made the chances of getting back one's painting expenses even worse. It is enough to make you dizzy."[32] This leaves one single example when van Gogh did, in fact, relate an episode of dizziness.[33] He wrote, "In Paris, I could never accustom

31. L592, 22 May 1889, *Letters* 3:175.
32. L638, 3 June 1890, *Letters* 3:278.
33. In letter 605, (7 or 8 September 1889, *Letters* 3:210), van Gogh wrote, "But I cannot live since I have this dizziness [which the article describes as vertigo] so often, except in a fourth or fifth-rate situation." Also, this does not follow the quote, "we must expect from time to time that I shall have an attack," as the article alleges. Van Gogh went on to say, "When I realize the worth and originality and the superiority of Delacroix and Millet, for instance, then I am bold enough to say — yes, I am something, I can do something." While van Gogh does use the French word, "vertige," he is actually translating into French a Dutch idiom, "in de war," which means to be confused or tangled in disorder. See the Dutch version of van Gogh's letters, *De Brieven van Vincent van Gogh* 4:1929, Letter 802 (605), where he writes, "Maar nu ik zu vak in der war ben, kan ik alleen maar leven in een vierde-, vijfderangs positie." Here, he was simply venting his frustration over his working conditions, not describing repeated attacks of vertigo. The article's references to letters W44 and 692, as examples of van Gogh's vertigo, are fabrications. There are 23 letters from van Gogh to his sister Wilhelmina, not 44, and 651 letters from Vincent to his brother Theo, not 692.

myself to climbing stairs, and I always had fits of dizziness. . . ."[34] Dizziness is a vague and commonly experienced symptom, indicating anything from hunger and fatigue to the presence of a brain tumor. Dizziness while climbing stairs, then, is certainly not sufficient evidence to suggest Menière's.

Finally, while Dr. Peyron did describe van Gogh's attacks as prolonged over a period of two months at a time, which the authors cite as indicative of Menière's syndrome, what van Gogh actually recounted were prolonged periods of depression and lethargy, which are also associated with epileptic phenomena. The article's bold conclusion that van Gogh's "voluminous correspondence should forever banish the notion that he was epileptic or mad," is completely false, since van Gogh's hypergraphia (extensive writing) actually supports a possible diagnosis of temporal lobe epilepsy. Although van Gogh was not insane, he did suffer episodic behavioral disturbances, which cannot be explained by a diagnosis of Menière's disease. It seems that the goal of this article, and others that have preceded it, is not to provide insight into the nature of van Gogh's mental illness, but to capitalize on his fame.[35]

A recent new "diagnosis" of van Gogh's illness appeared in *The British Medical Journal,* December 21-28, 1991. Dr. Wilfred Niels Arnold, a biochemist who had previously argued that van Gogh suffered from toxic brain poisoning as a result of his addiction to absinthe and other terpenes, here asserts, along with Dr. Loretta S. Loftus, that van Gogh suffered from a hereditary metabolic disease known as acute intermittent porphyria (A.I.P.). The authors cite van Gogh's complaints of gastrointestinal problems, hallucinations, seizures, and rapid recovery after attacks as indications of A.I.P., arguing that van Gogh inherited the defective gene from his father, Theodorus. While van Gogh did occasionally complain of stomach pain, it is difficult to say whether this is significant in diagnosing his illness. His poor diet, which included fasting, smoking tobacco excessively, and drinking large amounts of "bad coffee," as he put it to his sister, Wil, could certainly account for gastrointestinal discomfort. Patients suffering from acute intermittent porphyria, however, normally experience excruci-

34. W4, 22 June 1888, *Letters* 3:438.

35. What is perhaps most disturbing about this publication is that Jan Hulsker reviewed it a year before it was published and pointed out all the historical errors to the editors.

ating abdominal pain, so intense as to render them dysfunctional. Also, while van Gogh experienced long intervals of lucidity between crises, his recovery from the attacks was not rapid, but extended for several weeks and sometimes months. Not only did he suffer severe depression, but frequently entertained thoughts of suicide. Finally, there is no evidence whatever of a hereditary disorder, which would be crucial to the diagnosis of A.I.P.

In addition, some factors in van Gogh's case history would contradict such a diagnosis, such as the age of onset of van Gogh's illness. As the article points out, the peak age of onset for the disorder, A.I.P., is the period from twenty to twenty-nine, but van Gogh first began exhibiting symptoms at the age of thirty-four. Most patients suffering from acute intermittent porphyria show significant improvement and even full recovery by their late thirties. Van Gogh, however, did not improve, but rather became worse, with more frequent and severe attacks which finally culminated in his suicide at the age of thirty-seven. For example, van Gogh reported to his sister that he had experienced four seizures and three fainting spells from December of 1888 through April of 1889, noting that he had no recollection of what he said or what he did during these episodes.[36]

Patients suffering from A.I.P. also experience a unique and telling symptom, of which van Gogh was entirely free, namely discoloration of urine. To explain the absence of this symptom in van Gogh's case, the authors suggest that it went unobserved, ". . . dark or reddish urine is not mentioned in the correspondence. It may, however, have escaped observation. Vincent's living quarters were often primitive; for example, the 'Yellow House' in Arles had no toilet and he was forced to use the facilities at the hotel next door. We assume he relieved himself in the field while painting."[37] The suggestion that van Gogh, as well as his attending physicians, would have overlooked such an important symptom is inconsistent with the way van Gogh dealt with his illness. He was keenly aware of both his mental and physical symptoms as he struggled intently to overcome them. He would not have ignored such an important physical symptom.

36. W11, 10 April 1889, *Letters* 3:450.
37. Loretta S. Loftus and Wilfred Niels Arnold, "Vincent van Gogh's Illness: Acute Intermittent Porphyria?" *British Medical Journal* 303 (21-28 December 1991): 1590.

Most important in contradicting the diagnosis of A.I.P. is the absence of evidence to support the possibility that van Gogh inherited the disorder from his father. While Vincent van Gogh's siblings seem to have suffered numerous mental and physical disorders, it is noteworthy that such disorders did not seem to plague either of van Gogh's parents nor any of his grandparents that we know about. Van Gogh pointed out to his attending physicians in both Arles and St. Rémy that he had an aunt who experienced epileptic seizures, believing his own disorder to be related. Since van Gogh shared this family information, he would have also shared information regarding his parents and grandparents, if they had suffered a similar pattern of illness to his. While it is true that Vincent's father, Theodorus, died rather suddenly in 1885, he was sixty-three years old at the time and was apparently very robust and active throughout the course of his life, without the slightest hint of mental instability.[38] Vincent's mother, Anna van Gogh-Carbentus, died in 1907 at the age of eighty-nine, again without a suggestion of any mental disorder. The family history, then, is only significant with regard to van Gogh's siblings, which would rule out any directly inherited disorders, such as acute intermittent porphyria.[39]

Typical of the "proof texts" offered is Vincent's reference to "our neurosis" as a "fatal inheritance." The authors do not footnote their quotations, but when van Gogh made the relevant remark in a letter to Theo, he was speaking philosophically about his own and his brother's fate in following an artistic vocation, he as a painter and Theo as an art dealer. Since they came from a long line of art dealers and artists, including their great-grandfather, Vincent, who was a sculptor, the reference to their "fatal inheritance" in this context is a reference to their continued involvement in art. Van Gogh perceived this "calling" in somewhat negative terms, as if it was a heavy cross to bear, perhaps a portent of his tragic life. At any rate, it is fanciful to suggest that this constitutes an allusion to a genetic disease which Vincent supposedly believed he and Theo had inherited from their father. Vincent's actual words were: "My poor boy, our neurosis, etc., comes, it's true, from our way of living, which is too purely the artist's life, but it is also a fatal

38. Ibid.
39. I reviewed this article for an American medical journal and rejected it on the grounds that the "hereditary factor" suggesting that van Gogh's father had passed on the disorder was erroneous. Also, this disorder affects individuals in their late teens and normally subsides before the age of thirty. As noted earlier, van Gogh began to suffer his illness in 1886, at the age of thirty-four.

inheritance, since in civilization the weakness increases from generation to generation. If we want to face the real truth about our constitution, we must acknowledge that we belong to the number of those who suffer from a neurosis which already has its roots in the past."[40]

Regarding van Gogh's other siblings, we have very sketchy information, but the evidence concerning both Cor and Wilhelmina is far more consistent with a diagnosis of depression than with A.I.P. While Theo's symptoms could indicate A.I.P., they might as readily suggest other possible diagnoses. Recently, historians have uncovered medical records indicating that Theo died of syphilitic dementia.[41]

Despite a rash of alternative hypotheses, then, no one has yet convincingly disproved the first theory that van Gogh's mental illness was the result of some type of epilepsy, a dysfunction of one or both temporal lobes, which produced both episodic behavioral disturbances and reactive depression. Temporal lobe epilepsy and reactive depression explain van Gogh's self-mutilation, episodic psychosis, including his auditory and visual hallucinations, as well as his prodigious output of both letters and paintings. Until new evidence is uncovered to challenge this thesis, the credit for diagnosing and understanding van Gogh's mental crises belongs to his first attending physician, Dr. Felix Rey.

From the accounts van Gogh left in his letters, as well as the observations of his friends and attending physicians, a clear picture of van Gogh's epileptiform illness emerges. For example, one important aspect of van Gogh's initial collapse in Arles is that he had absolutely no recollection of the events of the night of December 23, 1888. Some of his biographers suggest that this was possibly the result of drinking to excess, but there is no evidence to that effect.[42] Actually, recurrent amnesia after a seizure is a significant symptom of temporal lobe epileptiform dysfunction. In this type of epilepsy, an individual experiences acute behavioral disturbances, including, on some occasions, homicide and suicide, but does not remember any of his actions after the initial aura of the oncoming attack.

Unfortunately, because van Gogh did not recall the events surrounding his self-mutilation, we know very little about it. Gauguin's is the only

40. L481, ca. 3 May 1888, *Letters* 2:557.

41. See Howard Wolinsky, "Experts Tie Van Gogh's Suicide to Kin's Death," *Chicago Sun Times,* 13 May 1991, 1, 47.

42. Hulsker, *Vincent and Theo,* 322.

first-hand account of van Gogh's collapse in Arles, an account which is notoriously unreliable. He published the following recollection of the fateful events of December 23, 1888, fifteen years after the event (1903) in one of his journals, *Avant et Après:*

> My God, what a day! When evening came I ate a scant dinner and felt the need to go out alone for a stroll amid the scent of blossoming laurel. I had got almost to the other side of the Place Victor-Hugo when I heard a well-known little step behind me, quick and jerky. I turned around just as Vincent rushed at me with a razor in his hand. The look in my eyes at that moment must have been very powerful, for he stopped, lowered his head and ran back toward the house.
>
> . . . I went straight to a good hotel in Arles and, after inquiring what time it was, took a room and went to bed. I was so upset that I was unable to fall asleep until nearly three in the morning, and woke rather late, about half past seven.
>
> Reaching the square, I saw that a large crowd had gathered. Near our house were some gendarmes, and a little man in a bowler hat, who was the chief of police.
>
> This is what had happened: van Gogh went back to the house and immediately cut off his ear, very close to the head. It must have taken him time to staunch the flow of blood, for the next day a number of towels lay on the stone floor of the two ground-floor rooms. The blood had soiled both rooms and the little stairway which led up to our bedroom.[43]

Gauguin then reported that he discussed the incident with the police and left suddenly for Paris, without seeing Vincent in the hospital.

Gauguin's account has come under scrutiny in recent years, particularly his claim that van Gogh attacked him with a razor. Van Gogh's dear friend, Emile Bernard, was greatly distressed to hear of van Gogh's breakdown. He went to Gauguin to ask for a detailed account of what had happened and then relayed the following in a letter, dated January 1, 1889, to the art critic, Albert Aurier:

> I am so sad that I need somebody who will listen to me and who can understand me. My best friend, my dear Vincent, is mad. Since I have

43. Ibid., 322.

found out, I am almost mad myself. . . . I rushed to see Gauguin who told me this: "The day before I left [Arles], Vincent ran after me — it was at night — and I turned around, for Vincent had been behaving strangely for some time and I was on my guard." He then said to me, 'You are taciturn, but I shall be likewise.' I went to sleep in a hotel, and when I returned, the entire population of Arles was in front of our house. It was then that the gendarmes arrested me, for the house was full of blood. This is what had happened: Vincent had gone back after I left, had taken a razor and cut off his ear. He had then covered his head with a large beret and had gone to a brothel to give his ear to one of the inmates, telling her, 'Verily I say unto you, you will remember me.' "[44]

This account, which Gauguin conveyed to Bernard just days after the incident, shows that van Gogh did not intend violence toward Gauguin, since Gauguin reported that he took up the razor after returning to the house. Also, van Gogh did not "cut off his ear very close to the head," as Gauguin relayed in *Avant et Après,* but dismembered a part of his ear, which led to the excessive loss of blood. We know this from Theo's wife, Jo van Gogh-Bonger, who wrote, "a telegram arrived from Gauguin which called Theo to Arles. On the evening of 23 December, Vincent had in a state of violent excitement . . . cut off a piece of his ear and brought it as a gift to a woman in a brothel."[45]

But Vincent recovered rapidly, according to this letter, dated December 31, 1888, to Theo from a friend of Vincent's, Rev. Salles:

Monsieur, I am writing to give you news of your brother. I have just seen him and found him calm, in a state which revealed nothing abnormal. Unfortunately, as a result of the insane act which necessitated his admission to the hospital, and of his more than strange behavior there, the doctors have found it necessary to isolate him and lock him up in a separate room. It is their opinion that he should be transferred to a lunatic asylum and they have sent a report to this effect to the Mayor. This report will lead to an inquiry and the result will be sent to the

44. Ibid., 323. (The letter from Bernard was first published in 1956 in John Rewald's *Post-Impressionism.*)

45. Ibid., 329.

Prefect, who will probably arrange for your brother's transfer to Marseilles or Aix.

I wanted to warn you of what is going on with respect to your brother, something of which he himself seems to be fully aware. I repeat, I found him talking calmly and coherently. He is amazed and even indignant (which could be sufficient to start another attack) that he is kept shut up here, completely deprived of his liberty.[46]

The postman Roulin, who had attended van Gogh with the police immediately after his self-mutilation, shared Rev. Salles' opinion that van Gogh was quickly well again. Note that he describes van Gogh's self-mutilation as an "unfortunate accident," not a deliberate act. In a letter to Theo, dated January 3, 1889, he wrote:

Monsieur Gogh, I am happy to confirm the telegram I sent you today, in which I told you that my friend Vincent has completely recovered; he will leave the hospital one of these days to return to his house. Do not worry, he is better than before that unfortunate accident happened to him. At present, he can move freely about the hospital; we walked for more than an hour in the courtyard; he is in a very healthy state of mind. I don't know how to explain the severe measures that were taken to keep him from seeing his best friends.[47]

Van Gogh was allowed to leave the hospital in Arles on January 7, 1889, just a few short weeks after his horrible confrontation with Gauguin.

Sadly, van Gogh's recovery was short-lived and he suffered another psychotic episode in the first week of February, characterized by paranoia and hallucinations. In a letter dated February 7, 1889, Rev. Salles reported to Theo:

Monsieur, your brother, whom we had believed cured and who had taken up his usual work once more, has recently again shown signs of mental distress. For three days he has believed that he is being poisoned and is everywhere seeing prisoners and poisoned people. The cleaning lady, who looks after him with complete devotion, noticing the more abnor-

46. Ibid., 331.
47. Ibid., 332.

mal state he is in, has considered it her duty to report it — something that the neighbors have brought to the attention of the superintendent of police. He has put a watch over your brother and this afternoon had taken him to the hospital where he has been placed in a private cell. I have just seen him and got a very painful impression of the condition he is in. He hides himself in absolute silence, covers himself with his bedclothes and at times is weeping without uttering a single word.[48]

This time, van Gogh was hospitalized for ten days and returned again to a rational state of mind. He wrote to Theo on February 17, "Today, I have come home provisionally, I hope for good. I feel quite normal so often. . . ."[49] Van Gogh was not to stay at home for long, however. Because of his bizarre episode with Gauguin, the townspeople of Arles viewed him as a dangerous madman. They appealed to the Chief of Police to have van Gogh interned indefinitely in the hospital against his will. Rev. Salles wrote to Theo on February 26 of this unfortunate development. Soon after, in a letter dated March 1, Rev. Salles relayed to Theo that Vincent appeared to be fine and that his involuntary internment seemed quite unjustified:

> Monsieur, I have just been to see your brother at the hospital and found him reasonably well. Everyone, the intern, the administrator and the board of management, is well disposed toward him and it has been decided that someone will go with him to his house in order that he may collect his brushes and paints so that he may find some distraction during his stay at the hospital. Nevertheless, the problem remains the same. The superintendent of police, who has the petition about which I have written to you and who has made inquiries in the district, remains convinced that suitable measures should be taken. Yet it seems to me, and this view is shared by M. Rey [van Gogh's attending physician] that it would constitute an act of cruelty to permanently lock up a man who has done nobody any harm and who, as a result of a treatment based on kindness, can return to his normal state.[50]

Rev. Salles' description of Vincent as "a man who has done nobody any harm" suggests that Gauguin's 1903 account claiming that Vincent stalked

48. Ibid., 342.
49. Ibid.
50. Ibid., 344.

him with a razor may have been a blatant fabrication. Also, Rev. Salles reported to Theo, in a letter sent in mid-March, that Vincent appeared to be completely recovered. He wrote, "I hasten to tell you that much to my surprise, I found him entirely lucid and with a complete awareness of his condition."[51] Van Gogh himself candidly explained the situation to his brother in a letter dated March 19. Although he was shocked at his "imprisonment," he seemed to feel the need to hide his indignation in order to demonstrate his sanity:

> Anyhow, here I am, shut up in a cell for days on end, under lock and key with keepers, without my guilt being proved or even open to proof. Needless to say deep down in my soul, I have much to reply to all that. Needless to say, I cannot be angry, and excusing myself would mean to accuse myself.
>
> . . . You will understand what a staggering blow it was to find so many people here cowardly enough to join together against one man, and that man ill. Very well — so much for your guidance; as far as my mental state is concerned, I am greatly shaken, but I am regaining a sort of calm in spite of everything, so as not to get angry. Besides, humility becomes me after the experience of the repeated attacks. So I am being a patient.[52]

Vincent apparently suffered no repeated episodes during the weeks of his "imprisonment," and thus gradually gained more freedom to move about on the hospital grounds. The artist, Paul Signac, visited Vincent at the end of March and wrote to Theo of his impressions:

> I found your brother in perfect health, physically and mentally. Yesterday afternoon and again this morning we went out together. He took me along to see his pictures, many of which are very good, and all of which are very curious.
>
> His courteous doctor, the intern Rey, is of the opinion that, if he should lead a very methodical life, eating and drinking normally and at regular hours, there would be every chance that the terrible crises would not repeat themselves at all.[53]

51. Ibid., 345.
52. Ibid., 346 (Hulsker's translation of letter 579, 19 March 1888).
53. Ibid.

Van Gogh was not to stay in the hospital in Arles indefinitely. Upon the recommendation of Dr. Rey, and with Vincent and Theo's consent, he was admitted to a nearby asylum for the mentally ill in St. Rémy. There he would be able to come and go more freely and, most importantly, he could continue his painting without restriction. However, the effect of the traumatic events between December of 1888 and April of 1889 was a long-term residual depression. Van Gogh wrote often to his sister, Wilhelmina, who shared the same tendency toward depression. In June, he wrote that he found coffee to be an aid, and mentioned that he frequently experienced a kind of religious exaltation after drinking it. Van Gogh's apparent addiction to caffeine was actually a part of his asceticism. Rather than eating a nourishing meal, which he often could not afford, as he would spend the bulk of his allowance from Theo on paints and supplies, he drank copious amounts of coffee as a way of keeping himself going. He seemed to experience a euphoria that helped him to work feverishly while ignoring his physical needs for food and sleep:

> All this correspondence does not tend to keep us, who are of a nervous temperament, vigorous, in case of possible immersions in melancholy of the type you mention in your letter, and to which I myself fall victim now and then.
>
> . . . The remedy for the immersion which you mention is not, as far as I know, to be found growing among the herbs with healing powers. Nevertheless, I am in the habit of taking large quantities of bad coffee in such cases, not because it is very good for my already damaged collection of teeth, but because my strong imaginative powers enable me to have a devout faith — worthy of an idolater or a Christian or a cannibal — in the exhilarating influence of said fluid.[54]

Once all the arrangements were made, Rev. Salles took van Gogh from Arles to St. Rémy and sent an encouraging report to Theo on May 10, 1889. "Our journey to St. Rémy took place under ideal circumstances. M. Vincent was perfectly calm and explained his case himself to the director, like a man who is fully conscious of his position. He stayed with me until I left and when I said goodbye, he warmly thanked me and

54. W4, 22 June 1888, *Letters* 3:431.

appeared somewhat moved by the thought of the entirely new kind of life he was entering in that house."[55]

Immediately after van Gogh's admission to St. Rémy, however, he began to experience terrifying nightmares. Just after his first episode in Arles, he wrote to Theo that he suffered from insomnia, which he said he treated with "a very, very strong dose of camphor in my pillow and mattress. . . ."[56] Dr. Peyron, who was van Gogh's attending physician, first mentioned the nightmares in a report to Theo on May 26:

> . . . I am pleased to tell you that since his entry into this house, M. Vincent is completely calm, and finds that his health is improving day by day. At first he was subject to painful nightmares which upset him, but he reports that these bad dreams tend to disappear and become less and less intense, so that now he has a more peaceful and restoring sleep; he also eats with better appetite.
>
> To sum up: since his arrival here, there has been a slight improvement in his condition which makes me hope for a complete recovery. He spends the whole day drawing in the park here, but as I find him entirely tranquil, I have promised to let him go in order to find interesting sights outside this establishment.
>
> You ask for my opinion regarding the probable development of his illness. I must tell you that for the time being I will not make any prognosis, but I fear that it may be serious as I have every reason to believe that the attack which he had was the result of a state of epilepsy and if this should be confirmed, one should be concerned about the future.

A new report from Dr. Peyron, sent in the beginning of September, reveals the erratic nature of van Gogh's illness. Dr. Peyron explained that van Gogh's nightmares persisted, that he had been suicidal, and that he was now once again lucid and calm. "I add a few words to your brother's letter to inform you that he has quite recovered from his crisis, that he has completely regained his lucidity of mind and that he has resumed painting just as he used to do. His thoughts of suicide have disappeared, only

55. Hulsker, *Vincent and Theo*, 353.
56. L570, 9 January 1889, *Letters* 3:116.

disturbing dreams remain, but they tend to disappear too, and their intensity is less great."[57]

Intervals of calmness and lucidity, in which van Gogh felt compelled to work diligently, always followed his "attacks." He took great consolation in his work during the intervals. He explained optimistically, "Now my brain is working in an orderly fashion, and I feel perfectly normal."[58] "It is a great consolation for me that the work is progressing instead of declining, and that I do it with absolute calmness and that, in this respect, my thoughts are quite clear and conscious."[59] Dr. Peyron assured Vincent that, because of the lengthy intervals of lucidity between the episodes of behavioral disturbances, he was not considered insane. He encouraged van Gogh to continue painting, trying to work around his illness.

Although the misconception persists that van Gogh painted in a frenzy of psychotic illusion, it is clear from van Gogh's own words regarding his flurry of activity during the intervals, that he did not paint at all while he was suffering an attack. Instead, he made every attempt to accomplish as much as possible while he was calm. His illness, therefore, had very little direct impact on his art. He explained, "I think Dr. Peyron is right when he says that I am not strictly speaking mad, for my mind is absolutely normal in the intervals, and even more so than before. But during the attacks, it is terrible — and then I lose consciousness of everything. But that spurs me on to work and to seriousness, like a miner who is always in danger, makes haste in what he does."[60]

In addition to the intervals of lucidity between his attacks, another prominent feature of van Gogh's illness was the experience of auditory and visual hallucinations during his periods of crisis, which occurred during both his hospitalizations in Arles and St. Rémy:

I am again, speaking of my condition — so grateful for another thing. I gather from others that during their attacks, they have also heard strange sounds and voices, as I did, and that in their eyes too, things seemed to be changing.

. . . There is someone here who has been shouting and talking like

57. L602a, 3 or 4 September 1889, *Letters* 3:199.
58. L604, 5 or 6 September 1889, *Letters* 3:204.
59. L606, 19 September 1889, *Letters* 3:213.
60. L610, ca. 8 October 1889, *Letters* 3:223.

me all the time, for a fortnight. He thinks he hears voices and words in the echoes of the corridors, probably because the nerves of the ear are diseased and too sensitive, and in my case, it was my sight as well as my hearing, which according to what Rey told me one day is usual in the beginning of epilepsy.[61]

As his illness progressed, van Gogh became increasingly focused on religion. This preoccupation dates from his internment in Arles and continued throughout the rest of his life. The postman Roulin explains that van Gogh turned to religion for comfort: "When I left him I told him that I would come back to see him; he replied that we would meet again in heaven, and from his manner, I understood that he was praying."[62] When van Gogh left the hospital in Arles, he wrote to Theo that his illness took on the character of religious exaltation, in which "there are moments when I am twisted by enthusiasm or madness or prophecy."[63] When van Gogh entered St. Rémy, he began having religious visions, which he attributed to his surroundings. The asylum of St. Paul-de-Mausole had once been an Augustinian monastery, and the nurses attending van Gogh were Catholic nuns. Although consumed with his own religious quest, van Gogh did not share the religious credulity of the nurses at St. Rémy:

> When I realize that here the attacks tend to take an absurd religious turn, I should almost venture to think that this even necessitates a return to the North. Don't talk too much about this to the doctor when you see him — but I do not know if this is not caused by living in these old cloisters so many months, both in the Arles hospital and here. In fact, I really must not live in such an atmosphere, one would be better in the street. I am not indifferent and even when suffering, sometimes religious thoughts bring me great consolation.
>
> . . . But what annoys me is continuing to see these good women who believe in the Virgin of Lourdes, and make up things like that, and thinking that I am a prisoner under an administration of that sort, which very willingly fosters these sickly religious aberrations, whereas the right thing would be to cure them.

61. L592, 2 June 1889, *Letters* 3:175.
62. Quoted in Hulsker, *Vincent and Theo*, 330.
63. L576, 3 February 1889, *Letters* 3:134.

. . . You understand that I have tried to compare the second attack with the first, and I only tell you this, it seemed to me to be caused by some outside influence than by something within myself. I may be mistaken, but however it may be, I think you will feel it quite right that I have a horror of all religious exaggeration.[64]

When van Gogh speaks here of his "horror of all religious exaggeration," he is referring to the superstitious beliefs of the French peasantry, particularly the peasants of Brittany who were the subjects of many of the works his friends Gauguin and Bernard painted. Gauguin's well-known *Vision after the Sermon,* for example, depicts Breton women, with their characteristic white bonnets, consumed with a vision of Jacob wrestling the angel as they are leaving a small country church. The French peasants believed in the reality of such visions as well as the magical healing powers of such "sacred places" as Lourdes. In his struggle to find a modern faith, van Gogh found this type of religious superstition especially repellent. He must have had similar types of auditory and visual hallucinations himself, since he came to feel that the environment of a former French Augustinian monastery was actually contributing to his illness.

Van Gogh's preoccupation with religious ideas and subject matter was actually somewhat unsettling to him. After he had painted his *Berceuse* (a portrait of Mrs. Roulin rocking a baby's cradle), for example, he wrote to Theo that he would have continued on to paint portraits of "saints and holy women," but that he found it too disturbing. This explains the tension in van Gogh's letters between his criticism of Gauguin's and Bernard's religious subjects, on the one hand, and his own painting of a number of overtly religious works during his stay at St. Rémy, on the other. He considered himself a "modern man," not given to "vulgar" religious sentiments, but was nevertheless uncontrollably drawn to the religious images of his youth. He explained:

. . . if I had the strength to continue, I should have made portraits of saints and holy women from life who would have seemed to belong to another age, and they would be middle-class women from the present day, and yet they would have had something in common with the very primitive Christians. However, the emotions which that rouses are too

64. L605, 7 or 8 September 1889, *Letters* 3:208.

strong, I shall stop at that [his painting of the Berceuse] but later on, I do not say that I shall not return to the charge.[65]

I am astonished that with the modern ideas that I have, and being so ardent an admirer of Zola and de Goncourt, and caring for the things of art as I do, that I have attacks such as a superstitious man might have and that I get perverted and frightful ideas about religion, such as never came into my head in the North.[66]

Along with Vincent, Theo was convinced that the "fits of religious exaltation," as Vincent called them, occurred because he was housed in a Catholic institution.[67] Theo insisted that should Vincent require hospitalization again, he must be sent to a secular institution.[68] Vincent explained to Theo that should another "fit" occur, he would like to leave at once, "without giving reason."[69] Neither of the brothers realized that the heightened sense of religiosity Vincent experienced was actually typical of his form of epilepsy, not simply a product of his environment.

We know from van Gogh's own letters that the first attending physician he saw, Dr. Rey, told him that he suffered from a form of epilepsy, which was the root cause of his mental disorder. Later, at St. Rémy, Dr. Peyron concurred with the diagnosis Dr. Rey made at Arles. When Vincent left the asylum, Dr. Peyron made the entry, "He tells us that a sister of his mother was epileptic and that there were several cases known in his family. What had happened to this patient seemed to have only been the continuation of what had happened to several members of his family."[70] Neither of van Gogh's attending physicians, in either institution in which he was treated, considered van Gogh to be insane.

Epilepsy was a celebrated topic of research and discussion within the medical community in nineteenth-century France. As early as 1838, a Dr. Esquirol published research on the phenomenon of epilepsy without convulsive seizures, which he described as a behavioral disorder characterized by episodes of bizarre activity. In 1862, Professor Trousseau, of the Faculty

65. Ibid., 211.
66. L607, 19 September 1889, *Letters* 3:214.
67. Ibid., 218.
68. T17, 18 September 1889, *Letters* 3:552.
69. L607, 19 May 1889, *Letters,* 3:218.
70. Quoted in Hulsker, *Vincent and Theo,* 353.

of Medicine at the University of Paris, published his findings that patients suffering from this disorder exhibited abnormal behavior, including even homicide and suicide.[71]

Dr. Rey was especially well-equipped to diagnose van Gogh's unique problem. His mentor during his medical training, Dr. Mairet, had been interested in the phenomenon then known as l'epilepsie larvée, or epilepsy "masked" by the absence of seizures. He published an article on the subject in 1889 in *La Revue de Medecine*. In addition, a fellow student, who submitted his doctoral thesis to the Faculty of Medicine at Montpellier in the same year as Dr. Rey, 1890, had written about the phenomenon of "masked epilepsy." Dr. Rey's colleague, Dr. Aussoleil, concluded that epilepsy does occur in patients who do not experience seizures, taking the form of periodic episodes of agitation and madness, followed by periods of calm. This pattern uniquely distinguishes l'epilepsie larvée from other types of mental illness. Dr. Aussoleil was an intern at the psychiatric hospital at Montdevergues, less than forty kilometers from the hospital in Arles where Dr. Rey was an intern. Perhaps Dr. Rey consulted his colleague in Montdevergues about van Gogh's case. He also could have consulted his mentor in Montpellier, which was close by, since he was in fact still in the process of completing his degree when he encountered van Gogh's case in December, 1888.

In 1928, Dr. Victor Doiteau and Dr. Edgar Leroy published the first major discussion of van Gogh's illness, *La Folie de Vincent van Gogh,* confirming Dr. Rey's original diagnosis of epilepsy. They published the original doctor's reports that were recorded when van Gogh entered the asylum at St. Rémy. Dr. Edgar Leroy had unique access to these accounts because he was, at one time, director of the asylum of St. Paul-de-Mausole. Many who have reported on van Gogh's mental crisis since have neglected these first-hand reports.

The following account, written by Dr. Peyron, explains van Gogh's condition when he came to St. Rémy:

> I, the undersigned physician, director of the Lunatic Asylum of Saint-Rémy, declare that Vincent van Gogh, 36 years old, born in the Netherlands, and at present living in Arles, undergoing a treatment in the hospital of that town, has been affected by a severe nervous attack,

71. Remo Fabbri, M.D., "Dr. Paul-Ferdinand Gachet: Vincent van Gogh's Last Physician," *Transactions of the College of Physicians* 4, series 32-33 (1964): 205.

accompanied by hallucinations of sight and hearing, which have led him to the act of mutilating himself by cutting off his ear. At present, he seems to have come back to reason, but he does not have the strength and courage to live in freedom as he has asked himself to be admitted to this house. In consequence of what preceded, I conclude that M. van Gogh is subject to attacks of epilepsy, far distanced from each other, and that there is reason to subject him to a prolonged observation in the establishment.

Saint-Rémy, 9 May 1889
Signed: Doctor Th. Peyron[72]

Two weeks later, Dr. Peyron wrote that van Gogh had experienced "notable improvement" but that he was still in need of further treatment and should be kept at St. Rémy.

After a year's stay at St. Rémy, van Gogh left with the hope that he might find full recovery and peace in his new home north of Paris, Auvers-sur-Oise. The small rural town of Auvers, located on the banks of the Oise River, had a significant "artistic presence." The famed French painter, Daubigny, built a large home and studio in the center of town, where he lived from 1861 until his death in 1878. Van Gogh paid homage to him in one of his last paintings, *Daubigny's Garden* (July, 1890). Cézanne had also painted at Auvers, and it is here that van Gogh made the acquaintance of his artist-friend and physician, Dr. Paul Gachet. Auvers represented a kind of "artists' colony" in the north to replace van Gogh's dream of his "artists' studio" in the south. That van Gogh went north had a particular significance as well, since he associated the southern regions with the French way of life and the northern regions with his Dutch heritage. Van Gogh expressed his association of northern France with his Dutch past with a specifically religious symbol, the church spire. The churches that van Gogh painted while living in the north of France, with their elongated pointed spires, recall the Dutch churches he painted when he was living in Nuenen. It was one of the ways in which van Gogh combined the traditions of the past with his new surroundings, a Dutch spire appearing in a French landscape. Van Gogh still had a need to feel connected to the past, but he had great hopes for healing and rejuvenation as he began a new life in the French countryside.

72. Quoted in Hulsker, *Vincent and Theo*, 352.

On van Gogh's final day at St. Rémy, May 16, 1889, Dr. Peyron made the following entry in the hospital registry regarding van Gogh's hospitalization:

> The patient, who was calm most of the time, has experienced during his stay in the institution several attacks with a duration of a fortnight to a month; during these attacks, the patient is a victim of terrible anxieties, and he has repeatedly tried to poison himself, either by swallowing the colors that he used in painting, or by drinking the petrol he had surreptitiously taken from the attendant who was filling the lamps. The last attack he has suffered took place after he made a trip to Arles and lasted some two months. In between the attacks the patient is completely calm and lucid; he then abandons himself with passion to his painting.
>
> Today, he asks for the permission to leave in order to move to the north of France, hoping that the climate there will be better for him.[73]

Clearly, van Gogh's illness had continued to follow the same course — with psychotic episodes, followed by periods of calm and prodigious output of artistic creativity. Dr. Peyron does, however, add some confusing details. He says that van Gogh's crises endured for two to four weeks at a time. It is more likely that van Gogh suffered brief periods of agitation or madness, followed by residual lethargy and depression. We know that he suffered such bouts of melancholia as he had described to his sister, Wilhelmina, and that he refrained from working during these periods which often endured for six to eight weeks. Dr. Peyron also mentions the strange incidents of van Gogh's ingesting his paints and the petrol he took from the attendants when they were lighting the lamps.[74]

73. Quoted in Hulsker, *Vincent and Theo*, 414.
74. In 1988, a biochemist, Wilfred Arnold, published an article in *JAMA* suggesting that van Gogh's behavior was a product of an addiction to the chemical, thujone, which may have been present in the lamp-oil and the oil paints, as well as the compound absinthe, which van Gogh was fond of drinking. Since Jan Hulsker has provided an excellent critique of Arnold's thesis, demonstrating that it depends on unreliable sources and greatly exaggerates van Gogh's "drinking problem," it is unnecessary to discuss the details of the argument here. It suffices to add that van Gogh's attacks became more severe and frequent when he had stopped drinking absinthe altogether. Van Gogh's first physician, Dr. Rey, had already made the appropriate connection between absinthe and van Gogh's condition; it was an exacerbating, not a causative factor.

Because of van Gogh's tendency toward depression, his ingestion of lamp-oil seems an attempt to poison himself and thus end his misery. Hoping that van Gogh might ultimately recover, Dr. Rey suggested that in addition to abstaining from alcohol, particularly absinthe, van Gogh should also refrain from tobacco and should establish a reasonable diet. However bizarre van Gogh's behavior may have seemed, Dr. Peyron apparently believed van Gogh was well enough to be released from St. Rémy. He stated the reason for van Gogh's release as "recovered."

After his release, Vincent went first to Paris to visit Theo and Johanna, to see his new nephew and namesake, Vincent, before settling in to his new home in Auvers. Johanna recorded that she was pleasantly surprised to see how remarkably well Vincent appeared when he disembarked the train. "I had expected a sick person, but he was a sturdy broad-shouldered man, with a healthy color, a smile on his face, and a very resolute appearance; . . . he looks much stronger than Theo, was my first thought."[75]

On May 20, 1889, van Gogh left for Auvers. Numerous other artists whose works van Gogh enjoyed, including Pissarro, Daubigny, and Cézanne, had previously found the small French village suitable for painting. Here van Gogh hoped to find rejuvenation and rest. He seemed somehow convinced that his entire problem could be resolved simply by a change in environment. "I still think that it is a disease of the south that I have caught and that returning here will be enough to dissipate the whole thing."[76] Van Gogh was put under the close supervision of a local doctor who was himself an artist, Dr. Paul-Ferdinand Gachet. At first, van Gogh seemed apprehensive to trust Dr. Gachet whom he remarked suffered from "the nervous trouble . . . at least as seriously as I."[77] Van Gogh's concern quickly dissolved, however, and he and Dr. Gachet soon became friends. He wrote to his sister, Wilhelmina, that "I have found a true friend in Dr. Gachet, something like another brother, so much do we resemble each other physically and also mentally. He is a very nervous man himself and very queer in his behavior; he has extended much friendliness to the artists of the new school, and he has helped them as much as was in his power."[78]

75. Hulsker, *Vincent and Theo*, 415.
76. L637, 25 May 1889, *Letters* 3:275.
77. Hulsker, *Vincent and Theo*, 418.
78. W22, ca. 5 June 1889, *Letters* 3:469.

Dr. Gachet was probably the only other first-hand witness, besides Gauguin, to another of van Gogh's crises, a crisis that mimicked his disastrous break with Gauguin. We must say "probably" because van Gogh's biographers have considered the source of the account of the incident, Dr. Gachet's son, Paul, to be unreliable.[79] Doiteau, in *La Folie de Vincent van Gogh,* first made the incident public in 1928, after van Gogh's work had achieved notoriety. Paul Gachet Jr. claimed that van Gogh's concern over what he believed was a disrespectful treatment of an important painting, a half-nude by Guillamin, which belonged to Dr. Gachet, had prompted the incident. According to Dr. Gachet's son, van Gogh, who was a great admirer of Guillamin, noticed one day that Dr. Gachet had a fine female nude in his possession that he had not yet framed:

> Noting this, he flew into a violent rage, burst into insults, and demanded that a frame be ordered at the carpenter's inn at Auvers without delay. When he came back a few days later, he found the painting in the same state. He showed a terrible irritation and suddenly, he put his hand in one of his pockets. Dr. Gachet understood that it was to seize a revolver. He did not lose his head; just like Gauguin in Arles, when Vincent had threatened him with a razor, he looked at him with a domineering glance, which stopped him at once. Overpowered, Vincent took his hand from his pocket, empty, went to the door and went out with a contrite air. The next day he came back to the doctor's place. He did not talk about his gesture of the preceding day. He certainly had no recollection of this painful adventure.[80]

The suggestion that Vincent had a revolver in his possession and intended to injure Dr. Gachet seems very unlikely. Just as the incident with Gauguin was falsely embellished, this encounter between van Gogh and Gachet seems to have been embroidered as well. Dr. Gachet would hardly have been able to conclude that van Gogh had a revolver by his simple gesture of placing his hand in his pocket, nor would Gachet have permitted van Gogh to leave his home, armed and deranged.[81] It seems likely, nonetheless, that something unusual did occur. Perhaps van Gogh

79. Hulsker, *Vincent and Theo,* 443.
80. Ibid., 442.
81. Ibid., 443.

had become excessively agitated for what seemed a trivial reason, verbally attacked Dr. Gachet, and then left suddenly with no recollection of the irrational outburst. Paul Gachet Jr. was nineteen at the time of the incident which he apparently witnessed with his seventeen-year-old sister, Marguerite. His recollection to Dr. Doiteau was probably not a fabrication but rather another sensationalized account of van Gogh's erratic behavior, similar to Gauguin's recollection of van Gogh's self-mutilation which appeared in *Avant et Après*. The event in question does follow the pattern of van Gogh's illness — episodic outbursts or incidents of psychotic behavior, followed by complete amnesia of the events that had just taken place — which Dr. Rey, in Arles, and Dr. Peyron, in St. Rémy, attributed to epilepsy.

Dr. Gachet shared the medical opinion of his predecessors, convinced that van Gogh suffered from a type of non-convulsive epilepsy, complicated by periods of reactive depression. He treated him according to the dictates of "le régime moral," which included bromide therapy.[82] The efficacy of bromide therapy for van Gogh's type of illness was controversial. We now know that bromide may in fact exacerbate the type of condition from which van Gogh suffered and may actually have contributed to both the severity and frequency of van Gogh's attacks during the last year of his life.

The diagnosis of temporal lobe epileptiform illness, however convincing, leaves a few unanswered questions. Why did Vincent van Gogh's siblings, for example, suffer similar mental disorders? Since epilepsy is not hereditary, the problems faced by van Gogh's two brothers, Theo and Cor, as well as his sister, Wilhelmina, cannot be automatically attributed to a type of psychomotor epilepsy. While van Gogh's siblings clearly suffered from depression, it was probably not related to epilepsy.

Neither can Dr. Rey's diagnosis of psychomotor epilepsy adequately explain van Gogh's suicide. A comparison of van Gogh's first acute mental crisis, the infamous mutilation of his ear, with his suicide reveals a very different pattern. Typical of psychomotor seizures, van Gogh's self-mutilation was involuntary. He experienced a lapse of consciousness, took the razor to his ear, and then collapsed. Later, he had no memory whatsoever of the incident. Had van Gogh died immediately from his self-inflicted

82. Fabbri, "Dr. Paul-Ferdinand Gachet: Vincent van Gogh's Last Physician," 202-8.

gunshot wound, it might also have appeared to be an involuntary act prompted by a psychomotor seizure. He did not, however, die until two days later. Adeline Ravoux, who was the daughter of the innkeeper who attended van Gogh in his room while he languished for two days, gave a detailed account of van Gogh's tragic death. Because it was not recorded until 1956, it may not be completely reliable, but it does indicate beyond question that van Gogh's suicide was a premeditated voluntary act:

> That Sunday he had gone out immediately after breakfast, which was unusual. At dusk he had not yet returned, which surprised us very much, for as he was extremely correct in his contacts with us, he always arrived at the regular hours of the meals. We were all sitting on the terrace of the café, which only happened on Sundays after the hustle of a day that was more exhausting than the weekdays. When we saw Vincent arriving, the night had fallen; it must have been around nine o'clock. Vincent walked bent down a little, holding his hands on his belly and exaggerating his habit of holding his one shoulder higher than the other. Mother asked him, "Monsieur Vincent, we were worried, we are glad to see you come home; has anything unfortunate happened to you?"
>
> He answered with a painful voice, "No, but I . . ." He did not finish the sentence, went across the café to the staircase and went up to his room. I was witness to that scene.
>
> Vincent had made such a strange impression upon us that Father stood up and went to the staircase to listen if something unusual was happening. He thought he heard someone groaning, went quickly upstairs, and found Vincent on his bed, crouched like a hunting dog, his knees up to his chin, and moaning heavily. "What is the matter?" asked Father, "Are you ill?" Thereupon Vincent lifted up his shirt and showed a small wound in the region of the heart. Father cried out, "Poor fellow, what have you done?"
>
> "I wanted to kill myself," Van Gogh replied.
>
> . . . Next morning, two gendarmes of the brigade of Méry, who had probably been alarmed by the gossip of the public, appeared at our house. One of them, called Rigaumon, questioned Father in an unpleasant tone, "Is it here that there has been a suicide?" Father asked him to watch his manners and then invited him to come upstairs to see the dying man. He went first into the room, explained to Vincent that in a case like this the French law prescribed an investigation for which

the gendarmes had come. They came in, and still in the same tone, Rigaumon questioned Vincent, "Is it you who has tried to commit suicide?"

"Yes, I think so," replied Vincent in his usual soft way.

"You know that you do not have the right to do so."

In the same quiet tone Van Gogh said: "Gendarme, my body is mine and I am free to do with it what I want. Accuse nobody, it is I who wanted to commit suicide."[83]

While van Gogh did not exhibit symptoms of a temporal lobe lesion until 1886, at the age of thirty-four, he first mentioned suicide to his brother in a letter from 1877. "I breakfasted on a piece of dry bread and a glass of beer — that is what Dickens advises for those who are on the point of committing suicide, as being a good way to keep them, at least for some time, from their purpose."[84] In early September of 1889, Dr. Peyron wrote to assure Theo that van Gogh's "thoughts of suicide" had disappeared.[85] A week later, van Gogh wrote describing his own intense struggle to recover after a recent attack, comparing it with a suicide attempt. "During the attacks, I feel a coward before the pain and suffering — more of a coward than I ought to be, and it is perhaps this very moral cowardice which, whereas I had no desire to get better before, makes me eat like two now, work hard, limit my relations with the other patients for fear of a relapse — altogether I am now trying to recover like a man who meant to commit suicide and finding the water too cold, tries to regain the bank."[86]

The very earliest letters we have from van Gogh to his brother, dating from 1873, indicate occasional bouts of depression. He urged, "Theo, I strongly advise you to smoke a pipe; it is a good remedy for the blues, which I happen to have now and then lately. . . ."[87] A somber tone pervades van Gogh's whole corpus of letters. The word "sorrow" appears very frequently, belying his rather melancholic nature. It was this melancholy that dictated his penitential piety, with its emphasis on suffering and persevering through the trials of the Christian pilgrimage toward the ultimate release and union with Christ in death. Van Gogh's depression

83. Hulsker, *Vincent and Theo*, 444.
84. L106, 18 August 1877, *Letters* 1:135.
85. L602a, 3-4 September 1889, *Letters* 3:199.
86. L605, 7 or 8 September 1889, *Letters* 3:207.
87. L5, 17 March 1873, *Letters* 1:4.

was at times so pervasive and profound that it all but consumed him, as he recounted in an 1876 letter: "I had been ill. My mind was fatigued, my soul was disillusioned, my body suffering. I, whom God had endowed at least with moral energy, and with a strong instinct for affection, I fell into an abyss of the most bitter discouragement, and with horror, I felt a deadly poison penetrate my smothered heart."[88]

Just weeks before his suicide, Vincent wrote to Theo, who was then experiencing some serious financial difficulties, despondent that he might be an unbearable burden to his brother at such a difficult time. The letter reveals the depths of van Gogh's emotional torment, as well as his increasing feelings of isolation and sadness.

> It was no slight thing when we all felt our daily bread was in danger, no slight thing than for reasons other than that we felt that our means of subsistence was fragile.
>
> Back here, I still felt very sad and continued to feel the storm which threatens you weighing on me too. What was to be done — you see, I generally try to be fairly cheerful, but my life is also threatened at the very root, and my steps are also wavering.
>
> I feared — not altogether but yet a little — that being a burden to you, you felt me to be rather a thing to be dreaded, but Jo's letter proves to me clearly that you understand that for my part, I am as much in toil and trouble as you are.
>
> There — once back here I set to work again — though the brush almost slipped from my fingers, but knowing exactly what I wanted, I have painted three more big canvases since.
>
> They are vast fields of wheat under troubled skies, and I did not need to go out of my way to try to express sadness and extreme loneliness.[89]

The paintings to which van Gogh refers include his enigmatic late work, *Crows over the Wheatfield* (July, 1890), often described as his "suicide painting." This letter, as well as the painting, demonstrates van Gogh's struggle to overcome despondency, to "try to be fairly cheerful," in the face of what he perceived to be a threat to his very survival, the possible loss of Theo's financial support.

88. L76, 9 October 1876, *Letters* 1:69.
89. L649, 10 July 1890, *Letters* 3:295.

Although patients with epileptiform illness often suffer reactive depression, both the duration and depths of van Gogh's melancholia suggest a separate cause. While most of the physicians who have attempted a posthumous diagnosis of van Gogh have searched for the one illness which would account for all of van Gogh's various physical and psychological symptoms, the possibility that he suffered from two different, possibly unrelated, disorders is more plausible.

Like most individuals with seizure disorders, van Gogh also frequently suffered from depression. But, was his depression simply a response to a stressful situation or event, such as an increase in the severity and number of his epileptic seizures, or was the depression more profound and pervasive, having instead a biological cause? While van Gogh's suicide clearly indicates psychotic depression, most physicians who attempted to diagnose his illness after his death argued that his depression was reactive and temporary.

Van Gogh often suffered lengthy periods of lethargy and despondency after his attacks, some lasting as long as six to twelve weeks. Some have suggested that van Gogh suffered from a "bipolar affective disorder," referring to manic depressive psychosis, arguing that van Gogh suffered alternating fits of exaltation and depression. While van Gogh does occasionally mention moods of heightened awareness and ecstasy, he did not have frequent mood swings, but struggled with melancholy throughout his life.

While popular notions of manic depressive disease suggest that the disorder is characterized by the opposite extremes of elation and despondency, this is rarely the case. "Manic depressive disease or psychosis is a disorder of affect [mood], consisting of episodes of depression or mania, or both. Although it has been regarded traditionally as a periodic or cyclic condition in which one major mood swing is followed by an equal and opposite excursion, this is seldom the case. Depression is far more prevalent than mania, and the mixed variety, containing both extremes, is relatively uncommon."[90]

Affective disorders often occur in the relatives of individuals who are clinically depressed, which might explain the tendency toward melancholia in van Gogh's sister, Wil, and brother, Theo, as well as the suicide of his brother, Cor. Individuals who suffer from affective disorders as well as those who suffer from depression are at high risk for committing suicide.[91]

90. Adams and Victor, *Principles of Neurology,* 1209.
91. Ibid., 1212.

When an individual who suffers from endogenous depression commits suicide, it is not generally a capricious or spontaneous act but premeditated and deliberate.[92] That both Vincent and Cor van Gogh took their own lives is clear indication of a family tendency toward endogenous depression.

In addition to a familial tendency toward depression, physicians now argue that the type of pervasive depression which both van Gogh and his two brothers and sister seemed to have experienced has a biological root cause, a deficiency of the biogenic amines: norepinephrine, serotonin, and dopamine. As a result of this deficiency, individuals simply do not experience pleasure to the same degree as others, often struggling with bouts of "the blues." This is certainly consistent with van Gogh's case history. Throughout his entire life, he exhibited a somber, serious disposition and struggled, much to his credit, to maintain hope for a better future. His suicide was simply the final act, ending a tragically difficult life.

A diagnosis of endogenous depression, in conjunction with temporal lobe dysfunction, would encompass the rest of van Gogh's symptoms, including his gastro-intestinal discomfort, impotence, insomnia, and tendency to experience feelings of worthlessness. "The essential diagnostic criteria of endogenous depression consist of a dysphoric mood or loss of interest or pleasure in almost all usual activities in combination with at least four of the following symptoms: (1) disturbance of appetite and change in weight; (2) sleep disorder; (3) psychomotor retardation or agitation; (4) decreased sex drive; (5) decreased energy and fatigue; (6) self-reproach, feelings of worthlessness or guilt; (7) indecisiveness, complaints of memory loss and difficulties in concentrating; (8) thought of death or suicide, or suicide attempts."[93] The characteristic symptom of "hypochondriacal preoccupation with bowel and digestive functions" might explain van Gogh's occasional complaints of problems with digestion and stomach pain.

Van Gogh experienced at least six of the hallmark symptoms of endogenous depression consistently over the course of his lifetime.[94]

92. Ibid., 1215.
93. Ibid.
94. Dr. R. E. Hemphil, in a paper presented to the Royal Society of Medicine in 1961, argues for a diagnosis of temporal lobe epilepsy and manic depressive psychosis, with the exacerbating factor of absinthe addiction.

A number of hypothetical diagnoses have been made. The most important were schizophrenia, psychopathic personality, temporal lobe epilepsy and cerebral syph-

Whether his depression was a form of manic depressive psychosis is diffi-
cult to ascertain, but certainly both the depression and the behavioral
disturbances which resulted from temporal lobe epileptiform illness were
physiological in nature. It is therefore inappropriate to view van Gogh as
insane or to view his art as the product of a mad, albeit creative, genius.
His illness did, however, have an effect on his art, not so much on its style,
as so many have argued, but rather, on the content. Next, we will examine
the way in which van Gogh's illness, which produced religious exaltations
and visions, affected his choice of subject-matter as an artist, a phenomenon
which has been largely overlooked.

ilis. These have been discussed fairly fully by Kraus (1941) and Gastaut (1956).
Of schizophrenia and cerebral syphilis I find no evidence. His relationships with
friends and indeed his character exude psychopathy and the episodes of antisocial
behavior were due entirely to illness or alcohol. Temporal lobe epilepsy has been
argued persuasively by Gastaut, but this diagnosis is too narrow to explain the
wide psychiatric disturbances.

In my opinion, van Gogh was a manic depressive who developed confusional
episodes and fits in the last two years of his life due to the toxic action of thujone,
the active agent of absinthe, to which he had become addicted. R. E. Hemphil,
M.A., M.D., D.P.M., "The Illness of Vincent van Gogh," *Proceedings of the Royal
Society of Medicine* 54 (13 June 1961): 28.

5. At Eternity's Gate

DURING THE YEARS BETWEEN 1880, WHEN HE LEFT THE CHURCH to become an artist, and his arrival at St. Rémy in May of 1889, van Gogh experimented with different approaches to religion in general and Christianity in particular. Although he digressed from his earlier Christian beliefs in search of a synthesis of Christianity with modernity, he never fully abandoned his past faith. It continued to inform his life as well as his art.

After his crisis and hospitalization in Arles, van Gogh began to return to the security of past traditions, both personally and artistically. In the final period of his life, the St. Rémy-Auvers period, for example, he abandoned his experiments with both impressionist and symbolist styles of painting. His palette became darker and more subdued, recalling the rich, golden hues of his Dutch artistic heritage. He no longer felt comfortable painting "from the imagination" as Gauguin had urged him to, but insisted instead on painting from reality. Finally, rather than the thin washes of color Gauguin and the other symbolists favored, van Gogh returned to the viscous layers of impasto, built one layer upon another, typical of artists he had admired in his earlier career, such as Monticelli.

Just as his artistic journey brought him back to the traditions of his Dutch past, his religious pilgrimage also returned to its roots. While van Gogh ached for regeneration in the asylum at St. Rémy, he became increasingly aware of his profound need for religious faith. He wrote to Theo, "That does not keep me from having a terrible need of — shall I say the

word — religion. Then I go out at night to paint the stars."[1] At St. Rémy, he began a journey back to the Christianity of his youth, in which Kempis and Bunyan had played such a formative role. During the St. Rémy period, van Gogh painted his first renditions of overtly Christian and biblical subjects: *The Pietà* (1889, plate 6), *The Raising of Lazarus* (1890, plate 7), and *The Good Samaritan* (1890, plate 8). He also reworked in oil one of his earliest prints, which he had given the obviously religious title, *At Eternity's Gate.* He painted other works which demonstrate by turns the tension and the synthesis of traditional religious imagery, which he had embraced before 1880, with modern, more subtle symbols. Many of these works, particularly the traditional Christian subjects, indicate the prolonged impact of van Gogh's devotional reading, especially *The Imitation of Christ* and *The Pilgrim's Progress,* on his life and his art. *Starry Night* (1889, plate 4) sums up the totality of van Gogh's religious experience in a breathtaking visionary masterpiece that recalls the mysticism of the Groningen School, the theology on which he was raised. Finally, in the works, *Crows over the Wheatfield* (1890, plate 12) and *At Eternity's Gate* (1890, plate 9), van Gogh expresses the sorrow as well as the sense of release as his life journey comes to its end. With all the torture and anguish of van Gogh's life during this period, he remained ultimately hopeful because, through it all, he persisted in his belief in a life "beyond the grave" where he would at once find rest and peace.

When van Gogh first came to St. Rémy in May of 1889, it was his hope and expectation that he would find healing and perhaps full recovery from the devastating illness and the mental crises that had plagued him since his self-mutilation in December of 1888. When he settled into the quiet retreat of Auvers-sur-Oise, he fully expected to leave his illness behind and start a new life, free from the nightmare of seizures, hallucinations, and depression. His hope for recovery never materialized, however, and his attacks became more frequent and severe. While this final period of van Gogh's life did not bring the recovery he expected, it was perhaps the most successful of his artistic career. His output was prodigious as well as prolific, especially given the limitations of his environment. Initially, because van Gogh's doctors would not permit him unaccompanied travel beyond the immediate environs of the asylum of St. Paul-de-Mausole, much of his work involved painting the grounds, particularly the gardens,

1. L543, 29 September 1888, *Letters* 3:56.

or producing works largely from memory or imagination, something which van Gogh never fully endorsed himself.

While most critics of van Gogh's art have spoken of the ostensible stylistic ramifications of his illness, it is actually the subject-matter van Gogh chose to paint during his confinement at St. Rémy that most demonstrates the effect of his illness on his work. The Christ with the Virgin Mother, the depictions of the biblical stories of Lazarus and the Good Samaritan, the old man at the threshold of eternity, the prophetic vision of his star-filled skies, as well as the symbolic images of death and resurrection in van Gogh's depictions of wheatfields, sowers, and reapers are all essentially religious subjects. They express van Gogh's struggle with his illness, his hope for deliverance and renewal, and his concern with issues of death and immortality.

These paintings from the last period of van Gogh's life also represent the contesting impulses of tradition and modernity in his life and his work. Van Gogh was uncertain about painting traditional religious subjects and consequently rejected Gauguin's *Christ in the Olive Garden.* His goal in the religious painting at St. Rémy was to develop a modern artistic language that would subtly suggest a numinous presence: hence his frequent painting of olive groves, often bathed in radiant golden light. As in earlier compositions such as *The Potato Eaters* (1885), he felt he could suggest the divine without depending on traditional religious imagery. That van Gogh often used the olive tree as a visual emblem of Christ, for example, is apparent in the following discussion of the propriety of painting biblical subjects in a letter to Theo:

> However, now is not the moment to ask me to admire our friend Gauguin's composition, and our friend Bernard has probably never seen an olive tree. Now he is avoiding getting the least idea of the possible, or of the reality of things, and that is not the way to synthesize — no, I have never taken any stock in their biblical interpretations.
>
> I said that Rembrandt and Delacroix had done this admirably, that I liked it even better than the primitives. . . . If I stay here, I shall not try to paint "Christ in the Garden of Olives," but the glowing of the olives as you still see it, giving nevertheless the exact proportions of the human figure in it, perhaps that would make people think.[2]

2. L614, 17 November 1889, *Letters* 3:229.

Van Gogh explained his ambivalence concerning traditional religious sub-
ject matter to his close friend, Emile Bernard, who was a Catholic mystic.
Bernard influenced both van Gogh's artistic development and his religious
experience. Bernard was particularly fascinated with the writings of the
medieval mystics and the religious woodcuts of the Middle Ages. Artis-
tically, this led to his cloisonist style, or the practice of outlining figures
in black, which he tended to define in more primitive, flattened symbolic
ways, rejecting the tradition of Realism that prevailed in religious history
painting from the Renaissance forward. Bernard was also attracted to the
mysticism of the French peasants, which, as noted earlier, van Gogh found
unsettling and inappropriate for the "modern" artist he perceived himself
to be. While van Gogh adopted much of Bernard's aesthetics, he found
Bernard's constant depictions of biblical subjects to be repulsive:

> . . . One can try to give an impression of anguish without aiming
> straight at the historic Garden of Gethsemane; . . . it is not necessary
> to portray the characters of the Sermon on the Mount in order to produce
> a consoling and gentle motif.
>
> Oh! undoubtedly it is wise and proper to be moved by the Bible,
> but modern reality has got such a hold on us that, even when we attempt
> to reconstruct the ancient days in our thoughts abstractly, the minor
> events of our lives tear us away from our meditations, and our own
> adventures thrust us back into our personal sensations — joy, boredom,
> suffering, anger, or a smile.
>
> The Bible! The Bible! Millet, having been brought up on it from
> infancy, did nothing but read that book! And yet he never, or hardly
> ever, painted Biblical pictures. Corot has done a "Mount of Olives,"
> with Christ and the evening star, sublime; in his works one feels Homer,
> Aeschylus, Sophocles, as well as the Gospel sometimes, yet how discreet
> it is, and how much all possible modern sensations, common to us all,
> predominate.
>
> . . . Being able to divide a canvas into great planes which inter-
> mingle, to find lines, forms which make contrasts, that is technique,
> tricks if you like, cuisine, but it is a sign all the same that you are
> studying your handicraft more deeply, and that is a good thing.[3]

3. B21, 20 November 1889, *Letters* 3:524.

Van Gogh wrote this to Bernard after he had completed *Starry Night* and *The Pietà.* With *Crows over the Wheatfield,* van Gogh significantly moved toward the simplification of forms and the division of the picture plane into two vast areas of color, which was typical of Bernard's compositions. It was after writing this letter to Bernard, however, that van Gogh painted his most conventional religious subjects, *The Raising of Lazarus* and *The Good Samaritan.* These works demonstrate how deeply van Gogh's religious faith affected his artistic aesthetics. As he pointed out to Bernard, in discussing the work of Corot, it was not the religious subject he rejected, but the traditional form of representing it.

Art historians, in discussing *Starry Night,* often point out van Gogh's refusal to paint religious subjects: "What van Gogh talked about with Gauguin and Bernard is the problem of working from the imagination and painting religious subjects, which Gauguin and Bernard did paint, but van Gogh could not."[4] They argue that van Gogh had no interest in painting religious subjects, favoring instead a naturalized subject, which they suggest is the appropriate interpretation of *Starry Night.* For example, in the only published study of van Gogh and Christianity, *Vincent van Gogh: Christianity versus Nature,* Tsukasa Kōdera argues that "however eclectic it might sound, the principal theme of *The Starry Night* is the conflict between religion and nature, between Christian belief and naturalism."[5] "To accept the Christian subjects was impossible for van Gogh, even a self-denial of his raison d'être, for his existence as an artist started with his rejection and abandonment of Christianity."[6] What Kōdera fails to note is that *Starry Night* was painted in June of 1889, before van Gogh painted the conventional subjects of *The Pietà, The Raising of Lazarus,* and *The Good Samaritan.* Van Gogh's paintings of the St. Rémy period do not "prove" his rejection of Christianity but indicate, rather, the tension in his oeuvre between the traditional and the modern. Van Gogh did ultimately abandon the more traditional iconography of the Bible in favor of a more modern, secular artistic vocabulary, which was, nonetheless, deeply religious. In the last two months of his life at Auvers, for example, he did not paint any biblical subjects, but he did paint the church at Auvers. For

4. Tsukasa Kōdera, *Vincent van Gogh: Christianity versus Nature* (Amsterdam: John Benjamins, 1990), 87.
5. Ibid., 89.
6. Ibid.

the most part, however, he chose to suggest the presence of the divine symbolically, in mundane subjects that were nonetheless spiritually charged — the sower, the sun, the wheatfield, the starry sky, or a grove of olive trees. This is a consistent tendency throughout his artistic career.

The Pietà, The Raising of Lazarus, and *The Good Samaritan* are among the most accomplished paintings, particularly with regard to color and expression, of van Gogh's career, yet they are little known.[7] *The Pietà* and *The Good Samaritan* have received very little critical analysis by art historians. This is in part because they are reprises after other works done by Delacroix and Rembrandt, and therefore some art historians have panned them as mere copies.[8] Van Gogh's practice of making reprises after known works by other artists during his stay at St. Rémy probably reflects the limitations of working without models and a proper studio. In order to work on his technique effectively, he asked Theo to send prints of specific paintings so that he could work from them. They are not copies, however. Some display a significant departure from the prints van Gogh used as "models." This is particularly the case with *The Raising of Lazarus.*[9] Van Gogh explained that it was not only the subject matter but the act of painting from works by other known artists that brought him great consolation in this terrible time of suffering and pain. Studying the works of other artists, whom he greatly admired, gave him a sense of continuity with them:

> When I realize the worth and originality and superiority of Delacroix and Millet . . . then I am bold enough to say — yes, I am something, I can do something. But I must have a foundation in these artists, and then produce the little I am capable of in the same direction.[10]

7. In the recent retrospective of van Gogh's work, honoring the one hundredth anniversary of his death, for example, both *The Pietà* and *The Raising of Lazarus* remained in the basement vault of the Rijksmuseum van Gogh because the organizers of the exhibit did not see them as works which van Gogh viewed as important, even though van Gogh discussed these paintings more in his letters than many others exhibited in the centennial retrospective. *The Good Samaritan* remained on view in rural Otterlo, unavailable to most who would be visiting the exhibit held in Amsterdam.

8. Charles Chetham, *The Role of van Gogh's Copies in the Development of His Art* (New York: Garland, 1976), 185.

9. See J. G. B. Jansen, "De Barmhartige Samaritaan uitgebeeld door Rembrandt en Vincent van Gogh," *Barmhartige Samaritaan in Rovers handen* (Apeldoorn: Uitgeverij Semper Agendo BV, 1974), 185-94.

10. L605, 10 September 1889, *Letters* 3:210.

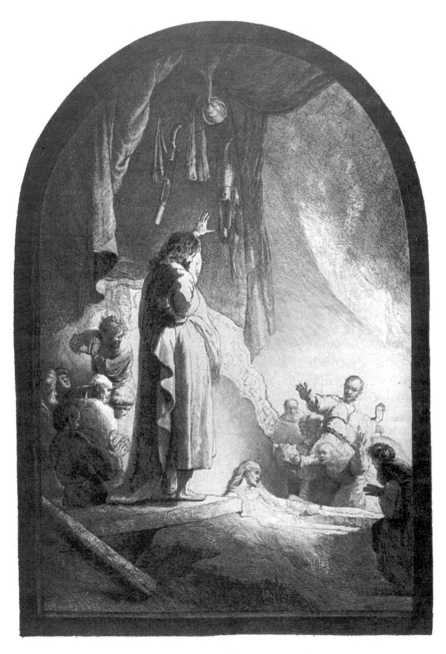

10. Rembrandt van Rijn, *The Resurrection of Lazarus*, ca. 1632, etching

. . . Because I am ill at present, I am trying to do something to console myself, for my own pleasure.

I let the black and white by Delacroix or Millet, or something made after their work, pose as a subject.

And then I improvise color in it, not, you understand all together myself, but searching for memories of *their* pictures — but the memory, "the vague consonance of colors that are at least right in feeling" — that is my own interpretation.

Many people do not copy, many others do — I started on it accidentally, and I find that it teaches me things, and above all, it sometimes gives me consolation.[11]

The main reason for ignoring these three brilliant examples of van Gogh's late style is that they are so overtly and traditionally religious. A tendency to dismiss van Gogh's rediscovery of his religious roots during the St. Rémy period as an unhealthy aberration or by-product of his mental illness has resulted in the neglect of these three paintings. Kōdera's critique of *The Raising of Lazarus,* in which he suggests that van Gogh displaced Christ with the Sun as an object of worship, betrays his bias against van Gogh's continued respect for Christian beliefs. Some art historians have openly lamented van Gogh's religious paintings, claiming, "The return of so many of his earlier ideas was unhappily flawed by a reemergence of religious hysteria."[12] This view reveals both disgust with the deepening of van Gogh's faith at St. Rémy and the view that van Gogh's former pursuit of a clerical vocation was a kind of fanatical hysteria. But van Gogh's life is one of a continuous religious pilgrimage, beginning with a profound commitment to follow the vita apostolica, evolving as van Gogh attempted to synthesize his religious experience with modern ideas and, at St. Rémy, ending with a recovery of some of his more traditional Christian beliefs. If we accept the legitimacy as well as the continuity of van Gogh's spiritual journey, the traditionally iconographic religious subjects of *The Pietà, The Raising of Lazarus,* and *The Good Samaritan* find a place as important works in van Gogh's art and life. That they are reprises after other works does not diminish their significance.

The question remains as to why van Gogh chose these particular

11. L607, 19 September 1889, *Letters* 3:216.
12. Chetham, *The Role of Vincent van Gogh's Copies in the Development of His Art,* 185.

subjects to rework, all of which are images of sorrow and deliverance, death and resurrection. As works which display his own tragic suffering and hope for recovery, they are among the most profoundly personal of his artistic career. By replacing the face of Christ in *The Pietà* as well as the face of Lazarus in *The Raising of Lazarus* with his own face, van Gogh deliberately displayed his identification with both the pain and regeneration of the subjects. These works demonstrate that it was in religion, and to some degree specifically in Christianity, that van Gogh ultimately sought solace and rebirth.

Van Gogh painted *The Raising of Lazarus* after an etching of Rembrandt's, in which the imposing figure of Jesus stands over the emaciated Lazarus with his hand raised in a gesture meant to suggest Christ's power to bring Lazarus back from the grave. All the figures, including Lazarus and the witnesses to this miraculous event, are bathed in a holy, mystical light, typical of many of Rembrandt's religious paintings and landscapes. Van Gogh described to Theo his use of color in attempting to capture the same symbolism Rembrandt had achieved through shades of light and dark. "The cave and the corpse are violet, yellow and white. The woman who takes the handkerchief off the face of the resurrected man has a green dress and orange hair; the other has black hair and a garment striped green and pink — at the back, a country side of blue hills, a rising yellow sun. The combination of the colors would thus speak by itself of the same thing which the light and shade of the etching express."[13]

It is with the lavish use of the color yellow, then, that van Gogh creates a sense of the same sacred, divine presence represented in the Rembrandt etching. The yellow encircling Lazarus' head is reminiscent of the halo surrounding the head of Christ in Delacroix's *Christ Asleep During the Tempest*, which van Gogh had previously cited as an artistic source for his rendition of *The Sower*. The yellow light is symbolic of the divine presence as well as the resurrection in van Gogh's *Pietà*, which he completed about a year before his painting of Lazarus. The color yellow, which van Gogh often used to represent love, particularly the sacred love of God, is here suggestive of the rayon d'en haut (light from above). Van Gogh said that he was painting a rising yellow sun, often symbolic of rebirth and renewal, and here symbolic of healing as well as resurrection.

Van Gogh's affinity for the figure of Lazarus is apparent in his representation of him with the red beard and hooked nose characteristic

13. L632, 3 May 1889, *Letters* 3:269.

of van Gogh's later self-portraits. Lazarus, as both van Gogh and Rembrandt represent him, is a frail, sickly wraith, much as van Gogh himself was as he languished at St. Rémy. Although Lazarus was so weak he could barely lift his head and open his eyes, he was nevertheless alive, raised from the dead; van Gogh's own acute sense of his fragile condition as well as his hope for rebirth and full recovery thus find in the biblical character a graphic parallel.

Van Gogh departed significantly from the original composition, however, eliminating all of the figures with the exception of Lazarus and his two sisters, Mary and Martha. The most striking change van Gogh made from the Rembrandt etching was the omission of the person of Jesus. Kōdera's critique of *The Raising of Lazarus* argues that van Gogh substituted the sun for Christ in his painting because he had deified the sun of the Midi in his mind. "The sun of the Midi was for van Gogh something to be 'believed in,' the 'good god sun,' and something to be loved by painters. If we keep in mind these connotations of the Midi sun and the tendency toward naturalization in van Gogh's thematics, it does not go too far to see a substitution of the sun for Christ in *The Raising of Lazarus*."[14] Kōdera recalls the tradition of identifying the sun with God. "The sun as a symbol of God or Christ and the sunflower as the symbol of a pious soul is, of course, not new. In the tradition of emblem books and visual arts, sunflowers were often used as symbols of faith or love. In his *Emblemata* published in 1625, Zacharias Heyns depicted a sunflower facing the sun with the motto 'Christi actio imitatio nostra' [Let us imitate Christ]. . . ."[15]

Given the traditional appropriation of the sun as an image of the divine presence, then, it is surely unnecessary and misleading to suggest that van Gogh perceived the sun itself as a god. More likely, van Gogh simply used the sun to represent Christ, as others had done in western art since the third century. This interpretation is far more consistent with van Gogh's oeuvre and life. It is consistent, too, with his repeated depiction of sunflowers which, as noted earlier, are traditionally associated with piety and devotion. (Van Gogh was so strongly identified with the sunflower that it became his personal symbol shortly after his death. The Symbolists, on the cover of the catalog for one of the early exhibitions of his work, show van Gogh as a dying sunflower with a halo.)

14. Kōdera, *Vincent van Gogh: Christianity versus Nature,* 35.
15. Ibid.

The story of Lazarus was itself fundamentally important in van Gogh's life, from his early reading of the Bible as well as Stricker's *Jezus van Nazareth* and Ernst Renan's *Life of Jesus*. The painting does not suggest a supplanting of Christ with the sun, then, but a tribute to Christ and the healing powers of faith. The very subject of Lazarus points to Christ, even without his physical representation in the painting, for two reasons. First, because it was Christ who miraculously brought Lazarus back from the dead to live again and second, because Lazarus' death and resurrection was a portent of Christ's own death, descent into hell, resurrection, and his final ascension. Van Gogh's painting of Lazarus is most certainly an overtly Christian work, demonstrating his concern to reveal the divine presence without painting simple "Bible pictures." When van Gogh chose to paint the resurrected Lazarus in his tomb, he clearly intended to render a Christian subject.

In the other two traditionally religious paintings of the group I will call the "St. Rémy trilogy," the influence of *The Imitation of Christ* is evident. Both art historians and biographers of van Gogh's life have virtually ignored the continuity between van Gogh's former religious beliefs, which were sustained by *The Imitation of Christ* and *The Pilgrim's Progress,* and his later life as an artist. Because he identified with the suffering of the dying Christ, the victimized Samaritan, and the decaying Lazarus, van Gogh emphasized his affinity for the intense pathos of his subjects by replacing the face of Christ in *The Pietà,* and the face of Lazarus in *The Raising of Lazarus,* with his own. It was the belief that temporal existence is a brief period of trial and pain, culminating in spiritual deliverance and rebirth, a belief fundamental to *The Imitation of Christ* and *The Pilgrim's Progress,* that dictated his choice of subjects. As such, all of these images, which deal with suffering and dying, are images of eternal hope.

The impact of van Gogh's reading of *The Imitation of Christ* is most pronounced in *The Pietà* and *The Good Samaritan,* both reprises after Delacroix. *The Pietà* shows how profoundly Kempis' notion of Christ as the suffering servant influenced van Gogh. Rather than portraying a triumphant Christ in glory, he shows Christ in his greatest moment of humility and pain, his crucifixion and death. As noted in Chapter Two, above, *The Imitation of Christ* taught: "If you would be my disciple, forsake yourself; if you would possess the blessed life, despise this present life; if you would be exalted in heaven, humble yourself here on earth; and if you would reign with Me, bear the cross with Me, for truly, only the servants

of the cross will find the life of blessedness and of everlasting light."[16] Van Gogh perceived himself as one bearing the cross, and like the Christ in *The Pietà*, he hoped for ultimate healing and rebirth.

The Pietà is van Gogh's *Imitatio Christi* in oil. Although van Gogh reproduced the painting from a lithograph of Delacroix's *Pietà*, the style of painting, in which the canvas is built up with layers of paint so that the figures appear molded out of clay, as well as the dramatic use of color and intimate rendering of the portrait figures make this van Gogh's own distinctive work. While working on his *Pietà*, van Gogh wrote to his brother, Theo, "I am not indifferent, and even when suffering, sometimes religious thoughts bring me great consolation. So this last time during my illness an unfortunate accident happened to me — that lithograph of Delacroix's *Pietà*, along with some other sheets, fell into some oil and paint and was ruined. I was very distressed — then in the meantime I have been busy painting it. . . . I hope it has feeling."[17]

Perhaps the most striking feature of the van Gogh *Pietà* is its symbolic use of color. The picture plane is divided into areas of intense sapphire blue juxtaposed with citron yellow. Rather than depicting Christ with a halo, van Gogh used an intense yellow light to convey the mystical quality of the dying Jesus. As he explained to Theo, "I want to paint men and women with something of the eternal which the halo used to symbolize, and which we seek to convey by the actual radiance and vibration of our coloring."[18] Mary's robes cascade in folds of various shades of blue, from light indigo to royal, so dark it appears almost black, forming a marked contrast with the luminous glow of light that strikes her right arm and face. This deep blue, characteristic of the visionary sky of *Starry Night*, was van Gogh's symbol of infinity. In a previous painting, *The Portrait of Eugène Boch*, he described his symbolic use of blue in the portrait figure's background: "Instead of painting the ordinary wall of the mean room, I paint infinity, a plain background of the richest, intensest blue I can contrive."[19]

Van Gogh's *Pietà* is a deeply personal portrait of Christ's suffering

16. Thomas à Kempis, *The Imitation of Christ,* ed. Harold C. Gardener (New York: Image Books, 1955), 4:56.

17. L605, 7 or 8 September 1889, *Letters* 3:208.

18. L531, 3 September 1888, *Letters* 3:25.

19. L520, 11 August 1888, *Letters* 3:6.

and Mary's devotion. The Christ figure is emaciated, his eyes closed, his head bowed. He appears to be dead, but Mary has stayed by his side, her face sympathetic, but her distant gaze wistful, even hopeful. Her arms present the figure expectantly rather than enfolding him in grief. Both Christ and Mary are bathed in a radiant blaze of golden light streaming from the sun rising behind the jagged cliffs. The morning light portends Christ's resurrection and ultimate triumph as well as the regeneration van Gogh hoped to find for himself through the healing of the asylum at St. Rémy.

While van Gogh depicts something of the ideology of Kempis' *Imitation of Christ* in *The Pietà,* he presents the ethics of Kempis in his rendering of *The Good Samaritan.* Of charitable works *The Imitation of Christ* teaches: "The outward deed without charity is little to be praised, but whatever is done from charity, even if it be ever so little and worthless in the sight of the world, is very profitable before God, who judges all things according to the intent of the doer, not according to the greatness or worthiness of the deed."[20] In the parable of the Good Samaritan (Luke 10:29-37), Jesus demonstrated the hypocrisy of the priest and the Levite who, seeing a poor man lying in the road, beaten and robbed, chose to pass by on the other side. It was only the Samaritan, who was despised by the Jews to whom Jesus preached, who practiced genuine charity. Van Gogh's choice of this subject shows both his rejection of the hypocrisy of the Christian clergy, as well as his continued commitment to the ethics of serving the poor, something in which he had engaged with great zeal in the Borinage.

The Good Samaritan also displays a far more personal concern, van Gogh's torment and desire for deliverance. During his stay at St. Rémy, he was preoccupied with the idea of suffering and regeneration, an idea which dominates all three of the St. Rémy religious paintings. Van Gogh read in *The Imitation of Christ,* "It is good therefore to remember often that you came to religion to serve and not to be served, and that you are called in religion to suffer and labor. . . ."[21] Van Gogh never viewed his personal trial as meaningless, believing that its purpose would someday be revealed in a "life beyond the grave." Just as the victim of the thieves in the parable

20. Kempis, *The Imitation of Christ,* 1:15.
21. Ibid., 1:18.

of the Good Samaritan was finally rescued and restored to health, van Gogh hoped he too would find the same deliverance.

Unlike *The Pietà*, with its striking contrasts of blue and yellow, *The Good Samaritan* shows van Gogh's weaving of the rich, vibrant coloring of Delacroix's romantic history paintings, with their splashes of crimson, sapphire, and gold, into a tapestry of subdued browns, grays, and red-ochers that recall the palette of his Dutch past. The dramatic colors of Delacroix set off the central figures of the Samaritan and the victim from the more subtly colored landscape. Characteristic of van Gogh's later paintings, the quick, heavy brush strokes of the road, along with the upward swirls that define the cliffs behind the central figures, give the painting an unsettling sense of agitation, as if everything is in flux. The movement comes to a startling arrest in the melancholy expression of the horse as he receives the rescued victim onto his back. It may have been van Gogh's intention that the Samaritan's horse become an emblem of Kempis' ideal of the long-suffering Christian servant. Shortly after arriving in St. Rémy, van Gogh wrote to his sister, Wil, "Have you noticed that the old cab horses there [in Paris] have large, beautiful eyes, as heartbroken as Christians sometimes have?"[22] *The Good Samaritan* embodies the ideal of the sacrifice of self in the service of others, while hinting at van Gogh's hope for his ultimate renewal in the face of his own anguish at St. Rémy, an ideal he encountered in his devotional literature while he prepared for the ministry and here translated into powerful, vivid images as an artist.

The impact of *The Pilgrim's Progress* on van Gogh's art is more subtle, but also more pervasive: one need only to think of the ubiquitous roads, paths, bridges, and canals, depicted in paintings such as *The Artist on the Road to Tarascon, Tarascon Diligence,* and *The Bridge at Trinquetaille,* or vertical symbols that mediate between the earth and the heavens, such as church steeples, cypresses, birds, and stars, in such works as *Starry Night, Road with Cypress and Star* (1890, fig. 12), and *Crows over the Wheatfield.* The journey motif is prominent in van Gogh's correspondence as well, as in this letter written to Theo from Arles: "I always feel I am a traveler, going somewhere and to some destination. . . . I know nothing about it, but it is just the feeling of not knowing that makes the real life we are actually living now like a one way journey on a train."[23] Like Christian

22. L591, 10-15 May 1889, *Letters* 3:170.
23. L518, 6 August 1888, *Letters* 3:2.

in Bunyan's allegory, van Gogh viewed temporal existence as an arduous journey which would ultimately end in spiritual rebirth. The theme of the transience of life is conveyed in his depiction of sowers, reapers, and wheatfields, which dominate his Arles and St. Rémy-Auvers periods, culminating in one of his most enigmatic works, *Crows over the Wheatfield*.

Crows over the Wheatfield, painted just a few weeks before van Gogh's suicide, has been the subject of a vast body of artistic criticism. Most of the interpretations, such as Meyer Schapiro's classic critique written in 1946, focus on the "sinister" elements of the swooping black crows as symbols of van Gogh's own imminent psychological crisis: "The artist's will is confused, the world moves toward him, he cannot move toward the world. It is as if he felt himself completely blocked, but also saw an ominous fate approaching. The painter-spectator has become the object, terrified and divided, of the oncoming crows whose zigzag form, we have seen, recurs in the diverging lines of the three roads."[24] This pessimistic reading was made popular in the film adaptation of Irving Stone's biography, *Lust for Life,* that envisions van Gogh painting *Crows over the Wheatfield* in a frenzy and then shooting himself. But if we date the painting to July 7-10 (the matter is uncertain), it would correspond to a letter in which van Gogh described the canvases he was currently painting as "vast fields of wheat under troubled skies," painted to show "the healthful and restorative forces that I see in the country" — a perspective consistent with van Gogh's representation of wheatfields in more than forty other works painted from 1888 to 1890.[25]

The painting in question consists of four major elements: wheat, crows, roads, and sky, but the three divergent roads that run out of the picture plane or disappear into the wheat are the most significant artistic symbols, recalling the notion of journeying so central to Bunyan's *The Pilgrim's Progress.* The roads, weaving their way through the wheat, serve as symbols of the journey of life, while the wheat itself symbolizes renewal

24. Meyer Schapiro, *Modern Art: Nineteenth and Twentieth Centuries, Selected Papers* (New York: George Braziller, 1979), 87.

25. "Compare the sentence in van Gogh's last letter of 23 July, where he writes of 'two size thirty canvases representing vast fields of wheat after the rain.' . . . The only Auvers paintings that show such skies are *Wheatfield under Clouded Sky* and *Crows over the Wheatfield,* which must have been painted contemporaneously from 7 to 10 July" (Ronald Pickvance, *Van Gogh in St. Rémy and Auvers* [New York: The Metropolitan Museum of Art, 1986], 276).

and rebirth in the cycle of life. The wheat is also a subtle reference to the divine presence, as it has been traditionally symbolic of the purest of Christian sacraments, the Eucharist. (Among the German Romantic painters, for example, Casper David Friedrich in his *The Cross in the Mountains* [1808], includes grapes and a sheaf of wheat at the corners of the picture frame.) Just as van Gogh found consolation in painting *The Pietà,* he viewed the wheatfields as sources of hope in the midst of despair. At St. Rémy, he had hoped to overcome his suffering and experience a healing resurrection. In moving to the northern countryside of Auvers, he hoped for rest and release; in the wheatfield he found a comforting symbol of his hope for ultimate deliverance: "It is just in learning to suffer without complaint, in learning to look on pain without repugnance, that you risk vertigo, and yet it is possible, yet you may even catch a glimpse of a vague likelihood that on the other side of life, we shall see good reason for the existence of pain, which seen from here sometimes so fills the horizon that it takes on the proportions of a hopeless deluge. We know very little about this, about its proportions, and it is better to look at a wheatfield, even in the form of a picture. . . ."[26]

The presence of the black crows, swooping down on the fields of ripening wheat, has, perhaps more than any other factor, led to the pessimistic readings of *Crows over the Wheatfield,* but crows were not always associated with death and disaster in western art, nor did they carry such negative connotations within van Gogh's own artistic oeuvre. In van Gogh's work, crows appear in contexts that suggest both death and rebirth. For example, in his Season series (1884), crows appear in the winter landscape with a peasant worker, and are also present in many of van Gogh's charcoal sketches depicting harvested sheaves of wheat. Crows are also present in van Gogh's Spring Season sketch, with a sower. Crows appear with sowers in the painting *The Sower,* done at Arles in 1888, and also *The Sower* reworked, after Millet, at St. Rémy in 1889. In the context of van Gogh's oeuvre, then, crows are associated with both death and rebirth as part of the cycle of nature. In depicting crows with the images of planting and harvesting wheat, van Gogh ties in the religious connotation of the Eucharist as it recalls the death and resurrection of the Lord.

Although Schapiro's interpretation of *Crows over the Wheatfield* places the greatest emphasis on the crows, the roads, as they carve through the

26. L597, 2 July 1889, *Letters* 3:188.

resplendent fields of glowing wheat, are the most dominant element in the painting. In addition to the space they occupy on the canvas, their vibrant coloring as well as the foreshortened perspective van Gogh used in painting them draw the viewer's eye magnetically to them. Van Gogh painted the three roads in a red ocher mixed with white and flanked them on both sides with a bright emerald green, an obvious use of Delacroix's color theory in which primary colors are placed adjacent to their complements in order to intensify both. The roads call to mind a painting van Gogh described in his one extant sermon, which we examined earlier, based on Bunyan's *The Pilgrim's Progress:*

> Our life is a pilgrim's progress. I once saw a beautiful picture: it was a landscape at evening. In the distance, on the right-hand side, a row of hills appeared blue in the evening mist. Above those hills, the splendor of the sunset, the grey clouds with their linings of silver and gold and purple. The landscape is a plain or heath covered with grass and its yellow leaves, for it was autumn. Through the landscape, the road leads to a high mountain far, far away, on top of that mountain is a city whereon the setting sun casts a glory. On the road walks a pilgrim, staff in hand. He has been walking a good long while already and is very tired. And now he meets a woman, or figure in black that makes one think of St. Paul's word: sorrowful yet always rejoicing. That angel of god has been placed there to encourage the pilgrims and to answer their questions, and the pilgrim asks her:
>
> > "Does the road go uphill then all the way?"
> > And the answer is, "Yes, to the very end."
> > And he asks again, "And will the journey take all day?"
> > And the answer is, "From morn to night, my friend."

And the pilgrim goes on, sorrowful yet always rejoicing — sorrowful because it is so far off and the road so long; hopeful as he looks up to the eternal city far away, resplendent in the evening glow. And he thinks of the two old sayings that he heard long ago — the one is:

"Much strife must be striven, much suffering must be suffered, much prayer must be prayed, and then the end will be peace."[27]

27. Sermon, 5 November 1876, *Letters* 1:90.

The "end," metaphorically represented in the painting van Gogh describes by the end of the road before the Eternal City, obviously refers to the end of one's temporal existence, physical death. Art critics, who have seen *Crows over the Wheatfield* as a disturbing symbol of van Gogh's imminent suicide, have misunderstood van Gogh's intent because they have misunderstood van Gogh's idea of death. He did not view death as a despairing finale to life, but as a passage from one form of existence into another, higher form; this was the view held by Bunyan and Kempis. Van Gogh's positive view of death is clear in his rendition of another painting, done earlier at St. Rémy, *Wheatfield with a Reaper* (1889, plate 11), which depicts a reaper cutting his way through a field of bright yellow wheat under a blazing golden sun and a sky flooded with light. He described it in a letter to Theo: "For I see in the reaper — a vague figure fighting like a devil in the midst of the heat to get to the end of his task — I see him as the image of death in the sense that humanity might be the wheat he is reaping. So it is — if you like — the opposite of the sower I tried to do before. But there is nothing sad in this death, it goes its way in broad daylight, with a sun flooding everything with a light of pure gold."[28] For van Gogh's reaper, as well as for Bunyan's Christian, there is joy in getting to the "end of the task," not sadness and despair. If the roads, as they run out of the painting or disappear among the resplendent wheat in *Crows over the Wheatfield,* were intended to represent death, it is a death of triumph and ultimate release. Taking into consideration van Gogh's view of death, the images of crows and wheat and country roads begin to come together to show what van Gogh describes as the "healthful and restorative forces" of the French countryside.

The vast, turbulent skies of deep royal blue, which occupy almost half of the compositional space of the painting, are symbolic of the infinite, the ultimate goal of the artist's pilgrimage. Just as in van Gogh's *Pietà,* the use of a deep, mysterious azure blue, further intensified when placed adjacent to a glowing golden orange-yellow, is intended to create a sense of infinite space. In van Gogh's *Portrait of Mdme. Ravoux,* one of his last paintings, the color blue is the essence of the portrait: "its jewel-like luminosity becomes the very idea of the painting, compulsive in its excess and leading us through its omnipresence and dark intensity, to a mystical ecstatic mood."[29] Not only the color, but the image of the sky itself evokes

28. L604, 5 or 6 September 1889, *Letters* 3:202.
29. Meyer Schapiro, *Vincent van Gogh* (New York: Harry Abrams, 1979), 124.

a feeling of the infinite. For van Gogh, death was not just a final release from pain and suffering, but the ultimate union of the soul with the infinite God, Kempis' mystical embrace and Bunyan's union with Christ in the Celestial City. In the totality of its images, van Gogh's painting of crows flying among a field of golden wheat, over a series of country roads, under a mysterious indigo sky, is not a painting of psychological deterioration, but a work depicting the journey of life, with the hope of ultimate rebirth.

While *Crows over the Wheatfield* expresses van Gogh's sense of impending death, as well as his hope for rebirth, *Starry Night* represents the culmination of van Gogh's total spiritual pilgrimage, the mystic's desire for union with the infinite God. While the many interpretations of *Starry Night*, van Gogh's most renowned work, have focused on its symbolic imagery, none of its critics have understood the fundamental importance of the painting as an autobiographical work. It tells, in oil, of van Gogh's spiritual journey from the darkness and hypocrisy of his experience in the Dutch church to the triumph of his encounter with God in nature. It is both a celebration of life and an acquiescence to impending death — with the hope that in death, he will find release and union with the infinite God. *Starry Night* is the most visionary and mystical of all van Gogh's works.

Starry Night has been analyzed at great length, perhaps more than any other of van Gogh's paintings, but few of its critics have attempted to understand the painting as a synthesis of van Gogh's ideas about religion and modernity.[30] While all of the various discussions of *Starry Night* have merit, they tend to focus on one aspect of the painting, namely the starry sky, coruscating with the brilliance of the stars and the sun-moon. Most fail to discuss the whole work with its three elements of village, cypress, and starry sky, and thus fail to understand its importance in describing van Gogh's whole spiritual pilgrimage, its defeat and ultimate triumph, its past and its future.

In one of the best-known critiques of *Starry Night*, Albert Boime argues that van Gogh attempted an accurate recreation of the night sky as he viewed it from his window in the asylum, suggesting that van Gogh's intent was to laud modern science and reject Christianity. He saw van

30. There are the biblical interpretations, by Loevgren and Schapiro, and to some extent, Soth, the empirical interpretation of Boime, the naturalist interpretation of Kōdera, and finally, the literary interpretations, which focus on the poetry of Walt Whitman as one of van Gogh's sources of inspiration, by Werness and Schwind.

Gogh as a modernist in the same vein as the astronomer, Camille Flammarion, noting, "Van Gogh, Flammarion and [Jules] Verne all looked to science for the solution to humanity's pressing problems."[31] But *Starry Night* celebrates van Gogh's mysticism and intuitive nature, his longing for ultimate union with the infinite and final peace. In comparing the relationship between science and reason on the subject, van Gogh's preference for Christianity shines through.

> Science — scientific reasoning — seems to me an instrument that will lag far, far behind. For look here, the earth has been thought to be flat. It was true, so it still is today, for instance, between Paris and Asnières. Which however does not prevent science from proving that the earth is principally round. Which no one contradicts nowadays.
>
> But notwithstanding this they persist nowadays in believing that life is flat and runs from birth to death. However, life too is probably round, and very superior in expanse and capacity to the hemisphere we know at present.
>
> Future generations will probably enlighten us on this so very interesting subject; and then maybe Science itself will arrive — willy nilly — at conclusions more or less parallel to the sayings of Christ with reference to the other half of our existence.[32]

Interpretations that focus on the literary sources for *Starry Night,* particularly the poetry of Walt Whitman, are more dependable, underscoring the whole spirit of van Gogh's radiant masterpiece. "In *Starry Night,* van Gogh created an image of divine love and of the glory and immensity of the cosmos. In the painting, man's temporal and terrestrial existence is contrasted with the immutable and eternal nature of cosmic time. Van Gogh found hope and comfort in the stars; the immutable cycling of the stars in their courses and the phases of the moon intimated immortality."[33] Both van Gogh and Whitman saw "the glory of God" in

31. Albert Boime, "Van Gogh's *Starry Night:* A Matter of History and a History of Matter," *Arts Magazine* (December 1984): 86-103.

32. B8, 23 June 1888, *Letters* 3:497.

33. Hope Werness, "Whitman and van Gogh: Starry Nights and Other Similarities," *Walt Whitman Quarterly Review* 2, no. 4 (Spring 1985): 37. Also see Jean Schwind, "Van Gogh's *Starry Night* and Walt Whitman: A Study in Source," *Walt Whitman Quarterly Review* 3 (Summer 1985): 1-15.

the stars as they evoked thoughts of death and immortality. On the death of Thomas Carlyle, another of van Gogh's literary heroes, Whitman wrote:

> Carlyle, and his approaching — perhaps even the actual — death, filled me with thoughts eluding statement, and curiously blending with the scene. The planet Venus, an hour high in the west, with all her volume and lustre recover'd. . . . While through the whole of its silent indescribable show, enclosing and bathing my own receptivity, ran the thought of Carlyle dying. (To soothe and spiritualize, and as far as may be, solve the mysteries of death and genius, consider them under the stars at midnight).
>
> And now that he has gone hence . . . does he yet exist, a definite, vital being, a spirit, an individual — perhaps now wafted in space among those stellar systems. . . . I have no doubt of it. In silence of a fine night, such questions are answered to the soul, the best answers that can be given. With me too, when depress'd by some specially sad event, or tearing problem, I wait till I go out under the stars for the last voiceless satisfaction.[34]

It is instructive to compare this passage from Whitman with a striking excerpt from van Gogh's letters, which also reveals his preoccupation with thoughts of an afterlife and immortality of the artists and poets:

> It certainly is a strange phenomenon that all artists, poets, musicians, painters, are unfortunate in material things — the happy ones as well. What you said lately about Guy de Maupassant is fresh proof of it. That brings up again the eternal question: Is the whole of life visible to us, or isn't it rather that this side of death we see only one hemisphere? Painters — to take them alone, dead and buried speak to the next generation or to several succeeding generations through their work.
>
> Is that all, or is there more to come? Perhaps death is not the hardest thing in a painter's life.
>
> . . . Looking at the stars always makes me dream, as simply as I dream over the black dots representing towns and villages on a map. Why, I ask myself, shouldn't the shining dots of the sky be as accessible as the black dots on the map of France? Just as we take the train to get to

34. Werness, "Whitman and van Gogh: Starry Nights and Other Similarities," 38.

Tarascon or Rouen, we take death to reach a star. One thing undoubtedly true in this reasoning is that we cannot get to a star while we are alive, any more than we can take the train while we are dead.

So to me it seems possible that cholera, gravel, tuberculosis, and cancer are the celestial means of locomotion, just as steamboats, buses and railways are terrestrial means. To die quietly of old age would be to go there on foot.[35]

Van Gogh urged his sister, Wilhelmina, to read Whitman's poetry. "Have you read the American poems by Whitman? I am sure Theo has them, because to begin with they are really fine, and the English speak about them a good deal. He sees in the future, and even in the present, a world of healthy, carnal love, strong and frank — of friendship — of work — under the great starlit vault of heaven, a something which after all one can only call God — and eternity in its place above this world."[36] That van Gogh also associated the stars, as well as his idea for *Starry Night,* with the immortality of the soul is apparent in his comment to Theo, "But don't let's forget that this earth is a planet too, and consequently a star, or celestial orb. And if all the other stars were the same!!! That would not be much fun; nothing for it but to begin all over again. But in art, for which one needs time, it would not be so bad to live more than one life. And it is rather attractive to think of the Greeks, the old Dutch masters, and the Japanese continuing their glorious schools on other orbs."[37]

Van Gogh shared his belief in a "life beyond the grave" in a letter to his friend, Emile Bernard, suggesting that life may possibly continue after earthly death in another realm or even on another planet:

> Yet our real and true lives are rather humble, these lives of us painters, who drag out our existence under the stupefying yoke of the difficulties of a profession which can hardly be practiced on this thankless planet on whose surface the "love of art makes us lose the true love."
>
> But seeing that nothing opposes it — supposing that there are also lines and forms as well as colors on the other innumerable planets and

35. L506, 9 July 1888, *Letters* 2:605.
36. W8, 27 August 1888, *Letters* 3:445.
37. L511, 15 July 1888, *Letters* 2:615.

suns — it would remain praiseworthy of us to maintain a certain serenity with regard to the possibilities of painting under superior and changed conditions of existence, an existence changed by a phenomenon no queerer and no more surprising than the transformation of the caterpillar into a butterfly, or of the white grub into a cockchafer.

The existence of painter-butterfly would have for its field of action one of the innumerable heavenly bodies, which would perhaps be no more inaccessible to us, after death, than the black dots which symbolize towns and villages on geographical maps are in our terrestrial existence.[38]

Van Gogh's invocation of the metaphor of the butterfly in this context is a clear allusion to the afterlife, since the butterfly, because of its metamorphosis from the caterpillar, has conventionally been a symbol of resurrection in western religious artistic traditions.[39] His "painter-butterfly" is a symbolic representation of his belief in the possibility of his own resurrection and rebirth. While Kōdera argues that *Starry Night* is an example of van Gogh's complete rejection of the supernatural, the preceding words indicate van Gogh's belief in one of the most fundamental notions of supernatural religion, further evidence that van Gogh continued to embrace some of the basic tenets of the Christianity of his youth. In *Starry Night,* van Gogh chose a modern expression of these traditional ideas.

If it were possible to choose one painting of van Gogh's that would sum up all of his religious longing, the totality of his religious journey, it would most certainly be *Starry Night,* a painting that he had always dreamed of doing. "But when then, shall I do the starry sky, that painting which preoccupies me? Alas! Alas! It is like the excellent friend, Cyprien, says in *En Ménage,* by J. K. Huysmans, the most beautiful paintings are those one dreams about when smoking a pipe in bed, but which one does not do. The matter is, nevertheless, to attack them, as incompetent as one may feel in the face of the ineffable perfections of the glorious splendors of nature."[40]

38. B8, 23 June 1888, *Letters* 3:496.

39. "Because of its life cycle, the butterfly is a resurrection symbol. It is a symbol of eternal life, of metamorphosis, the butterfly breaking out of the pupa and soaring toward heaven in a new and beautiful form" (Gertrude Grace Sill, *A Handbook of Symbols in Christian Art* [New York: Macmillan, 1975], 18).

40. B7, 18 June 1888, *Letters* 3:492.

Starry Night is a visionary masterpiece, recounting the story of van Gogh's ultimate triumph over suffering, and exalting his desire for a mystical union with the divine. In many ways, it recalls the mysticism of the religion of van Gogh's youth, the Groningen theology and the piety of his uncle Stricker. In defining religion, van Gogh's uncle Stricker wrote, "Religion is not the fruit of rational contemplation and scientific investigation, but especially, the understanding of the human heart of its kindred sense of a higher world than the purely sensual and material world. Religion is a continual striving to a more intent communion with the Perfect."[41] The notion that the goal of religion is oneness with the divine was a fundamental tenet of the Groningen theology, ". . . we can and must become one with God, by faith and love, and eventually attain eternal life, which is already here on earth."[42]

Starry Night, as the preeminent expression of van Gogh's religious experience, is an autobiographical landscape, which we can divide into three separate areas, illustrating three of the most significant ideas in van Gogh's art and life. The village scene, the cypress tree, and the sky are all representative of specific religious beliefs van Gogh held. The church provides both a focal point and vertical accent in the village scene. Art historians point out that van Gogh's rendition of this church is imaginary, since the steeple is typical of the Dutch landscape, but not the landscapes of Provence.[43] In addition to being a Dutch church in style, van Gogh's rendition of the church is curious in another way. While every house glows

41. Stricker, *Een Laaste Woord bij het Nederleggen zijner Evangeliebediening inzonderheid gericht tot de vrijzinninge leden der Nederlandsche Hervormd Kerk* (Amsterdam: J. H. van Heteren, 1884), 5.

42. Hofstede de Groot, *De Groninger Godgeleerden in Hunne Eigenaardigheid* (Groningen: Scholtens, 1955), 44.

43. Lauren Soth notes the difference between the on-site sketches van Gogh made as preparatory studies for *Starry Night* and the actual painting:

> In the passage from sketched observation to painted image, one significant transformation took place: the form of the church was changed.
>
> St. Martin, the church in St. Rémy, had a dome that van Gogh clearly indicates in his drawing. The church in the *Starry Night* is not domed; it has a long nave and transept with steeply pitched roofs. With its tall spire, it is a type of church rare in Provence but common in the north and especially common in Brabant, van Gogh's homeland.
>
> Lauren Soth, "Van Gogh's Agony,"
> *Art Bulletin* 68, no. 2 (June 1986): 304

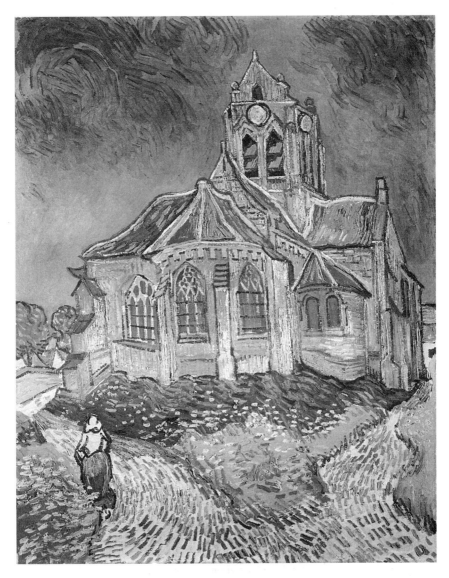

11. Vincent van Gogh, *The Church in Auvers,* 1890, oil on canvas

with yellow light under the brilliance of the starry sky, the church remains completely dark. This is also true of his *Church in Auvers* (1890, fig. 11), in which the foreground is brightly lit by the sun, but the church neither reflects not emanates any light of its own. The darkness of the "inside of

a church" is van Gogh's symbol of the empty and unenlightened preaching of the clergy which left him embittered and alone when he was forced to leave the ministry in 1880. In *Starry Night,* van Gogh reveals, however, that he did not close the door on religious faith, just the church. *Starry Night* shows van Gogh's journey from the darkness of the inside of a church, with its reference to his Dutch past, to the triumph of the mystic's communion with God through nature. While many have argued that the painting indicates van Gogh's rejection of Christianity and the supernatural, his observation (often quoted in conjunction with essays on *Starry Night*) that "When all sounds cease, God's voice is heard under the stars" actually comes from the heart of his "evangelical period," 1877, and reflects a lifelong spiritual conviction.[44]

The next compositional element of the painting, the cypress, which shoots up into the firmament like a giant flame, represents van Gogh's own as well as the universal striving for ultimate release from the sufferings of this world and ultimate union of the soul with the infinite. During his St. Rémy period especially, van Gogh painted a number of works featuring the cypress as the dominant pictorial image. In *Road with Cypress and Star* (1890, fig. 12), as in many of these works, the cypress looms so large that it actually bursts out of the picture plane and is cut off by the frame. He explained his fascination with the cypress to Theo: "You need a certain dose of inspiration, a ray from above which is not ours, to do the beautiful things. When I had done these sunflowers, I looked for the contrary and yet the equivalent, and I said this is the cypress. . . . It is as beautiful as the Egyptian obelisk."[45] The sunflower, as we have already noted, appeared with increasing regularity in the landscapes of van Gogh's St. Rémy period as symbols of devotional piety and love of God. Here the cypress, which van Gogh had formerly described as "funereal" in a darker sense, represents the longing for the soul to embrace God through death.[46]

It is the sky, however, full of radiant light and pulsating rhythms that dominates the painting. In the aesthetics of the transcendental Romantic writers, with whom van Gogh was very familiar, as well as the tradition of northern Romantic landscape painting, the sky is often symbolic of infinity or the Infinite Being. In his "Nine Letters on Landscape

44. L100, 5 June 1877, *Letters* 1:124.
45. L596, 25 June 1889, *Letters* 3:185.
46. L541, 27 September 1888, *Letters* 3:47.

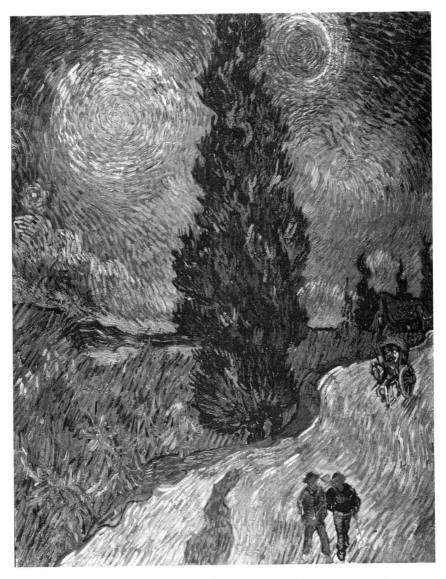

12. Vincent van Gogh, *Road with Cypress and Star,* 1890, oil on canvas

Painting" (1815-1824), Carus wrote, "The clear quintessence of air and light, is the true image of infinity, and since our feeling has a tendency toward the Infinite, the image of the sky strongly characterizes the mood

173

of any landscape under its lofty vault."[47] This hungering for the infinite, Shelley's "the moth's desire for a star," is one of van Gogh's most persistent personal qualities. The sky, particularly the star-filled sky, often evoked, for van Gogh, an ecstatic and mystical mood.

Van Gogh further emphasized his concern with expressing the infinite with his use of a deep azure blue as a backdrop for the pulsating, spiraling stars. In a portrait he had painted earlier of his friend, the poet Eugène Boch (*Portrait of Eugène Boch* [1888]), he explained his symbolic use of color and his intent to evoke the notion of infinity with his background of deep blue: "I should like to paint the portrait of an artist friend, a man who dreams great dreams. . . . I paint him as he is, as faithfully as I can to begin with. But the picture is not yet finished. To finish it, I am now going to be the arbitrary colorist. I exaggerate the fairness of the hair, I even get to orange tones and pale citron yellow. Behind the head, instead of painting the ordinary wall of the mean room, I paint infinity, a plain background of the richest, intensest blue that I can contrive, and by this simple combination of the bright head against the rich blue background, I get a mysterious effect, like a star in the depths of an azure sky."[48] Behind the head of the poet, van Gogh also painted small white dots resembling twinkling stars in a distant sky. In *Starry Night,* he translated the color symbolism into radiant stars against the indigo sky to evoke the same mysterious, mystical mood.

Another important symbolic element in *Starry Night* is van Gogh's unusual configuration of the moon, entirely different from other renditions of the moon in his oeuvre. Van Gogh once wrote to Theo of his association of the constellations of the night sky with eternity and the divine love of God, and it was perhaps to this memory that *Starry Night* speaks: "The moon is still shining, and the sun and the evening star, which is a good thing — and they also speak of the love of God, and make one think of the words: 'Lo, I am with you always, even unto the end of the world.' "[49] It is noteworthy that van Gogh speaks of the sun and the moon and the evening stars all shining together, and of how deeply he feels God's presence under this heavenly canopy. Since *Starry Night* was the first of van Gogh's

47. Quoted in Lorenz Eitner, *Neo-Classicism and Romanticism* (Englewood Cliffs: Prentice-Hall, 1970), 50.

48. L520, 11 August 1888, *Letters* 3:6.

49. L101a, 12 June 1877, *Letters* 1:127.

"memories of the north," it represents, in part, van Gogh's recollections of the past, when he was preparing for the Christian ministry. Just as he had felt God's presence in the night sky in Amsterdam, he still felt the presence of the divine when he beheld the magical "vault of heaven" at St. Rémy.

Perhaps the reason van Gogh painted the moon and sun together in one image, as a crescent within an orb, was to suggest the time of day, the passage of day into night. Van Gogh referred to this natural phenomenon as "blessed twilight," because it was in the mystical hours when the day turns into the night and the world is bathed in a magical somber light that he seemed most aware of the divine:

Twilight is falling — "blessed twilight," Dickens called it, and indeed he was right. Blessed twilight, especially when two or three are together in harmony of mind and, like scribes, bring forth old and new things from their treasure. Blessed twilight, when two or three are gathered in His name and He is in the midst of them, and blessed is he who knows these things and follows them too.

Rembrandt knew that, for from the rich treasure of his heart he produced, among other things, that drawing in sepia, charcoal, ink, etc., which is in the British Museum, representing the house in Bethany. In that room twilight has fallen; the figure of our Lord, noble and impressive, stands out serious and dark against the window, which the evening twilight is filtering through. At Jesus' feet sits Mary, who has chosen the good part, which shall not be taken away from her; Martha is in the room busy with something or other — if I remember correctly, she is stirring the fire, . . . I hope I forget neither that drawing, nor what it seems to say to me, "I am the light of the world, he that followeth me, shall not walk in darkness, but shall have the light of life."

. . . The light of the Gospel preached unto the poor in the Kingdom of my Father shining like a candle on a candlestick, upon all that are in the house (see Matt. 5:15). "I am come that they might have life and have it in abundance" (see John 10:10). "I am the Resurrection and the life, and he that believeth in me, though he were dead, yet shall he live; and whosoever liveth and believeth in me shall never die. Whomever loveth me, my father shall honor him, and we will come and make our abode with him" (John 14:23); "we shall come unto him and have supper with him." Such are the things twilight tells to those who have ears to

hear and a heart to understand and believe in God — blessed twilight! And it is also twilight in that picture by Ruyperez, the *Imitation of Jesus Christ,* as well as in another etching by Rembrandt, *David Praying to God.*[50]

Van Gogh also depicted the mystical twilight hour in a painting similar to *Starry Night, Road with Cypress and Star,* which he painted in May of 1890. Here, the idyllic image of the wayfarers, who wander on the road, with a horse-drawn carriage following behind, indicate van Gogh's need for companionship and love. The travelers are like pilgrims on a journey, in the presence of the looming cypress, which divides the pictorial space, emphasizing its vertical thrust. The images of the landscape indicate van Gogh's continued concern with eternity and life after this world. On one side of the cypress is a radiant evening star, with concentric circles of light, shown as it barely emerges in the night sky. On the other side of the cypress, the obelisk of death, is the newly formed crescent moon, which recalls van Gogh's prevailing concern with renewal and rebirth, the consolation of the end of the spiritual journey — a parallel to Bunyan's light of the Celestial City, as it beckons the pilgrims to their eternal home. This painting, even more than *Starry Night,* reflects the somber reality that van Gogh had begun to believe that he was nearing the end of his earthly life and was looking to the hope of eternal release in death. Van Gogh's *Starry Night* mediates between the two worlds of heaven and earth, life and death, the world "at eternity's gate." The passing of day into night, the imposing image of the cypress as it soars from the earth to the heavens, and the stars, which represent van Gogh's longing for ultimate union with the Infinite Being, evoke thoughts of death and immortality.

The image of the old man by the fire in van Gogh's early print, *At Eternity's Gate,* comes to mind, a subject which he reworked at St. Rémy. An observation penned in 1876 demonstrates that van Gogh thought deeply about the question of the cycle of life, especially what lies on the other side after we "vanish" from this world, as he put it: "And the evenings? To sit beneath the wide canopy of the fireplace, feet in the ashes, gazing up at a star which sends down its ray through the opening of the chimney, as if to send me an appeal; or deep in a vague reverie, watching the flames as they are born, rise, pant, flicker, succeed each other, as if out

50. L110, 18 September 1877, *Letters* 1:142.

of desire to lick the pot with their fiery tongues, and reflecting that this is human life: we are born, we work, we love, we grow, we vanish!"[51] Van Gogh's reworking of his earlier print in an oil painting shows his continued preoccupation with the issues of suffering, sickness, and death, with the ultimate hope of deliverance in a "life beyond the grave." It was his belief in the immortality of the soul that consoled him in his darkest times of grief and pain in the asylum of St. Paul-de-Mausole. Van Gogh's tenacious affirmation of an afterlife was one of the constants of his religious experience. He believed fundamentally that earthly suffering would give way to eternal hope when he embraced the theology of *The Imitation of Christ* and *The Pilgrim's Progress.* When he left the institutional church, he espoused the theology of Renan, who maintained a hope for eternal life as the chief consolation of the religious life. Finally, when van Gogh began to return to the religious traditions of his youth at St. Rémy, he clung still to the hope for eternal redemption.

Artistically, the reworked canvas of *At Eternity's Gate* displays van Gogh's simplification of forms as well as content, his reduction of artistic images into the deeply expressive subject and its parallel affirmation of the universal kernel of religious truth. While the original drawing depicts the objects of the hearth and the peasant's home, the oil painting is void of these trappings, concentrating instead on the figure of the care-worn old man, with his face buried in his hands, hidden from the viewer. The chair on which he sits is reminiscent of the one van Gogh painted in Arles, as a companion to Gauguin's chair. We might also recall that it was on the chair in *The Potato Eaters* that van Gogh etched his signature, implying his identification with this object as a symbolic representation of himself. In *The Potato Eaters,* the figure in the chair stares off into space with an expression of the most profound sense of isolation and loneliness. The image of the chair also recalls van Gogh's sobs of sorrow after his father's departure when he viewed the empty chair Theodorus had used while visiting him in Amsterdam during his studies for seminary. The image of the old man by the fire, then, is even more to be pitied for his loneliness in his final hour. The grieving old man in *At Eternity's Gate* has lost hope in the possibility of happiness in this lifetime — he is prepared to go home. Van Gogh's belief in ultimate salvation through death is perhaps best expressed in the poetry of Walt Whitman, which we know he greatly admired:

51. L76, 9 October 1876, *Letters* 1:69.

Come lovely and soothing death,
undulate round the world, serenely arriving, arriving,
In the day, in the night, to all, to each,
Sooner or later delicate death.

Praised be the fathomless universe,
For life and joy, and for objects and knowledge curious,
And for love, sweet love — but praise! praise! praise!
For the sure-enwinding arms of cool-enfolding death.

The night in silence under many a star,
The ocean shore and husky whispering wave whose voice I know,
And the soul turning to thee O vast and well-veil'd death,
And the body gratefully nestling to thee.[52]

It seems that the "sure-enwinding arms of cool-enfolding death" did not come fast enough for van Gogh. Care-worn and fearful of his future in this world, he chose to take his own life and come to death himself, hoping for a renewed existence on the other side of this "deluge of pain." In his own mind, van Gogh's suicide was not so much a tragic end to life as a passing through to a new beginning, like the metamorphosis of the caterpillar to the butterfly.

52. Walt Whitman, "When Lilacs Last in the Dooryard Bloom'd," in *Leaves of Grass,* Comprehensive Reader's edition, ed. Harold W. Blodgett and Sculley Bradley (New York: W. W. Norton, 1965), 335.

Conclusion

V AN GOGH WAS DEEPLY RELIGIOUS NOT ONLY IN THE YEARS FROM
1875 to 1880, when he pursued the Christian ministry as a vocation,
but throughout the course of his entire life. Many of the ideas that had
directed his life while a student in preparation for the ministry and as an
evangelical missionary continued to influence him when he became an
artist. While he left the Church in 1880 because of his frustration with
his perceived hypocrisy of the clergy, particularly that of his father and his
uncle, van Gogh continued to hold to many aspects of his earlier Christian
faith: his respect for the Bible and the person of Jesus Christ, his concern
for the poor and his belief in a revolution that would bring about the
kingdom of God on earth, as well as his belief in the reward of an afterlife
for those who had suffered the earthly journey of faith. He viewed his
religious experience as an arduous pilgrimage through the woes and sor-
rows of temporal existence, with the hope of ultimate renewal and rebirth
on the other side of life. This notion of the central and fundamental
importance of religion pervades his artistic oeuvre.

While some have argued that he practiced a morbid religious fanat-
icism in his early years, his asceticism, in reality, was not aberrant but a
living out of a long-established religious tradition dating from the teach-
ings of Jesus Christ himself, the vita apostolica, which van Gogh appro-
priated from his devotional reading, particularly *The Imitation of Christ* and
The Pilgrim's Progress. He attempted to put the teachings of Thomas à
Kempis and John Bunyan into practice through his missionary work

among the coal miners of the Belgian Borinage. We may recall, for example, the testimonies about van Gogh that he gave away all his best clothes and slept on a bed of straw, that he went into the mines to rescue workers from the terrible underground explosions, suffering burns himself, and that his Christian humility drove him to the brink of exhaustion. While successful in his ministry to the poor, he was nonetheless unable to obtain a permanent appointment and was forced to resign his first calling. We remember the stories of the dramatic conversions he obtained among the coal miners, as well as their great respect for him as their pastor. When the Consistory dismissed him, they applauded his service but lamented his lack of oratory skills as a preacher. When he left the missionary work, he left behind his life-long dream to follow in the footsteps of his father and grandfather as ministers of the Gospel and chose instead to become an artist.

It is with this decision that most of his biographers have argued van Gogh left his former faith entirely. He left the Church, however, not because he rejected the teachings of Christianity, but because he was repulsed by the hypocrisy he encountered in the clergymen of the Consistory in the Borinage as well as in his father and his uncle. He rejected the Church, thereafter referring to the inside of a church as the white-washed wall of icy hypocrites. But he did not reject Christianity, seeking rather to find a synthesis of his faith with modernity. This was particularly apparent in his love of modern literature, especially the ironic Realism of Zola and the Romantic tragedies of Hugo. Van Gogh was especially drawn to the Christ-like heroes, such as Pauline in Zola's *La Joie de Vivre* and Jean Valjean in Hugo's *Les Misérables*. He did not denigrate the Bible but believed instead that modern literature was a good supplement to Bible reading. While many of van Gogh's biographers have seen in this a radical departure from what they believed to be a strict Calvinist upbringing, van Gogh was not a Calvinist, but was instead raised on the theology of the mediating school of Groningen and was exposed to the liberal theology of Dutch Modernism through both the teaching and writing of his uncle. The tension he saw and tried to resolve between Christianity and modernity manifested itself in works such as *Still-life with Open Bible*. Van Gogh experienced the divine in the most mundane acts of human existence, such as the sowing and harvesting of wheat. It was in van Gogh's first major work, *The Potato Eaters,* that he attempted to suggest the divine presence symbolically, without actually depicting the person of Jesus, through his

subtle allusion to the celebration of the eucharist. This tendency to represent the infinite in the finite became one of the prevailing signatures of van Gogh's artistic expression. He saw in the universe around him, from the smallest sunflower facing upward to the noon-day sun, to the glorious vault of heaven that surrounded him in the star-lit night sky, a revelation of the transcendent God that remains above nature.

Van Gogh's continued preoccupation with the symbols and subjects that first came to him through the parables and sayings of Jesus is apparent in his many renditions of sowers, reapers, and wheatfields throughout his artistic career. As Millet had done before him, van Gogh viewed the peasant as a sacred prototype, whose simple acts of plowing, sowing, and harvesting wheat seemed a kind of divine labor. When van Gogh was struck down with the debilitating illness, temporal lobe dysfunction and depression, that led to his self-mutilation and eventual suicide, his auditory and visual hallucinations took on a decidedly religious nature, perhaps due to his surroundings, but certainly as a reflection of his whole life experience. It was religion that played a fundamental role in providing solace and hope to van Gogh during his illness and confinement at the asylum in St. Rémy. We remember that he told Theo that even the act of painting the religious subject of Christ in the arms of the Virgin gave him comfort in his terrible time of pain. It was religion that often dictated his choice of subjects, such as the Pietà, the Good Samaritan, and the resurrected Lazarus. Finally, van Gogh's continued belief in an afterlife informed the symbolism of his later works, such as *Starry Night, Crows over the Wheatfield,* and *At Eternity's Gate.*

Van Gogh's 1888 letter to his closest friend, Emile Bernard, who was sympathetic to his appreciation of Christianity, shows how deeply the struggle with the Christian faith had permeated his whole life. His frustration with the Church, his admiration for Christ, his understanding of the difficulty of imitating Christ, as well as his respect for the Bible and his belief in the consoling power of faith and the promise of an afterlife are all apparent in this intimate account. His words also demonstrate how deeply he identified with Christ, as an artist, and how he believed religion and art to be fundamentally intertwined:

> It is a very good thing that you read the Bible. . . . The Bible is Christ, for the Old Testament leads up to this culminating point.
> . . . Christ alone, of all the philosophers, Magi, etc. — has affirmed, as a principal certainty, eternal life, the infinity of time, the nothingness

of death, the necessity and the raison d'être of serenity and devotion. He lived serenely, as a greater artist than all other artists, despising marble and clay as well as color, working in living flesh. That is to say, this matchless artist, hardly to be conceived of by the obtuse instrument of our modern, nervous, stupefied brains, made neither statues nor pictures nor books; he loudly proclaimed that he made . . . *living men, immortals.*

. . . Though this great artist — Christ — disdained writing books on ideas (sensations), he surely disdained the spoken word much less — particularly the parable. (What a sower, what a harvest, what a fig tree!)

. . . These considerations, my dear Bernard, lead us very far, very far afield; they raise us above art itself. They make us see the art of creating life, the art of being immortal and alive at the same time.[1]

Emile Bernard described the funeral of his dear friend, whom he had left behind in Paris four years before, in a letter to the art critic, Albert Aurier, who was the first to acknowledge van Gogh's genius, noting the importance of light, the color yellow, and the symbol of the sunflower in van Gogh's life and work.

On the walls of the room where the body lay all his canvases were nailed, forming a sort of halo around him, and rendering his death all the more painful to the artists who were present by the splendor of the genius which radiated from them. On the coffin a simple white linen, masses of flowers, the sunflowers which he loved so much, yellow dahlias, yellow flowers everywhere. It was his favorite color, as you will remember, a symbol of the light he dreamt in hearts as well as in paintings.[2]

Appropriately, van Gogh's *Pietà,* with its red-haired Christ in his moment of transition from death to resurrection, was the painting that hung on the wall over the casket at the funeral. Perhaps the artists and friends who loved and admired him hoped van Gogh had taken "death to reach a star," and was finally at peace.

1. B8, 23 June 1888, *Letters* 3:495.
2. Quoted in Jan Hulsker, *Vincent and Theo van Gogh: A Dual Biography* (Ann Arbor: Fuller Publications, 1990), 447.

Selected Bibliography

LETTERS

De Brieven van Vincent van Gogh. 4 vols. Edited by Han van Crimpen and Monique Berends-Albert. 's Gravenhage: Sdu Uitgeverij, 1990.

The Complete Letters of Vincent van Gogh. 3 vols. Introduction by V. W. van Gogh. Preface and Memoir by Johanna van Gogh-Bonger. Greenwich, Conn.: New York Graphic Society, 1958.

BOOKS

Adams, Raymond, M.D., and Maurice Victor, M.D. *Principles of Neurology.* 4th ed. New York: McGraw-Hill, 1989.

The Articles of the Synod of Dort. Translated by Thomas Scott. Utica, New York: Williams, 1831.

Athanasius. *The Life of St. Anthony.* The Classics of Western Spirituality. Translated by Robert C. Gregg. New York: Paulist Press, 1980.

Bangs, Carl. *Arminius: A Study in the Dutch Reformation.* Grand Rapids: Zondervan, 1985.

Blok, Johannes Petrus. *History of the People of the Netherlands.* 5 vols. New York: G. P. Putnam's Sons, 1889.

Brauer, Herman. *Bulletin of the University of Wisconsin.* Vol. 2, *The Philososphy of Ernst Renan.* Madison: University of Wisconsin, 1903.

Bunyan, John. *The Pilgrim's Progress.* World Classics edition. Oxford: Oxford University Press, 1984.

Cabanne, Pierre. *Van Gogh.* New York: Thames and Hudson, 1986.

Cannon, William Ragsdale. *The Theology of John Wesley.* New York: Abingdon-Cokesbury, 1956.

Chetham, Charles. *The Role of van Gogh's Copies in the Development of His Art.* New York: Garland, 1976.

The Concise Oxford Dictionary of the Christian Church. Edited by Elizabeth A. Livingstone. Oxford: Oxford University Press, 1977.

De Groot, Hofstede. *De Groninger Godgeleerden in Hunne Eigenaardigheid.* Groningen: Scholtens, 1955.

De Jong, Peter Y. *Crisis in the Reformed Churches, Essays in Commemoration of the Synod of Dort, 1618-1619.* Grand Rapids: Reformed Fellowship, 1968.

Durkheim, Emile. *The Elementary Forms of the Religious Life, a Study in Religious Sociology.* New York: Macmillan, 1915.

Edwards, Cliff. *Van Gogh and God.* Chicago: Loyola University Press, 1989.

Eitner, Lorenz. *Neo-Classicism and Romanticism.* Englewood Cliffs: Prentice-Hall, 1970.

Eusebius. *Ecclesiastical History.* Twin Books edition. Grand Rapids: Baker Book House, 1977.

Frye, Roland. *God, Man and Satan — Patterns of Christian Thought and Life in Paradise Lost, Pilgrim's Progress and the Great Theologians.* Princeton: Princeton University Press, 1960.

Furlong, Monica. *Puritan's Progress: A Study of John Bunyan.* London: Hodder and Stoughton, 1975.

Graetz, Heinz R. *The Symbolic Language of Vincent van Gogh.* New York: McGraw-Hill, 1963.

Hammacher, Abraham and Renilde. *Van Gogh: A Documentary Biography.* New York: Macmillan, 1976.

Heinich, Nathalie. *The Glory of van Gogh: An Anthropology of Admiration.* Translated by Paul Leduc Browne. Princeton: Princeton University Press, 1996.

Hulsker, Jan. *The Complete van Gogh.* New York: Harry N. Abrams, 1980.

———. *Van Gogh's Diary: The Artist's Life in His Own Words and Work.* New York: William & Morrow, 1971.

———. *Van Gogh door van Gogh: de Brieven als Commentaar op Zijn Werk.* Amsterdam: Meulenhoff, 1973.

―――――. *Vincent and Theo van Gogh: A Dual Biography.* Ann Arbor: Fuller Publications, 1990.

Ignatius, Saint. *Letter to the Romans.* Loeb Classical Library edition. Cambridge, Mass.: Harvard University Press, 1977.

Jansen, J. G. B. "De Barmhartige Samaritaan uitgebeeld door Rembrandt en Vincent van Gogh." In *Barmhartige Samaritaan in Rovershanden.* Apeldoorn: Uitgeverij Semper Agendo BV, 1974. Pp. 185-94.

Jaspers, Karl. *Strindberg and van Gogh: An Attempt at a Pathographic Analysis with Reference to Parallel Cases of Swedenborg and Holderlin.* Translated by Oskar Grunow and David Woloshin. Tucson: The University of Arizona Press, 1977.

Kelly, J. N. D. *Early Christian Doctrines.* New York: Harper & Row, 1960.

Kempis, Thomas à. *The Imitation of Christ.* Edited by Harold C. Gardener. New York: Image Books, 1955.

Kinder, Herman, and Werner Hilgemann. *The Anchor Atlas of World History.* 2 vols. New York: Doubleday, 1974.

Kōdera, Tsukasa. *Vincent van Gogh: Christianity versus Nature.* Amsterdam: John Benjamins, 1990.

Kromminga, D. H. *The Christian Reformed Tradition, from the Reformation to the Present.* Grand Rapids: Eerdmans, 1943.

Latourette, Kenneth. *Christianity in a Revolutionary Age.* Vol. 2, *The Nineteenth Century in Europe: The Protestant and Eastern Churches.* Westport, Conn.: Greenwood Press, 1977.

Leistra, Josephine. *George Henry Boughton: God Speed! Pilgrems op Weg naar Canterbury.* Amsterdam: Rijksmuseum Vincent van Gogh, 1987.

Levensberichten der Afgestorvene Medeleden van de Maatschappij der Nederlandsche Letterkunde. Leiden: E. J. Brill, 1887.

Leymarie, Jean. *Qui était van Gogh?* Geneva: n.p., 1968.

Lubin, Albert J. *A Stranger on the Earth: A Psychological Biography of Vincent van Gogh.* New York: Henry Holt, 1972.

Origen. *An Exhortation to Martyrdom, Prayer and Selected Works.* The Classics of Western Spirituality. Translation and introduction by Rowan A. Greer. New York: Paulist Press, 1979.

Palmer, Michael F. *Paul Tillich's Philosophy of Art.* Berlin: Walter de Gruyter, 1984.

Pickvance, Ronald. *Van Gogh in Arles.* New York: Harry N. Abrams, 1984.

―――――. *Van Gogh in St. Rémy and Auvers.* New York: The Metropolitan Museum of Art, 1986.

Piérard, Louis. *The Tragic Life of Vincent van Gogh.* Translated by Herbert Garland. Boston: Houghton Mifflin, 1925.

Pourrat, P. *Christian Spirituality in the Middle Ages.* Vol. 2. London: Burns, Oates and Washbourne, 1924.

Rasker, A. J. *Der Nederlandse Hervomde Kerk vanaf 1795: Haar Geschiedenis en Theologie in de Negentiende en Twintigste Eeuw.* Kampen: J. H. Kok, 1974.

Readings in Western Civilization. Vol. 4. Edited by Julius Kirshner and Karl F. Morrison. Chicago: University of Chicago Press, 1986.

Renan, Ernst. *The Life of Jesus.* New York: Carlton House, 1927.

Rewald, John. *Post-Impressionism from van Gogh to Gauguin.* New York: The Museum of Modern Art, 1978.

Roessingh, K. H. *Verzamelde Werken.* 2 vols. Groningen: Erven B. Van der Kamp, 1914.

Schapiro, Meyer. *Modern Art: Nineteenth and Twentieth Centuries, Selected Papers.* New York: George Braziller, 1979.

————. *Vincent van Gogh.* New York: Harry Abrams, 1979.

Secretan-Rollier, Pierre. *Vincent van Gogh chez les Gueles Noires.* Lausanne: L'Age d'Homme, 1977.

Sill, Gertrude Grace. *A Handbook of Symbols in Christian Art.* New York: Macmillan, 1975.

Spitz, Lewis. *The Renaissance and the Reformation Movements.* Chicago: Rand McNally & Co., 1971.

Stellingwerf, Johannes. *Werkelijkheid en Grondmotief bij Vincent Willem van Gogh.* 2 vols. Amsterdam: Swets & Zeitlinger, 1959.

Stokvis, Benno J. *Nasporingen Omtrent Vincent van Gogh in Brabant.* Amsterdam: S. L. van Looy, 1926.

Stricker, Johannes Paulus. *Christelijk Album.* Amsterdam, 1858.

————. *Christelijk Maadschrift.* Amsterdam, 1861.

————. *Een Laaste Woord bij het Nederleggen zijner Evangeliebediening inzonderheid gericht tot de vrijzinninge leden der Nederlandsche Hervormd Kerk.* Amsterdam: J. H. van Heteren, 1884.

————. *Jezus van Nazareth volgens de Historie Geschetst.* Amsterdam: Gebroeders Kraay, 1868.

Tralbaut, Marc Edo. *Vincent van Gogh.* Lausanne: Edita, 1969.

Turner, Edith and Victor. *Image and Pilgrimage in Christian Culture.* New York: Columbia University Press, 1978.

Underhill, Evelyn. *Mysticism: A Study in the Nature and Development of Man's Spiritual Consciousness.* New York: Meridian, 1955.

Van den Berg, Frank. *Abraham Kuyper.* Grand Rapids: Eerdmans, 1960.

Van Beselaere, Walter. *De Hollandsche Periode in het Werk van Vincent van Gogh.* Antwerp: De Sikkel, 1937.

Van Uitert, Evert, Louis van Tilborgh, and Sjraar van Heugten. *Paintings, Vincent van Gogh.* Milan: Arnoldo Mondadori Arte and Rome: De Luca Edizioni D'Arte, 1990.

Vanderlaan, Eldred C. *Protestant Modernism in Holland.* London: Oxford University Press, 1924.

Weisbach, Werner. *Vincent van Gogh, Kunst und Schicksal.* 2 vols. Basel: Benno Schwabe & Co., 1949.

Whitman, Walt. *Leaves of Grass.* Comprehensive Reader's edition. Edited by Harold W. Blodgett and Sculley Bradley. New York: W. W. Norton, 1965.

Zemel, Carol. *Van Gogh's Progress: Utopia, Modernity, and Late Nineteenth Century Art.* Berkeley: University of California Press, 1997.

PERIODICALS

Arenberg, Kaufman, M.D., et al. "Van Gogh Had Menière's Disease and Not Epilepsy." *JAMA* 264, no. 4 (25 July 1990): 491-93.

Arnold, Wilfred Niels. "Vincent van Gogh and the Thujone Connection." *JAMA* 260, no. 20 (25 November 1988): 3042-44.

Boime, Albert. "Van Gogh's *Starry Night:* a Matter of History and a History of Matter." *Arts Magazine* (December 1984): 86-103.

De Montmorand, Brenier. "Ascétisme et Mysticisme: Étude Psychologique." *Revue Philosophique* (March 1904): 242-62.

Erickson, Kathleen Powers. "Self-Portraits as Christ." *Bible Review* 6, no. 3 (June 1989): 24-31.

————. "Testimony to Theo: Vincent van Gogh's Witness of Faith." *Church History* 61, no. 2 (June 1992): 206-20.

Fabbri, Remo, M.D. "Dr. Paul-Ferdinand Gachet: Vincent van Gogh's Last Physician." *Transactions of the College of Physicians* 4, series 32-33 (1964): 202-8.

Garmon, Linda. "Of Hemispheres, Handedness and More." *Psychology Today* 19 (November 1985): 40-48.

Gastaut, Henri. "La Maladie de Vincent van Gogh Envisagée a la Lumière des Conceptions Nouvelles sur L'epilepsie Psychomotrice." *Annales*

Médico-Psychologiques Revue Psychiatrique: Bulletin Officiel de la Société Médico-Psychologique 114 (1956): 196-238.

Hammacher, A. M. "Van Gogh — Michelet — Zola." *Vincent* 4, no. 3 (1975): 2-21.

Hemphil, R. E. "The Illness of Vincent van Gogh." *Proceedings of the Royal Society of Medicine* 54 (13 June 1961): 27-32.

Hulsker, Jan. "1878, A Decisive Year in the Lives of Theo and Vincent." *Vincent* 3, no. 3 (1974): 15-36.

Loftus, Loretta S., and Wilfred Niels Arnold. "Vincent van Gogh's Illness: Acute Intermittent Porphyria?" *British Medical Journal* 303 (21-28 December 1991): 1589-91.

Nordenfalk, Carl. "Van Gogh and Literature." *London University Warburg Journal* 10 (1947-48): 132-47.

Sabbadini, Andrea. "L'enfant de Remplacement." *La Psychiatrie de L'enfant* 32, no. 2 (20 November 1989): 519-41.

Schwind, Jean. "Van Gogh's *Starry Night* and Walt Whitman: A Study in Source." *Walt Whitman Quarterly Review* 3 (Summer 1985): 1-15.

Soth, Lauren. "Van Gogh's Agony." *Art Bulletin* 68, no. 2 (June 1986): 301-13.

Tralbaut, Marc Edo. "Over de Godsdienstige Richtingen in Vincent's Tijd." *Van Goghiana* 7 (1970): 103-8.

Van den Eerenbeemt, H. F. J. M. "The Unknown Vincent van Gogh, 1866-68, the Secondary State School at Tilburg." *Vincent* 2, no. 1 (1972): 2-12.

Van Tilborgh, Louis. "De Bijbel van Vincent's Vader." *Van Gogh Bulletin* 3 (1988), published by Rijksmuseum Vincent van Gogh.

Werness, Hope. "Whitman and van Gogh: Starry Nights and Other Similarities." *Walt Whitman Quarterly Review* 2, no. 4 (Spring 1985): 35-41.

Whitney, Charles A. "The Skies of Vincent van Gogh." *Art History* 9, no. 3 (September 1986): 351-61.

Wylie, Anne Stiles. "Vincent and Kee and the Municipal Archives in Amsterdam." *Vincent* 2, no. 4 (1973): 2-7.

Index

Page numbers followed by asterisks refer to illustrations.